When Harry Met Pablo

TRUMAN, PICASSO, *and the* COLD WAR POLITICS *of* MODERN ART

MATTHEW ALGEO

CHICAGO
REVIEW
PRESS

Published by Chicago Review Press Incorporated
814 North Franklin Street
Chicago, Illinois 60610
ISBN 978-1-64160-787-2

Library of Congress Control Number: 2023940201

Typesetting: Jonathan Hahn

Printed in the United States of America
5 4 3 2 1

CONTENTS

INTRODUCTION

ONE DAY IN JUNE 1958, Harry Truman, along with his wife, Bess, and their friends Sam and Dorothy Rosenman, traveled up the winding streets of Cannes to a hilltop mansion where Pablo Picasso, the world's most famous artist, lived with his future second wife, Jacqueline Roque. Later that day, Truman and Picasso, two towering figures of the twentieth century, were photographed outside the pottery in Vallauris where Picasso made ceramics, shaking hands like two old friends. This photograph—actually a stereoscopic color slide probably taken by Sam Rosenman—pops up occasionally on history-themed social media accounts, usually accompanied by a comment about the incongruity of the encounter.

It is a jarring image. Truman and Picasso were contemporaries—they were born just three years apart and would die less than four months apart—and they were both shaped by and shapers of the great events of the twentieth century. But in most ways they couldn't have been more different. Picasso was a communist, and probably the only thing Harry Truman hated more than communists was modern art. Picasso was an indifferent father, a womanizer, and a multimillionaire. Truman was utterly devoted to his family and, despite his fame, not spectacularly wealthy. The cubist and the square, as one of my friends put it. Truman didn't strike me as the kind of guy who would go out of his way to knock on Picasso's door, and Picasso wasn't the kind of guy you just popped in on anyway, even if you were once the most powerful person on earth.

The photo was taken while the Trumans were vacationing with the Rosenmans in the South of France. The two American couples spent a day sightseeing along the Riviera with Picasso and Roque, racing from one attraction to another, much like any other tourists. This guided tour was a rare gesture of hospitality by Picasso, who was notoriously prickly about entertaining visitors.

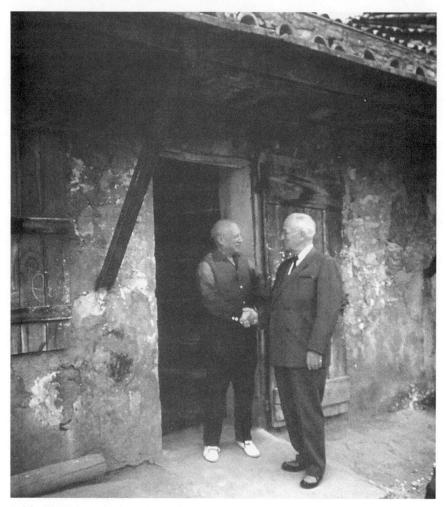

Pablo Picasso and Harry Truman, Vallauris, France, June 11, 1958.
Harry S. Truman Presidential Library & Museum

I knew there had to be a story behind this improbable rendezvous between the president who authorized the use of atomic bombs against civilians and the man who painted *Guernica*. Whose idea was it? Neither man seemed likely to propose getting together with the other. How was it arranged? And why? It had to be more than a simple social call. And what the heck did they talk about? Did they get along?

I pitched a story about Harry and Pablo's sightseeing excursion to the editors of *White House History Quarterly*, the White House Historical Association's

magazine, and they accepted it. Once I started my research, it didn't take long for me to realize the story demanded much more than a two-thousand-word article. That's because it encompasses some of the biggest issues of the twentieth century: the Cold War, McCarthyism, communism, modernism, Nazis, Stalinists, blacklists, a secret CIA operation, and a military coup that returned Charles de Gaulle to power in France just weeks before Truman met with Picasso.

Unraveling the story has been an adventure in itself, taking me from the Côte d'Azur to Kansas City and many points in between. I have retraced the Trumans' Mediterranean vacation and visited the places they went with Picasso, including Picasso's villa, La Californie, in Cannes; Poterie Madoura, Picasso's pottery in Vallauris; and the former Château Grimaldi in Antibes, now the Musée Picasso.

When Harry Met Pablo tells the story of that day, the events large and small that led to it, and my own efforts to get to the bottom of what happened. Incredibly, none of Picasso's or Truman's many biographers have discussed the meeting at any length. David McCullough's magisterial and megasized *Truman* biography doesn't mention it at all.

Which is surprising, because it's an amazing story. You see, by shaking Picasso's hand in France, Harry Truman was giving Far Right Republicans back home the bird.

For more than a decade, conservative Republicans in Congress, most notably a Michigan representative named George Dondero, had been attacking modern art as communistic, subversive, and un-American. These acolytes of the red-baiting senator Joseph McCarthy forced Truman, and later Eisenhower, to cancel State Department cultural programs overseas that included modern art—programs that were intended to showcase the United States' supposed freedom of expression. They also threatened to cut federal funding for museums that promoted modern art. In one speech on the House floor, Dondero claimed communists were infiltrating American museums like "termites," language eerily similar to that which the Nazis had used to denounce the makers of modern art. As a result of these attacks, many American painters and sculptors, like many Hollywood writers, directors, and actors likewise identified as "red" or "pink," found themselves blacklisted, effectively banned from displaying their works in public galleries and museums. Commissions dried up, and promising careers were cut short.

Harry Truman was no fan of modern art. He called it "ham and eggs art" because he thought most of it looked like something that belonged on a breakfast plate rather than a museum wall. Having come of age in fin de siècle Missouri, his tastes ran more toward Frederic Remington than Auguste Rodin. But he was a fundamentalist when it came to the First Amendment. He believed artists had the right to work without fear of being harassed by the government—even if, in his opinion, the art they made was "half-baked." Harry Truman may have been a philistine, but he was no fascist. "I am going to tell you how we are not going to fight communism," he declared in a 1950 speech. "We are not going to try to control what our people read and say and think. We are not going to turn the United States into a right-wing totalitarian country in order to deal with a left-wing totalitarian threat."

My research has revealed that Truman's meeting with Picasso was quietly arranged by Alfred H. Barr Jr., the founding director of New York's Museum of Modern Art and an early champion of Picasso in the United States. Barr knew that if he could convince these two ideological antipodes, the straight-talking politician from Missouri and the communist cubist from Málaga, to simply shake hands, it would send a powerful message, not just to reactionary Republicans like George Dondero but to the whole world: modern art is not evil.

Although the events depicted in this book occurred more than six decades ago, some aspects will still strike modern readers as depressingly familiar: the Far Right's hatred of all things modern or progressive, a general inability to comprehend that a political opponent's point of view may have some validity, the outrageous prices American tourists are often charged in Europe.

While he often railed against modern art—and seemed to delight in doing so—Truman also recognized the movement's power to influence public opinion, especially abroad. It was under his watch that the CIA began a clandestine program to promote modern art overseas. And while the president maligned their art, the artists' ability to produce it was not impeded. What better example of the power of free speech and democracy? So Truman found himself at once condemning the art but supporting the artists' right to make it. Unlike many of today's political leaders, Truman was able to distinguish between his personal tastes and the public good. While Truman merely mocked modern art, Republicans like George Dondero actively worked to punish those who made it, those who promoted it, and even those who wrote favorably about it.

When Harry Met Pablo is based on my research in numerous archives, including the Harry S. Truman Presidential Library and Museum in Independence, Missouri; the Museum of Modern Art Archives in New York; and the Smithsonian Institution Archives of American Art in Washington, DC. I also consulted remotely with archivists at the Picasso museums in Paris and Barcelona. Much of the correspondence pertaining to this trip and several of the photographs in this book have never been published before.

The book is also a travelogue, an excursion I have taken to calling Harry Truman's European Adventure. Truman's meeting with Picasso, while certainly noteworthy, was just one element of this adventure. Everywhere he went, from the ruins of Herculaneum to the Roman amphitheater in Arles, he traveled as an ordinary tourist (the Secret Service would not begin protecting former presidents until after the assassination of John F. Kennedy). People in Italy and France were accustomed to their leaders seeming more regal, more imperious, more remote. So the sight of a former US president casually sipping an espresso at an outdoor cafe in Monaco or accidentally crashing a wedding in Genoa or even helping to push his car after it stalled in Sanremo was to them astonishing. Truman's trip to the Mediterranean combined the ordinary and the extraordinary in ways that have made Harry Truman one of the twentieth century's most enduring personalities.

I hope you enjoy the trip as much as he did.

PART I

ART WITH A CAPITAL *A*

1 | THE NELSON GALLERY

HARRY TRUMAN DID NOT grow up in an environment teeming with visual art. It's not as if his family was uncultured; there was an upright Kimball piano in the parlor, and young Harry was made to take lessons, which he did happily even long past adolescence, rising at five o'clock every morning to practice. Chopin's "Funeral March," Mozart's Ninth Sonata, and Beethoven's *Sonata Pathétique*—these were among the pieces he learned by heart. He achieved an impressive level of proficiency and even considered a career as a musician. "My choice early in life was either to be a piano player in a whorehouse or a politician," he once joked. "And to tell the truth there's hardly any difference."

But in young Harry Truman's world, the visual arts—paintings, drawings, sculptures—were largely absent outside a commercial context. He may have seen reproductions of famous patriotic works like John Trumbull's *Declaration of Independence* or Emanuel Leutze's *Washington Crossing the Delaware* in his high school textbooks, but he never received an education in art or art history, and he never evinced a talent for drawing to rival his musical aptitude. We know of nothing he sketched, apart from a few doodles scribbled out of boredom while listening to interminable debates in the Senate, none of which (doodles or debates) are especially noteworthy.

College was out of the question. He'd hoped to attend West Point, but his eyesight was too poor, and his parents couldn't afford to send him anywhere else. So he went to work. In the spring of 1903, just before his nineteenth birthday, Harry took a job as a clerk at the National Bank of Commerce in downtown Kansas City and eventually moved into a boardinghouse at 1314

3

Troost Avenue, operated by a Mrs. Trow. Room and board (breakfast and din-
ner) was five dollars a week. One of Mrs. Trow's other boarders was Harry's
coworker at the bank, a fellow clerk who would eventually rise to become the
bank's vice president. His name was Arthur Eisenhower. Many years later,
Harry would also work with Arthur's little brother, Dwight.*

Harry's salary was thirty-five dollars a month, which didn't leave him
much in the way of discretionary income, so he finally had to quit taking
piano lessons. Other than occasional nights out at the theater, his main source
of entertainment was, as always, reading. He became a regular patron of the
Kansas City Public Library, which was housed in a grand Beaux-Arts building at
Ninth and Locust, less than a mile from Harry's boardinghouse. On the library's
second floor was a small art gallery, just two rooms, rather grandly named the
Western Gallery of Art, and it was here that Harry Truman likely saw for the
first time the works of the old masters, full size and in living color—although
the paintings were actually masterful reproductions.

The Western Gallery of Art was the brainchild of burly William Rockhill
Nelson, publisher of the *Kansas City Star*. Born in Fort Wayne, Indiana, in 1841,
Nelson was a lawyer by training but a newspaperman at heart. When he moved to
fast-growing Kansas City to start a paper in 1880, he was appalled by the condition
of the city, which, though its population was fifty-five thousand, was still very
much a cow town. The unpaved streets were "veritable quagmires," the sidewalks
were "in a disgraceful condition," and as for sewers, he wrote, "we have none."

"Kansas City needs good streets, good sidewalks, good sewers, decent pub-
lic buildings, better street lights, more fire protection, a more efficient police
force, and many other things which are necessary to the health, prosperity
and growth of a great city," he wrote in a *Star* editorial less than a year after
starting the paper. "She needs these improvements now."

Another improvement the city needed, Nelson believed, was an art museum.

William Rockhill Nelson became a very rich man in Kansas City. He under-
cut competing newspapers' prices then bought them out. As the city grew
phenomenally—from 1880 to 1900 the population nearly tripled, reaching
163,000—so did the *Star*'s circulation and ad revenue.†

* For more on Truman's early life, see McCullough, *Truman*, and Ferrell, *Harry S. Truman*.
† Nelson was quite progressive for his era—except when it came to matters of race.
Black people's names appeared in his newspaper only in connection with crimes. Nelson

William Rockhill Nelson. *Wikimedia Commons*

In 1895 Nelson, now fifty-four, and his wife, the former Miss Ida Houston, forty-five, whom he had met and wed shortly after moving to Kansas City, embarked on that rite of passage of wealthy middle-aged White couples at the time: the Grand Tour of Europe. Like many aristocrats, he had taken an interest in art—then as now a symbol of status as well as taste—and he was determined to add to his personal collection while on the Continent. This he did, purchasing "a Reynolds, a Corot, a Troyon, a Monet, a Constable, a Gainsborough, a splendid Ribera, and others" to hang on the walls of Oak Hall, his mansion back home.

"Then his thought turned to Kansas City," wrote the authors of a hagiography of Nelson published by the *Star* shortly after his death in 1915. "It had no pictures. He felt that a collection of originals would not be practical. The cost would be prohibitive. Besides it was impossible to get the best of the classic pictures. They were not for sale." In Florence, Nelson hit upon a solution.

was also instrumental in establishing segregation in Kansas City. He became a real estate developer, and the homes he built came with restrictive covenants stipulating that they could only be bought, sold, and occupied by White people. In January 2021 the *Star* removed Nelson's name and image from its masthead, saying its founder's values "don't square at all with The Star newsroom of today."

He and Ida were introduced to the Pisani family, art dealers who specialized in reproductions of classic paintings.

It was not unusual for copies of great works to be displayed in museums at the time. In fact, painting them was a cottage industry in Europe. Museums periodically permitted artists into their galleries to create exact reproductions of the masterpieces hanging on their walls. Though these copies were nearly perfect, even down to the gilding on the frames, they weren't forgeries; they were never intended to deceive the viewer, only to impress audiences unable to see the real thing in the Louvre, the Uffizi, or the Prado.

The United States was an especially important market for these duplicates. Until the middle of the twentieth century, museums including Boston's Museum of Fine Arts, New York's Metropolitan Museum of Art, and the Art Institute of Chicago displayed reproductions. The artists who produced these copies were exceptionally talented, but like musicians in modern-day cover bands, aping other people's work was the only way they could monetize their own talents. Most of the names of the great copyists of the eighteenth and nineteenth centuries have been lost to history, though in recent years their work has come to be recognized as important in its own right.*

KC was never going to get the OGs, of course, so perfect reproductions were the next-best thing. Nelson purchased nineteen copies in Europe, including Raphael's *Madonna of the Chair*, Botticelli's *Madonna of the Magnificat*, and Titian's *Sacred and Profane Love*. Of the sixteen artists represented, the most recently deceased was the Italian master Carlo Dolci, who had died in 1686, more than two centuries earlier.

Nelson also purchased some five hundred photographs of other notable paintings as well as twenty life-size casts of famous sculptures, including the Venus de Milo and the Winged Victory. The total value of the collection was estimated at $15,000.

"I have had in mind for some time to do something that might aid in increasing the interest in art in Kansas City," Nelson said shortly after he and Ida returned from their Grand Tour. "I have felt the need of a good gallery, where one might see, if not the originals of famous pictures, at least photographs and faithful copies of them."

* Sotheby's now holds auctions of old master copies, with some pieces commanding prices in excess of $20,000.

Nelson donated the works to the city's only art school, the Kansas City Art Association and School of Design (now known as the Kansas City Art Institute), with the expectation that a museum would be built to house the collection. But that never happened. A fundraising drive petered out, and instead of a grand new museum, the collection was ultimately relegated to the library. Nelson had stipulated that the name of the gallery that displayed his collection must include the word *western*, so the two rooms on the second floor were christened the Western Gallery of Art, though Kansas Citians would always just call it the Nelson Gallery. However humble, it became the city's "shrine of painting and sculpture." And while the works were "only" reproductions, they impressed visitors all the same. The life-size copy of the Dutch master Bartholomeus van der Helst's masterpiece *Banquet of the Amsterdam Civic Guard in Celebration of the Peace of Münster* measured ten by twenty feet, and the guardsmen were so lifelike that you could practically feel their breath when you stood close.

Nelson continued to donate works to the gallery over the years, and by the end of 1904, its walls were so crowded that nearly every inch was covered by paintings and photographs, creating an almost comedic effect. Even a window was covered by a large painting. "In the main art gallery the lack of space necessitates the crowding of paintings together as though they were intended to be united in one grand panoramic picture," the *Star* reported. "Even the gilded frames look uncomfortable and seem to be begging elbow room."

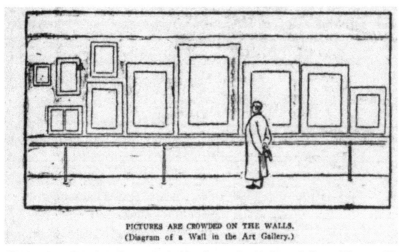

PICTURES ARE CROWDED ON THE WALLS.
(Diagram of a Wall in the Art Gallery.)

An illustration showing the crowded walls at the Nelson Gallery (*Kansas City Star*, February 24, 1905). *Newspapers.com / Kansas City Star*

Calls to build a proper art museum grew more urgent. "Kansas City is young, to be sure, but it is high time that something should be done in this direction," lamented Kansas City artist George Van Millett in November 1904. "Chicago, Cincinnati, Columbus, Indianapolis, Detroit, St. Louis, Omaha and Denver all have their art galleries and museums, why cannot we? It makes me blush with shame, that my home city, the place of my birth, with her great industries, her immense commerce, with her beautiful parks and public buildings and fine residences, should be further behind in this one particular than some of these smaller cities." A museum was necessary, Millett said, for "the progressive people who are trying to cultivate themselves."

But Kansas City would not get a proper art museum until December 1933. By then William Rockhill Nelson was long dead, and Harry Truman was less than a year away from winning election to the US Senate.

By single-handedly creating Kansas City's first public art space, Nelson performed an admirable public service. But there was also something paternalistic about the gesture. The art he chose reflected who he was—or who he wished to be seen as—as well as what he wanted his adopted hometown to be: White, classical, masculine, conservative, Europhilic. There was nothing adventurous, at least by twentieth-century standards, and certainly nothing contemporary about the art Nelson chose. It was backward looking. (It's worth noting that he chose a living impressionist, Monet, for his personal collection but not for the public gallery.)

Like Harry Truman, William Rockhill Nelson had no training in art or art history, but the works he chose for the Western Gallery of Art would shape the tastes of residents of Kansas City and northwestern Missouri for generations.

Young Harry Truman was undoubtedly among those influenced by Nelson's choices, though he encountered fine art elsewhere on his daily peregrinations. There were small art galleries in each of Kansas City's three major department stores—Emery, Bird, Thayer; George B. Peck Dry Goods Company; and Jones Dry Goods Company. As these galleries were intended to attract customers, they typically displayed works that were unlikely to arouse objections. In 1905 the Emery store boasted of a "$10,000 Oil Painting" on display in its fourth-floor gallery, a reproduction of the Italian master Orazio Gentileschi's *Lot and His Daughters*, and in early 1907 the Jones store announced with much fanfare that it had purchased a collection of twelve "fine Indian Paintings and other masterpieces" by Astley David Middleton Cooper, an artist

who specialized in realistic depictions of Indigenous American life. "We do this because this store is indebted to you people of Kansas City and the great West," the store explained in a newspaper advertisement. Cooper, at least, was a living artist, but this department store art was still no more avant-garde than the works in the Nelson Gallery.

On November 30, 1953, less than a year after he left the White House, Harry Truman was visiting New York. Relaxing in his suite at the Waldorf Astoria, he began paging through the latest issue of the *New Republic* magazine when an article on page 16 caught his eye. It was a review of *Voices of Silence*, a new English translation of *Les voix du silence*, a 661-page treatise on the history of Western art by the French intellectual André Malraux. What troubled Truman about Malraux's book was not the content but the cover price: twenty-five dollars. (The first volume of Truman's memoirs would release two years later at a cost of five dollars.) So troubled was Truman that he pulled a piece of hotel stationery out of the desk drawer and put his thoughts on paper:

> Been reading an article in the New Republic on Art with a capital A. It is a review of a book by André Malraux called Voices of Silence. After reading it I felt as if I'd read a third level State Department monograph on the Cold War. But the reviewer wound up with an understandable sentence, he advised the reader to buy the book for $25.00. Most modern readers dislike to pay 25 cents for a Western or Murder Mystery. Can you imagine any one of them paying $25.00 for a book on "Art"?
>
> Well the vast majority of readers will not pay $25.00 for any book, let alone one of capital A Art.
>
> I am very much interested in beautiful things, beautiful buildings, lovely pictures, music—real music, not noise.
>
> The Parthenon, Taj Mahal, St. Paul's Cathedral in London, York Minster, Chartres Cathedral, the Dome of the Rock in Jerusalem, the Capitol buildings of Mississippi, West Virginia, Utah, Missouri, the New York Life Building, N.Y. City, the Sun Insurance building, Montreal, the Parliament Building in London, the Madeleine in Paris, the lovely Palace of Versailles, St. Mark's and the Doge's Palace in Venice.
>
> Pictures, Mona Lisa, the Merchant, the Laughing Cavalier, Turner's landscapes, Remington's Westerns and dozens of others like them.

I dislike Picasso, and all the moderns—they are lousy. Any kid can take an egg and a piece of ham and make more understandable pictures.

Music, Mozart, Beethoven, Bach, Mendelssohn, Strauss waltzes, Chopin waltzes, Polonaises, Etudes, Von Weber, Rondo Brilliante, Polacca Brilliante. Beautiful harmonies that make you love them. They are not noise. It is music.

William Rockhill Nelson would have been proud.

Harry Truman's taste in art was of course not unusual for his place and time. Well into the nineteenth century, Western art, as it had for centuries, held to rigid rules. It was expected be realistic and lifelike, correct in proportions and perspective, preferably depicting biblical, historical, heroic, or tragic scenes. These rules persisted for centuries largely because the production, exhibition, and sale of art was tightly controlled by academies in Europe and, later, the United States. These academies were art schools, but not in the modern sense. They were also exclusive clubs with carefully chosen members who trained the next generation of artists, who, like their teachers, aspired to belong to the club, self-perpetuating the academic style in an endless feedback loop of perfect proportion and perspective. When kings, popes, aristocrats, or robber barons commissioned a work of art, only members of the academies would be considered, because anyone outside the academies was, ipso facto, unqualified.

This is all a terrible oversimplification of course. In the Low Countries, a system of guilds and apprenticeships made the art world somewhat more accessible for both creators and collectors. In the United States and Europe, folk art especially thrived outside the academies. In Africa, nonmimetic art had been produced for centuries (and would deeply influence many modern artists, including Picasso). But up until the last quarter of the nineteenth century, if you wanted to make a decent living as an artist in the West, the best, if not only, route was through the academies. Widespread by the seventeenth century, these academies—including the Accademia delle Arti del Disegno in Florence (founded in 1563), Académie Royale de Peinture et de Sculpture in Paris (founded in 1648 and renamed the Académie des Beaux-Arts after the French Revolution), and the Royal Academy of Arts in London (1768)—were deeply conservative institutions, averse to change or innovation.

The United States' first art academy, the New York Academy of the Fine Arts (later renamed the American Academy) was founded in 1802, and,

beginning in 1817, was led by John Trumbull, a Revolutionary War veteran and aforementioned painter of the patriotic masterpiece *Declaration of Independence*. Independence, however, was not something Trumbull valued in his students, who chafed at his stern tutelage and in 1825 founded the rival National Academy of Design, which put the American Academy out of business. Despite being revolutionaries of a sort, the students who founded the National Academy still clung rigidly to the standards of execution and composition favored by the European academies, and by the middle of the nineteenth century, the National Academy (and its counterpart in Philadelphia, the Pennsylvania Academy of the Fine Arts) controlled art in the United States nearly as tightly as its counterparts in Europe. The National Academy, a self-appointed and self-perpetuating group of 450 White men, effectively controlled the country's museums and galleries. Longer even than in Europe, artists in the US clung to the rules of illusionism and perspective followed since the Renaissance. Although this had begun to change by the turn of the twentieth century, particularly in New York City, modernism was slower to reach the interior of the country. As a result, modern art was unknown in young Harry Truman's world—and most everyplace else in the United States.

In young Pablo Picasso's world, however, art was everywhere. His father, José Ruiz y Blasco, was a painter and teacher at Escuela de Bellas Artes, a second-tier academy in Málaga, the town on the coast of southern Spain where Picasso was born in 1881. José was a competent copyist, but he was never offered membership in the academy because his original work, mostly landscapes and still lifes in the academic tradition, was—according to Picasso biographer John Richardson—"execrable." However, José's son, Pablo, demonstrated considerable artistic aptitude at a young age. The mythopoeic Picasso would later claim he "drew like Raphael" when he was a child, as if his talent was divinely ordained, but early drawings that Richardson unearthed, including an 1890 sketch of Hercules wielding a club, are "no more or less mature than one would expect of a gifted nine-year-old." But José tutored his precocious son, and by thirteen his work had matured considerably, clearly surpassing his father's. His oil portraits of friends, neighbors, family members, and local characters were superb, though strictly lifelike in the academic style. (By Spanish custom, Picasso's surname was a combination of his parents' family names: Ruiz y Picasso. But he would eventually jettison his father's family name, Ruiz, and simply go by his mother's: Picasso.)

Picasso's critics—including Harry Truman—would come to believe that he only drew "ham and egg" pictures because he was incapable of drawing realistically. This is ludicrous. Some of Picasso's early portraits have been compared favorably with the masterpieces of Spain's seventeenth-century golden age. Clearly the kid had talent, and when he was just shy of his fourteenth birthday, his parents enrolled him in La Llotja, the fine arts school in Barcelona, where the family was living at the time.

Picasso was precocious in more than art. He began frequenting prostitutes when he was fourteen. "These early experiences in the brothels of Barcelona seem to have reinforced Picasso's Andalusian misogyny," John Richardson writes. "Thirty years later, in image after image, the misogynistic pasha would endlessly reduce his teenage mistress, Marie-Thérèse Walter, to a thing of flesh and orifices in works of orgasmic explosiveness." By contrast, although Harry Truman liked to joke that if he hadn't gone into politics he would've ended up as a piano player in a whorehouse, there is no evidence that he ever actually set foot in one, and "orgasmic explosiveness" is not a phrase oft associated with the thirty-third president. So far, so different, the early lives of these two men.

At sixteen Picasso moved to the Real Academia de Bellas Artes de San Fernando in Madrid, the most prestigious art school in Spain, but he found the atmosphere stifling: "[The teachers here] haven't a grain of common sense," he wrote in a letter to a friend. "They just go on and on, as I suspected they would, about the same old things: Velázquez for painting, Michelangelo for sculpture, etc., etc." He attended classes irregularly for only a few months before he stopped going altogether. After surviving a bout of scarlet fever in the spring of 1898, he moved back to southern Spain, staying on a friend's farm for a time, then went back to Barcelona, where in early 1900 the first exhibition of his work was held at the Quatre Gats, a tavern he frequented.

After a friend's suicide in February 1901, Picasso sank into a deep depression and began to paint differently. He moved away from the academic realism of his portraits and began experimenting with color and perspective. Most of his paintings from this time, which has come to be known as his *blue period*, are melancholy depictions of the downtrodden, such as prostitutes and beggars, rendered in various shades of blue. In 1904, at twenty-two, he moved to Paris, taking up residence in Montmartre at 13 Rue Ravignan, in a former piano factory nicknamed the Bateau-Lavoir, or "Washhouse Boat," because it resembled one of the laundry boats that plied the Seine. The dilapidated old building had

no gas or electricity and only a single shared bathroom. It had been haphazardly divided into twenty small rooms that artists lived and worked in as squatters.

In Paris Picasso's style changed again. His pictures became more joyful, depicting harlequins, clowns, and demimondaines in bright colors. This has come to be known as his *rose period*. Endowed with a peculiar gift for reinventing himself, by the end of 1909 Picasso had made another abrupt change and abandoned realism altogether for abstract shapes. Picasso and another artist, his friend Georges Braque, began using squares, triangles, and circles—shapes known as *facets*—to represent people and objects from multiple perspectives on the two dimensions of a flat canvas. They were inspired by their friend, a mathematician and aspiring artist named Maurice Princet, who introduced the concept of the fourth dimension to Picasso, Braque, and the other artists who frequented the Bateau-Lavoir. The movement got its name when the French critic Louis Vauxcelles accused Braque of reducing everything to "geometrical schemas, to cubes."

Picasso was famously opaque when it came to explaining cubism. "When we invented cubism we had no intention whatever of inventing cubism," he once said. "We simply wanted to express what was in us." Braque was a bit more forthcoming:

> Traditional perspective gave me no satisfaction. It is too mechanical to allow one to take full possession of things. It has its origins in a single viewpoint and never gets away from it. But the viewpoint is of little importance. It is as if someone spent his life drawing profiles and believed that man was one-eyed. When we arrived at this conclusion, everything changed, you have no idea how much.

A single viewpoint would not do. Multiple viewpoints had to be represented on the canvas. The rules of perspective that had governed painting for centuries were shattered. It was a new art for a new century.

Without belaboring the point, it's worth mentioning that while Picasso was gaining fame in Paris, another artist, some six hundred miles east in Vienna, was trying to launch his own career. "How it happened, I myself do not know, but one day it became clear to me that I would become a painter, an artist," Adolf Hitler later wrote in *Mein Kampf*. "There was no doubt as to my talent for drawing." Hitler drew landscapes and buildings with some aptitude, but

he was twice rejected by the Academy of Fine Arts Vienna, and he detested the new modern art that he began to see around him in the Austrian capital. His resentment for modern art and its makers would fester for decades. He will, inevitably, pop up again later in this story.

While Picasso was in Paris surfing the crest of a wave of fame that would carry him into the distant future and Hitler was in Vienna nursing grudges that would later manifest horrifically, Harry Truman was back in Missouri, riding the back of an Emerson gangplow pulled by four horses. In the summer of 1906, he'd quit his Kansas City bank job and moved back in with his parents to help them run the family's six-hundred-acre farm fifteen miles south in Grandview, Missouri. He was twenty-two. If he'd gotten into West Point, he would've been a second lieutenant by now. Instead, he was learning how to be a farmer. If he was bitter about this turn of events, he never showed it. He hadn't grown up on a farm—when he was a boy the family lived in the town of Independence, where his father owned a business buying and selling livestock—and he didn't know much about farming, but as with all new enterprises he confronted, he was a quick learner. He studied the latest agricultural techniques and was careful to rotate the crops and vaccinate the livestock. Farming would be his occupation for the next eleven years, until he went off at thirty-three to fight the First World War.

Picasso in 1908, the year he turned twenty-seven. *Wikimedia Commons*

Truman in 1908, the year he turned twenty-four. *Harry S. Truman Presidential Library & Museum*

It was a diversified farm. The family grew several crops, including wheat and oats, and raised Hampshire pigs and Shorthorn cattle. They sold home-made sausage on the side to help make ends meet. Money was always tight. "We always owed the bank something," Harry remembered many years later. The hours were long—he arose at 4:30 AM in the summer and 6:30 AM in the winter—and the work was backbreaking. Except for a steam-powered thresher that the family rented to harvest the wheat, the work was all performed by people or animals, mainly horses and mules. Harry's slight build was not suited to hard labor, yet he shirked no task, whether it be stacking bales of hay in the barn loft or wrestling a recalcitrant bull. Truman later said he "plowed, sowed, reaped, milked cows, fed hogs, doctored horses, baled hay and did everything there was to do on a six-hundred-acre farm." His time as a farmer looms large in the legend of Harry Truman.

During this period, his personality came into full bloom. He managed five to fifteen hired hands and gained a reputation as a good boss and a good listener, willing to take advice, delegate authority, and admit his mistakes. He also had a good sense of humor and a gift for storytelling, important qualities for a long day with the farmhands spent toiling in the hot sun. More important, and despite his Baptist faith, he was also willing to buy them some whiskey from time to time.

"It was on the farm that Harry got all his common sense," his mother once said. "He didn't get it in town."

"I always give my occupation as 'farmer,'" Truman said when he was president. "I am just a farmer from Missouri who had bad luck and got kicked into a big job."

During his time on the farm, Truman discovered, somewhat to his surprise, that people instinctively respected him—and liked him. He began to think that maybe he should go into politics. Like the rest of his family, he was a Democrat (his mother would famously refuse to sleep in the Lincoln bedroom when he became president), so he began attending meetings of the Tenth Ward Democratic Club in Kansas City. There he became acquainted with Mike Pendergast, whose brothers Jim and Tom were the leaders of the city's formidable Democratic machine. The small gears of history had begun turning. Politics satisfied a need in Truman, a hunger for companionship. As he was still single and tethered to the farm, the Tenth Ward meetings became an outlet for his preternaturally extroverted personality. But he expected nothing

extravagant out of the enterprise. Even a seat on the Jackson County commission seemed fanciful. His future, he thought, was on the farm. "I'm going to be happy following a mule down a corn row for the rest of my happy existence," he would write in a letter from France to his cousin Mary Ethel Noland in 1919.

Harry's only other extracurricular activity of note during this time was the wooing of his sweetheart, Bess Wallace, who lived in Independence. They'd met in Sunday school when Harry was six and Bess was five. It was, in Harry's memory, love at first sight, though Bess was less smitten and didn't seem too keen on getting hitched to a farmer. But Harry was persistent, and he wrote long letters to Bess often and visited her whenever he could.

The simple two-story farmhouse in Grandview where Harry, his parents, his brother Vivian, his sister Mary Jane, and his grandmother Louisa Young lived had no running water or indoor plumbing, though it did include one modern convenience: a telephone. The Trumans were on a party line with ten other families. The bill was three dollars a month—not a small expense in the first decade of the twentieth century, but it was worth it to Harry because it made it easier for him to keep in touch with Bess.

One thing the home did not contain was art. We know of no pictures that hung on the walls. It practically goes without saying that Harry had no time at all for art.

2 | INSULTS TO CLASSICAL IDEALS

THE FIRST HALF OF 1911 was memorable for both Pablo and Harry: Picasso because his art was exhibited in the United States for the first time, Truman because he proposed marriage to his longtime sweetheart, Bess Wallace.

Neither would be thrilled with the results.

The Picasso exhibition took place at the Little Galleries of the Photo-Secession, a tiny exhibit space on the top floor of an "old and decrepit" five-story building at 291 Fifth Avenue in Midtown Manhattan. Better known simply as 291, the gallery was founded in 1905 by the photographer Alfred Stieglitz, who wanted to secede from the stodgy hobbyists who didn't share his enthusiasm for artistic photography.

The son of German Jewish immigrants, Stieglitz was born in Hoboken, New Jersey, in 1864. He bought his first camera in his early twenties and was soon "obsessed" with photography. This obsession was financed by his father, a successful merchant; his wealthy friends; and later by his first wife, Emmeline, whose family was rich. A bit of a moocher, maybe, but also a visionary. At a time when nearly all photographs were stiffly posed, often portraits taken in studios with garish backdrops, Stieglitz used his cumbersome camera equipment to take pictures of people and landscapes as they appeared in the real world, often in shadows, moody, rain slicked. While modern painting was moving away from realism, modern photography was moving toward it, yet both were somehow heading in the same direction.

In early 1900 Stieglitz met a twenty-one-year-old art student and aspiring photographer named Edward Steichen. On his way from his Milwaukee home

17

to Paris to study art, he stopped in New York just to show Stieglitz his portfolio. Stieglitz, whose eye for talent was unparalleled, was so impressed that he purchased three of Steichen's photographs (a self-portrait and two landscapes) on the spot for five dollars each. Steichen told Stieglitz he'd never earned so much money for his work. Stieglitz replied, "I am robbing you at that." Steichen would go on to become one of the most accomplished photographers of the twentieth century, and Stieglitz would later praise him as "the greatest photographer that ever lived."

Despite the difference in their ages—Stieglitz was fifteen years older than Steichen—the two men formed an instant bond. When Steichen returned from Paris, he soon settled in New York, becoming Robin to Stieglitz's Batman, though instead of fighting crime they fought the pallid, staid, conservative attitudes then prevailing in the art world. In 1903 Stieglitz founded *Camera Work*, a quarterly journal dedicated to proving that photography could be as artistic as painting or sculpture—"a medium of individual expression," as he put it. Each issue was lavishly illustrated with photogravures, an early photomechanical process for reproducing photographs. Steichen worked closely with Stieglitz, designing an art deco font for the magazine and contributing more pictures during its fourteen-year run than any other photographer.

In 1905 Steichen told Stieglitz he should open a gallery for photographs in New York as an answer to the city's many art galleries, none of which deigned to exhibit photographs. As Steichen recalled many years later, Stieglitz told him "there wasn't enough good photography in New York to fill a gallery." So Steichen suggested the gallery include other works of contemporary art as well as photographs. "If artists won't admit us to their gallery," he said, "we'll admit them to ours." Steichen knew just the place for the gallery: a small apartment that his family had just moved out of. It was on the top floor of a building at 291 Fifth Avenue.

The Little Galleries of the Photo-Secession opened on November 24, 1905. As Steichen remembered it many years later, the exhibit space itself was nondescript.

> Our Little Gallery had a two-by-four elevator and was on the top floor. There were three rooms at 291: the largest one was about 10-by-14, and the two smaller ones about 10-by-10. I covered the walls with burlap—the two small, inside galleries with natural color burlap, and the main gallery with olive colored burlap.

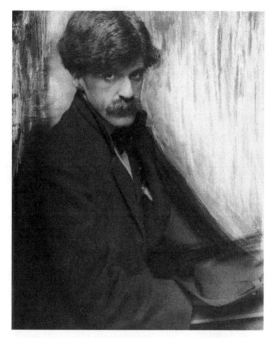

Alfred Stieglitz in 1902. *Library of Congress*

But the images that hung on the burlap-covered walls transformed those three small rooms into the first American cathedral of modern art. Stieglitz conceived 291 as a vehicle for promoting photography as a legitimate art. Reasoning that photographers who strive to be artists should be cognizant of trends in contemporary art, he displayed works by Cézanne, Matisse, Renoir, and Rodin in the gallery's early years; Stieglitz liked to call these nonphotographic works "anti-photographic art." The gallery also displayed works by American modernists, including many women, which was unusual for the time. One of these artists was Georgia O'Keeffe, whom Stieglitz would later marry, but that's another story. As one critic put it, 291 became "the artistic soul of New York."

Stieglitz usually charged artists a mere 15 percent commission for works the gallery sold—and he often waived even that. Stieglitz was many things—arrogant, prickly—but greedy was not one of them. He carefully vetted prospective customers to ensure they were worthy of possessing the art they wished to purchase. He was an early influencer. Stieglitz also charged no admission to the gallery; he was determined to make it accessible to all.

Many of the early exhibitions at 291 were considered radical, but none so much as the 1911 Picasso exhibition.

Although Stieglitz is often credited with introducing Picasso to an American audience for the first time, it was his friend, the Mexican artist Marius de Zayas, who was instrumental in arranging the Spaniard's American premiere at 291. Born into a wealthy family in 1880, Zayas began his career as an illustrator working for two newspapers his father owned in the Mexican state of Veracruz. When the newspapers ran afoul of the country's dictator Porfirio Díaz in 1907, Zayas swiftly relocated to New York, where he was soon introduced to Stieglitz, as all artists newly arrived in the city seemed to be. Each man was proud of his ginormous bushy mustache and discerning eye for art. Zayas found work illustrating for the *Evening World* newspaper, and in the spring of 1910 an exhibition of his caricatures of prominent New Yorkers, life size and mounted on cardboard, was one of 291's most popular ever, with crowds lined up on the sidewalk out front waiting to get in. Later that year, Zayas went to Paris to scout new artists for Stieglitz to promote. His timing was propitious.

At the time, the Académie des Beaux-Arts sponsored an annual art show (or Salon) in Paris every spring. The first was held in 1667, during the reign of Louis XIV. By the middle of the nineteenth century, the Paris Salon had become the cultural event of the year in France and attracted more than a million visitors annually, with the show lasting as long as three months to accommodate the crowds.

The Salon and its artists had represented the vanguard of French art for two centuries, but that changed with the rise of impressionism and other modernist movements that broke away from the academy. By 1910, to call the Salon conservative would be an understatement. A jury made up of members of the academy decided which works would be displayed, and while works produced by artists outside the academy were occasionally included, any art that strayed from their strict and conservative pictorial standards was interdicted. According to the art historian Sue Roe, "Works were expected to be microscopically accurate, properly 'finished' and formally framed, with proper perspective and all the familiar artistic conventions." Artists whose work was accepted for the Salon could expect recognition and steady work. Artists whose work was rejected could expect to find another line of work. At each Salon the jury also selected the "best" works for medals and awards.

"There are hardly fifteen art lovers in Paris capable of liking a painter without the Salon's approval," said Renoir, whose own work was repeatedly rejected by the jury. "And there are eighty thousand who would not buy a thing from a painter not exhibited at the Salon." The academy's show could make or break an artist. A painter named Jules Holtzapffel* submitted two paintings to the Salon jury in 1866. Both were rejected, and Holtzapffel went home and blew his brains out. Monet, also rejected by the jury, took it more stoically but admitted the financial implications: "That fatal rejection has almost taken the bread out of my mouth; in spite of my not at all high prices, dealers and collectors turn their backs on me."

It had become a system designed to stifle innovation. Modern art was about as welcomed in the academy's Salon as a cancan line in a sculpture garden. There are interesting parallels to be drawn between the Salon and the Grammy Awards, where rap and heavy metal music were not officially recognized until 1989. And just as there has been a documented correlation between winning a Grammy Award and record sales, the same was true for the Salon: getting selected was good for business. When a French haute bourgeois wanted to have his or his wife's portrait painted, he would typically stipulate that the artist would receive 1,000 francs if the painting wasn't selected for the Salon, 2,000 if it was, 3,000 if it received an honorable mention, and 4,000 if it won an award. Americans were not blameless for its dominance, and robber-baron families like the Havemeyers (the Domino sugar people) helped keep the Salon humming in the late nineteenth century.

In 1903—the same year the Wright brothers made their first successful flight—a group of modernists, including Renoir and Rodin, organized their own salon, to take place every fall. The Salon d'Automne soon became an important alternative to the academic Salon and one of the most prestigious annual exhibitions of contemporary art in France.

After a trip from New York lasting thirteen days, Marius de Zayas arrived in Paris on Thursday, October 13, 1910. Over the next two weeks, he visited the Salon d'Automne four times. Then, as it did from its second year until 2011, the show took place under the massive glass and steel canopy of the Grand Palais, an exhibition hall built for the 1900 Paris Exposition. Though 1910's exhibition was only the eighth annual Salon d'Automne, it was already challenging the

* The name is also sometimes spelled Holzapffel.

academic Salon for supremacy in the art world. The Salon d'Automne, with its unusual pictures, proved enormously popular. "The galleries were full; everyone was contemplating the pictures, some with abstraction, others with curiosity, and others with a mocking air," Zayas recalled. "But no one was scandalized, no one protested in a loud voice." One painting in particular caught Zayas's eye: a cubist concoction titled simply *Nu*, or "nude." The artist wasn't Picasso, however. It was Jean Metzinger, a twenty-seven-year-old artist from Nantes who moved to Paris in 1903 and soon came under the influence of Picasso, Braque, and the Bateau-Lavoir milieu.

The caricaturist didn't know what to make of Metzinger's funny picture at first. It was like observing an alien planet where nothing, including colors and shapes, made sense. At first cubism struck Zayas as a "deadly movement," "more reactionary than evolutionary."

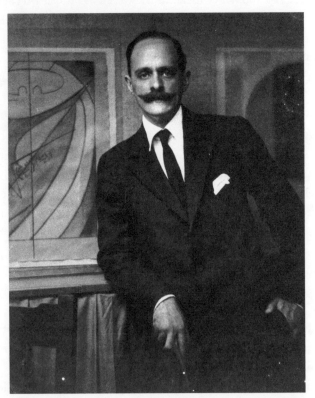

Marius de Zayas in 1913, photographed by Alfred Stieglitz.
National Portrait Gallery, Smithsonian Institution

"I could not understand anything," he later wrote. "I looked, but did not see: it seemed to me as if I were in the Tower of Babel of painting, in which all the languages of technique, color, and subjects, were spoken in an incoherent and absurd manner, and I began to surmise that this Salon was nothing but a charge d'atelier [a workshop piece], peculiar to the humorous artists."

On October 28 Zayas wrote Stieglitz to update him on his progress.

> There is one picture which took particularly my attention and a good deal of my time trying to solve it. Its title is "Nu" and it is executed by Mr. Metzinger. I was lucky enough to find a reproduction of it in a magazine. The theory of this gentleman is that he sees everything geometrically, and to tell the truth, he is absolutely consequent with his theory. To him a head represents a certain geometrical figure, the chest another, and so forth. The fourth dimension was not enough for him so, he applies the whole geometry. Afterwards I was told that this [person] is also an imitator, that the real article is a [S]paniard, whose name I don't recall, but Haviland knows it, because he is a friend of his brother.

The Spaniard of course was Picasso. Haviland was Paul Burty Haviland, a photographer, a friend to both Zayas and Stieglitz in New York, and a regular exhibitor at the 291 gallery. Haviland's brother was Frank Burty Haviland, an artist who lived in Paris and was familiar with the Bateau-Lavoir crowd. Frank arranged for Zayas to meet Picasso in November or December of 1910. The caricaturist and the cubist hit it off immediately, due in no small part to the fact that both men's first language was Spanish. Picasso's mastery of French was still incomplete, and he relished opportunities to speak—about himself, especially—in his native tongue. Zayas met Picasso several more times in early 1911 and was completely won over to cubism. He convinced Picasso to lend more than fifty watercolors and drawings for an exhibition at 291. "In 1910 we thought that the New York public was ripe enough to receive Picasso's cubist work," Zayas later wrote.

> Picasso was then at the period when he had his studio at Boulevard de Clichy. The proposed exhibition was to be of drawings only, and for their selection a real "jury" was composed by Picasso him-

self, Steichen, Frank Burty and myself, who most conscientiously performed our duties. Picasso brought out all the latest drawings he had, and there were many. I don't remember how many we took, but certainly enough to fill the Little Gallery, and you can be sure they were the best Picasso had done up to that time. The drawings were "cubistic," needless to say.

The Picasso exhibition at 291 opened on March 28, 1911. Among the works on display was *Standing Female Nude*, a charcoal drawing that, according to the Metropolitan Museum of Art—which now owns the piece and can describe it much better than I—"reinterprets the female nude as a series of lines and semicircles. Areas of shading provide only hints of three-dimensional form; however, essential parts of a human body—head, neck, shoulders, arms, torso, breasts, legs, and kneecaps—appear nonetheless."

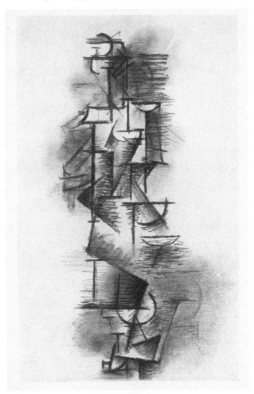

Pablo Picasso, *Standing Female Nude*, 1910. © *2022*
Estate of Pablo Picasso / Artists Rights Society (ARS), New York

"It has been called a glorified fire escape, a wire fence and other sarcastic names," wrote a *New York Sun* reporter at the time. "It is almost pure pattern. It is undoubtedly rhythmic in high degree. There is a curious fascination about it. Based probably upon a human figure, it is still pretty thoroughly abstract." While *Standing Female Nude* bears at least a passing resemblance to an actual standing female nude, viewers at the time would have been startled by its departure from conventional representation. Eventually cubism would pull even further away from realism, with works from its later phases appearing almost completely abstract.

Marius de Zayas prepared an essay about Picasso that Stieglitz printed as a pamphlet for the exhibition. In the essay, Zayas anticipated the negative reactions the art might generate. "I want to tell at present of Pablo Picasso, from Málaga," he wrote, "who finds himself in the first rank among the innovators, a man who knows what he wants, and wants what he knows, who has broken with all school prejudices, has opened for himself a wide path, and has already acquired that notoriety which is the first step towards glory."

Many critics were baffled by Picasso's drawings, and more than a few were outraged. The *New York Globe*'s Arthur Hoeber was the dean of the city's art critics. He was also an academically trained painter whose work had hung in the Paris Salon, and he was a member of the conservative National Academy of Design in New York. "The display is the most extraordinary combination of extravagance and absurdity that New York has yet been afflicted with," he wrote in his review of the Picasso exhibition.

> Any sane criticism is entirely out of the question; any serious analysis would be in vain. The results suggest the most violent wards of an asylum for maniacs, the craziest emanations of a disordered mind, the gibberings of a lunatic! By the side of these all previous efforts seem academic, sane, conventional, well ordered and acceptable. It is almost worth a visit to these galleries to see how far foolishness and imbecility will go and what colossal and monumental egotism can accomplish!

It's easy to dismiss the early critics of Picasso and modern art in general as woefully out of touch, but a smidgen of empathy is required. From the distant perspective of the 2020s—when art is defined broadly and artists are free to

explore all avenues of creativity, when, indeed, art in general and modern art in particular have become multibillion-dollar industries—it is easy to forget just how shocking and boat-rocking experimental art like Picasso's was in the first two decades of the twentieth century. Only the most outrageous art still manages to shock us today: think Andres Serrano's 1987 work *Piss Christ*, a photograph of a crucifix submerged in a jar filled with the artist's urine, or Chris Ofili's 1996 piece *The Holy Virgin Mary*, a painting of the Virgin that incorporates elephant dung. To the early critics of Picasso, *Standing Female Nude* was just as scandalous, if not more so.

At the same time, the first fissures that would divide the United States in the so-called culture wars were becoming evident. A few critics seemed to get what Picasso was after. James Huneker, the *New York Sun* art critic, sensed that Picasso was onto something, that his art was breaking new ground. "It's anarchic, certainly; that's why we tolerate it despite its appalling ugliness; anything is better than the parrotlike repetitions of the academic," wrote Huneker. "There is method in his wildest performance, method and at times achievement even to the uninitiated eye."

Alfred Stieglitz, a believer in the philosophy that there is no such thing as bad publicity, proudly reprinted all the reviews, good and bad, in the next issue of *Camera Work*.

Given all the hubbub, it's no surprise that the Picasso exhibition was a hit, becoming the most sensational and likely the best attended exhibition in the history of the 291 gallery. Not just art connoisseurs went to see it; so did hundreds of working-class men and women, drawn by an intense curiosity to see what all the fuss was about. For Picasso himself, however, the final accounting of the exhibition was a bitter disappointment. Although some of the drawings were priced as low as $12, only two were sold. One was *Standing Female Nude*, which was purchased by Stieglitz himself for the grand sum of $65. Stieglitz hung it over his fireplace. After a long day, he would go home and stand before the drawing, gaining from it, he said, "a genuine stimulus." Stieglitz called the drawing "a sort of intellectual cocktail."

Stieglitz begged the Metropolitan Museum of Art to purchase all the other works in the exhibition for $2,000. The museum refused. "Such mad pictures," the Met's curator of paintings Bryson Burroughs told Stieglitz, "would never mean anything to America." When Stieglitz died in 1946, he bequeathed

Standing Female Nude to the Met—a gesture of unusual magnanimity for a man who never forgot a slight.

What might Harry Truman have made of these epochal changes taking place in the art world? Well, like most Americans, he probably knew little about them. While the Picasso exhibition was much discussed in the New York newspapers, it was all but ignored everywhere else. I could find no mention of it in the Kansas City papers or the national weekly magazines. Besides, Harry had much more important things going on in his life.

The year 1911 began well enough for him. In January and February he visited Bess Wallace in Independence at least twice. "I certainly did enjoy myself Tuesday night," he wrote after one visit. "That stew couldn't *be beat*." The two also exchanged letters almost weekly. Harry's missives are breezy and humorous, filled with wry observations on farm life, and on life in general. In one he mentions a "good fellow" he'd heard of who had developed a variety of peas shaped like cubes instead of spheres "so they won't roll off the knife when you eat them."

"If I can get the seed I shall certainly raise them," he informed Bess.

> It is very embarrassing to take up a nice big knife full of peas and carry it carefully to your mouth and then have the whole works roll off and go under the table, down your sleeves and neck and perhaps spoil someone's nice red tablecloth. You see, the man who invented cubic peas is a benefactor to the farmer. Now if someone would invent a fork with a spring, so you could press it and spear a biscuit at arm's length without having to reach over and incommode your neighbor—well he'd just simply be elected President, that's all.

Harry wrote Bess at least twelve letters in the first four months of 1911. He told her he'd begun reading the collected works of Mark Twain and wrote of his work on the farm "sowing oats all week" until his face got so sunburned that he looked like "raw beef or a confirmed 'booze fighter.'" He shared his thoughts on religion, saying he liked to "play cards and dance as far as I know how and go to shows and do all the things they say I shouldn't, but I don't feel badly about it," adding that he was a Baptist "but not a strenuous one."

The year was progressing swimmingly until one day in April when an encounter with a four-hundred-pound calf ended with Harry suffering a broken leg. "I only grabbed his tail and made a wild grab for his ear in order to guide him around properly when he stuck his head between my legs, backed me into the center of the lot, and when I went to get off threw me over his head with a buck and a bawl and went off seemingly satisfied, I guess, for I didn't look. I set up a bawl of my own." Forced to recuperate for six weeks, Harry had ample time to reflect on his life. He turned twenty-seven that May, and his future seemed set: a life on the farm, active in the local Democratic Party and the Masons. What he needed, he came to believe, was a wife. On June 22 he proposed to Bess Wallace in a letter:

> Dear Bessie:
> From all appearances I am not such a very pious person, am I? The elements evidently mistook one of my wishes for dry instead of wet. I guess we'll all have to go to drinking whiskey if it doesn't rain very soon. Water and potatoes will soon be as much of a luxury as pineapples and diamonds.
>
> Speaking of diamonds, would you wear a solitaire on your left hand should I get it? Now that is a rather personal or pointed question provided you take it for all it means. You know, were I an Italian or a poet I would commence and use all the luscious language of two continents. I am not either but only a kind of good-for-nothing American farmer. I've always had a sneaking notion that some day maybe I'd amount to something. I doubt it now though like everything. It is a family failing of ours to be poor financiers. I am blest that way. Still that doesn't keep me from having always thought that you were all that a girl could be possibly and impossibly. You may not have guessed it but I've been crazy about you ever since we went to Sunday school together. But I never had the nerve to think you'd even look at me. I don't think so now but I can't keep from telling you what I think of you.

Bess said no. So, in addition to a broken leg, Harry also had to recover from a broken heart. But he never gave up, and Bess would eventually agree to his proposal—eight years later.

3 | A BEAUTIFUL CIRCLE

THE FIRST MAJOR EXHIBITION of modern art in the United States took place from February 17 to March 15, 1913, inside a cavernous National Guard armory at Twenty-Fifth and Lexington in Manhattan. Usually the home of New York's Sixty-Ninth Infantry Regiment—known since the Civil War as the Fighting Irish—the armory was converted into a giant temporary art gallery for what was officially called the International Exhibition of Modern Art but soon came to be known simply as the Armory Show. Included in the show were more than twelve hundred drawings, paintings, and sculptures by nearly three hundred artists, including the cream of Europe's crop of moderns: Duchamp, Matisse, and Picasso. Their work represented what to most Americans was an array of incomprehensible isms—from cubism to fauvism to futurism. The Armory Show introduced Americans to the avant-garde, experimental art that had already preoccupied Europe since the 1890s, when the postimpressionists—Cézanne, Gauguin, Van Gogh, and Seurat—began to build on what the impressionists and others had begun and started pulling further away from the strictly literalist art that had dominated the West for centuries.

The Armory Show was organized by a group of some twenty-five young American artists who called themselves the Association of American Painters and Sculptors. Founded in December 1911, the AAPS wanted to break away from the stodgy National Academy of Design, which had controlled art in the United States with an iron grip since John Quincy Adams was president. For the most part, only academy-approved artists could hope to win big commissions or have their work shown in major galleries or be appointed to art school

faculties in New York, which was the center of the American art world at the time. The only galleries that showed radical new art were tiny, like Stieglitz's 291. If anything, the National Academy had become even more conservative than its European counterparts, as if to prove American artists weren't a bunch of dilettantes. The academy worshipped the old masters. "Originality is the bane of art," the academic sculptor William Ordway Partridge declared. "Art is a matter of evolution; a new note is not struck more than once in a thousand years." The AAPS was declaring war on the National Academy.

The AAPS wanted to introduce Americans to modern art, especially the European moderns, to give the country "a mental jolt to stir [it] out of its long esthetic complacency," as Milton W. Brown wrote in his history of the Armory Show. This would be accomplished "by holding exhibitions of the best contemporary work that can be secured representative of American and foreign art," explained the painter Walt Kuhn, one of the group's founders.

Other groups had tried and failed to break the academy's monopoly over the years. Kuhn was asked what made this attempt different. "The difference," Kuhn replied, "is that we mean it." Kuhn and two other members of the group, artist Arthur B. Davies and artist-critic Walter Pach, spent much of 1912 scouring the United States and Europe for the best examples of contemporary art. They beseeched museums, collectors, and the artists themselves to lend their most prized works for the show. Their pitch was that the United States represented a great untapped market for modern art, fertile new ground for recognition—and customers. If they chose, the lenders could offer their works for sale at the show.

It cost the AAPS $5,000 to rent the armory. Then there were travel expenses as well as the cost of packing, shipping, and insuring hundreds of works of art. Who paid for all this? Arthur B. Davies liked to say it was "a lot of rich old ladies," and this was partially true. Gertrude Vanderbilt Whitney and Dorothy Whitney Straight, who were undeniably rich but far from old in 1913, each contributed $1,000 to the AAPS. But many members of the group put in their own money. It helped that several came from families of some means. Davies himself contributed more than $4,000 toward the effort. Taking on the establishment wasn't cheap. It was hoped that the price of admission—twenty-five cents on afternoons and weekends, a dollar in the evening—would help defray expenses.

The Sixty-Ninth Regiment Armory was designed by the architect brothers Joseph and Richard Hunt in the Beaux-Arts style and completed in 1906 at a cost of $650,000. An ornate three-story building with a mansard roof served as the regiment's headquarters, while a thirty-four-thousand-square-foot, barrel-vaulted drill shed attached to the rear of the building gave the soldiers ample space to practice marching in formation.

Like most armories at the time, however, its function was not solely martial. The drill shed also served as a public space. One of the first major events held at the armory was an automobile show in January 1906, which attracted throngs that, according to the *New York Tribune*, "be[spoke] the popularity of the horseless carriage." Four years later the armory hosted a track meet in which the Swedish long-distance runner Thure Johansson won a marathon on the one-tenth-mile track in an impressive 2:36:55, a mark that still stands as one of the ten fastest indoor marathons—though, to be fair, there aren't many marathons run indoors anymore. In more recent years the armory has hosted roller derbies, NBA games, Soundgarden concerts, Victoria's Secret Fashion Shows, and comic book conventions. The armory was one of the first in the United States to abandon the Gothic, fortresslike style that characterized previous armories. In that way, it was forward looking and modern: the perfect venue for the International Exhibition of Modern Art.

The AAPS took possession of the armory on Wednesday, February 12, 1913, and in just five days turned it into the largest gallery of art the United States had ever seen. Burlap-covered partitions divided the massive drill shed into eighteen octagonal galleries, each assigned a letter from *A* to *R*. From above it looked like a giant honeycomb. Garlands strung along the tops of the partitions and potted pine trees placed throughout the galleries gave the giant room a festive air. The transformation was remarkable.

More remarkable, of course, was the art. Postimpressionists, by then well established, were represented (Manet, Cézanne, Van Gogh), as were the newer cubists (Braque, Picasso), expressionists (Hanns Bolz), futurists (Joseph Stella), and fauvists (Georges Dufrénoy, Raoul Dufy, Henri Manguin). Picasso had eight pieces in the show (five oils, one gouache, one charcoal, and one bronze), four of which were for sale—though only one, the gouache *Les Arbres*, was purchased, by Arthur B. Davies, for $243. For reasons unclear, Picasso's name was anglicized in the catalogue as Paul Picasso, an error that was widely repeated in

newspaper coverage of the show. Roughly 20 percent of the artists represented overall were women.

The show opened with a reception on the evening of Monday, February 17. Invited guests strolled the galleries serenaded by the Sixty-Ninth Regiment band. One of the speakers that night was John Quinn, a wealthy New York lawyer, collector of modern art, and AAPS benefactor. Quinn had lent more works to the show than any other collector. "The members of this association have shown you that American artists—young American artists, that is—do not dread, and have no need to dread, the ideas or the culture of Europe," said Quinn. "They believe that in the domain of art only the best should rule. This exhibition will be epoch-making in the history of American art."

Early reviews in the popular press were mixed. The *New York Tribune* said the show included "some of the most stupidly ugly pictures in the world and not a few pieces of sculpture to match them," while the *New York Times* conceded that it was "entirely ready to confess that some very beautiful arrangements of form and color have come out of this fresh interpretation of the aim of art." Only about a third of the pieces came from Europe, but these were the most radical works and drew the most attention. Modern American art was still in its infancy; compared to the Europeans, the work of the Americans—George Bellows, Arthur B. Davies, Edward Hopper, Walt Kuhn, Joseph Stella, etc.— seemed subdued. This was viewed positively by some critics. "Be it said to the credit of our countrymen that their indulgence in egotistical fatuity has as yet been slight," the *New York Tribune* noted. "A few of them swagger about, so to say, making portentous use of their new found 'independence,' but, frankly, it is not to them that the show owes such fantasticality as it possesses." Such fantasticality the paper ascribed to the cubists, displayed in room I, which was sarcastically nicknamed the "Chamber of Horrors":

> With Picasso and the rest of the Cubists the farce grows wilder. They throw upon the canvas a queer agglomeration of line and color, in which one may divine in a fragmentary way elements of the human form. The fragments possess here and there some expressive qualities. It is like the monstrous potato or gourd which the farmer brings to the village store to see if his cronies can make out in certain "bumps" which he indicates the resemblance that he has found to General Grant or the late P. T. Barnum.

The old guard was aghast. Kenyon Cox was a painter of portraits and allegorical murals who supplemented his income as an art critic for popular magazines like *Scribner's*. His academic art bona fides were unimpeachable: he was a member of the National Academy and a painter of murals in the Library of Congress. He was also one of the most vocal defenders of the "small minority of artists who still follow the old roads." They follow the old roads, he explained, "not from ignorance or stupidity or a stolid conservatism, still less from willful caprice, but from necessity, because those roads are the only ones that can lead them where they wish to go."

> All art is symbolic; images are symbols; words are symbols; all communication is by symbols. But if a symbol is to serve any purpose of communication between one mind and another it must be a symbol accepted and understood by both minds. If an artist is to choose his symbols to suit himself, and to make them mean anything he chooses, who is to say what he means or whether he means anything? If a man were to rise and recite, with a solemn voice, words like "Ajakan maradak tecor sosthendi," would you know what he meant? If he wished you to believe that these symbols express the feeling of awe caused by the contemplation of the starry heavens, he would have to tell you so *in your own language*; and even then you would only have his word for it. He may have meant them to express that, but do they? The apologists of the new schools are continually telling us that we must give the necessary time and thought to learn the language of these men before we condemn them. Why should we? Why should they not learn the universal language of art?

The Armory Show exposed the deeply conservative nature of not only the country's art establishment but its press and its culture as a whole. The exhibition was widely mocked. It was an easy target, but an uneasy one too, for this new art made people uncomfortable while it perplexed them.

When the Armory Show opened in February 1913, the United States was in the midst of breathtaking changes. While older women who attended the show dressed in the waning Gilded Age style—plumed hats, corsets, bodices, bustles, dresses that reached the floor—younger women wore shorter, simpler dresses that anticipated the flapper fashions of the nearing 1920s. The last

president with facial hair was in the White House when the Armory Show opened, and he would be gone by the time it ended. Skyscrapers were rising and airplanes were flying over them. Music was changing in 1913 too: Stravinsky's *Rite of Spring* premiered in Paris, nearly sparking riots, while in New Orleans a young Louis Armstrong began playing cornet in the band at the Colored Waifs' Home, and the word *jazz* appeared in print for the first time. Yet, as the art historian Hugh Eakin notes, "despite the extraordinary pace of change, the American establishment was often parochial, moralizing, xenophobic, and rife with prejudice."

The Armory Show came to represent all that was new in an increasingly complex world, and for that it was widely misunderstood and feared. Now even the sacred principles of perspective and proportion were being proved mutable. The Armory Show was ridiculed, much as modern art would continue to be ridiculed for the rest of the century, not necessarily because it was ridiculous but because it was different and because, perhaps most outrageously of all, its creators didn't seem to care whether the general public "got it" or not. This was all very unnerving at a time when conformity reigned.

And yet the Armory Show proved to be wildly popular, and the crowds attending the show grew larger by the day. Daily receipts rose from $515.90 on February 19 to $1,010.65 on March 7. The show proved so popular that it was also put on in Boston and Chicago. It's estimated that the total attendance in the three cities was 250,000, a staggering number for an exhibition of any kind, much less one focusing on what some perceived as the products of disordered minds in Europe.

Antimodernists, including Kenyon Cox and National Academy president John W. Alexander, organized a counter exhibit they called the Academy of Misapplied Art. Satirical versions of modern works were displayed at the Lighthouse, a school for the blind in New York (hilarious, right?). The goal was to "outcube the Cubists and put the Futurists into the middle of the past tense." Some two hundred paintings were hung, "burlesques on several of the more striking canvases seen in the Sixty-ninth Regiment exhibit." Local celebrities, academic artists, and children were invited to submit works "ridiculing the modernists." Frederick Judd Waugh, famous for his seascapes, submitted a work titled *Hunting for Nudes off the Banks of Newfoundland*. The opera singer Enrico Caruso contributed *Portrait of a Lady*. Another work, *The Garden of Eden*, depicted Adam and Eve as horses eating a purple apple. It was painted by eleven-year-old Nannette Turcas, proving, the organizers said, "that children can out-Matisse Matisse."

The one painting that came to symbolize the Armory Show, the undisputed star of the show, was a large (nearly six feet tall and three feet wide) oil painting by Marcel Duchamp enigmatically titled *Nu descendant un escalier n° 2* (*Nude Descending a Staircase, No. 2*). Neither the nude nor the staircase was clearly evident in the picture, just a series of brownish rectangular, conical, and cylindrical shapes that flowed from the upper left to the lower right of the canvas. The lack of a discernible nude left many viewers bemused, befuddled, and even a little unsettled. According to the Philadelphia Museum of Art, where the painting now hangs, "*Nude Descending a Staircase (No. 2)* peels away the traditional beauty of the nude in art, its carnality, even its identifiable sex. Instead, the painting aims to expand our perception of the human body in motion, a topic of fascination for Duchamp around this time."

Marcel Duchamp, *Nude Descending a Staircase, No. 2*, 1912.

When the Armory Show opened, Marcel Duchamp was only twenty-five but already famous in Paris for his unconventional works. Born in Normandy in 1887, Duchamp came from an affluent and cultured family—two older brothers and a younger sister were also talented artists. But Marcel outshone his accomplished siblings with his unusual approach to art, which he believed was meant to exercise the brain. Pictures that merely pleased the eye, such as the academic artists produced, he dismissed as "retinal" art. He also liked to push people's buttons. He would go on to create "readymade" pieces like *Bicycle Wheel* (1913), a bicycle wheel attached to a stool, and *Fountain* (1917), an ordinary urinal mounted on a pedestal. With Matisse and Picasso, Duchamp would revolutionize art in the first half of the twentieth century.

In 1904, when he was seventeen, Duchamp moved to Paris to study art. His older brothers introduced him to current trends as well as fellow artists, and soon Duchamp was putting his own twist on things. He painted *Nude Descending a Staircase* in 1912, inspired, he would later say, by the emerging medium of motion pictures. "The whole idea of movement, of speed, was in the air," he explained. Duchamp submitted the painting for exhibition in the annual Société des Artistes Indépendants in 1912, but the organizers demanded he change the title, which they considered unnecessarily provocative. Duchamp refused and fetched the picture, bringing it home in a taxi. The painting was exhibited publicly later that year at a Barcelona gallery, and when Duchamp learned that a group of Americans was organizing a big modern art show in New York, he offered the painting for exhibition there, aware and possibly hopeful that it might cause another stir. If his goal was attention, he succeeded beyond his wildest dreams.

Hung between a work by his brother, Raymond Duchamp-Villon, and a sculpture by the Ukrainian cubist Alexander Archipenko, *Nude Descending a Staircase* became the "prize puzzle" of the show, as one paper put it.

Crowds gathered before the painting, attempting to divine a nude, a staircase—anything really—and to debate the meaning of it all. "The painting by Duchamp, called 'Nude Figure Descending a Staircase' [*sic*], was the picture which in all that immense collection attracted the most attention," a Cincinnati art critic wrote. "It proved the storm center of the exhibition and was seized upon alike by layman, critic, cartoonist, poet and geometrician as a theme full of infinite variety on which to test each his peculiar powers."

Duchamp attempted to explain the painting. "My aim was a static representation of movement, a static composition of indications of various positions

taken by a form in movement—with no attempt to give cinema effects through painting," he said of it. "The reduction of a head in movement to a bare line seemed to me defensible." But his critics still could not comprehend.

The novelist Rupert Hughes, very much a proponent of academic art, chalked up the controversy to a "typographical error on the part of the printer who printed the name of the picture. It is not a 'Nude Descending a Staircase,' but 'The Staircase Descending a Nude.'" Doggerel was an unfortunate staple of big city newspapers at the time, and bad poems mocking *Nude Descending* practically became a genre unto itself:

> On an old symbolic staircase,
> Looking forty ways at once;
> There's a Cubist Nude descending,
> With the queerest sort of stunts.
> For the staircase is a-falling,
> And the Noodle seems to say,
> "Tho' you hear my soul a-calling,
> You can't see me, anyway!"

"The Rude Descending a Staircase (Rush Hour at the Subway)," a cartoon published in the *New York Sun* on March 20, 1913, was one of many parodies of Duchamp's provocative painting *Nude Descending a Staircase*.
Newspapers.com / New York Sun

Explications of the painting's meaning, genuine and sarcastic, filled countless newspaper columns. In an editorial, the *New York Times* said the painting looked like "an explosion in a shingle mill." Others described it as undressed lumber, a pack of cards in a cyclone, a riot in a lumberyard, an Omaha woodshed after a big wind, a pile of disused golf clubs and bags, an assortment of half-made leather saddles, an elevated railway station in ruins after an earthquake, a dynamited suit of Japanese armor, an orderly heap of broken violins, and an artichoke.

Newspapers loved to print supposed conversations by people looking at the picture. "If I caught my boy Tommy making pictures like that, I'd certainly give him a good spanking," one "matron" allegedly said to a friend as they looked at the picture. Some patrons twisted themselves into pretzels trying to make sense of it. One man removed his hat and bent down to look at the canvas upside down between his legs. The magazine *American Art News* offered a ten dollar reward to anyone who could "find the lady" in Duchamp's painting. The offer "brought a wide and unexpected response," with the magazine awarding the prize to a reader who claimed to find "a crude human figure in the right hand side of the shingle pile" and included some explanatory verse (of course):

> You've tried to find her,
> And you've looked in vain
> Up the picture and down again,
> You've tried to fashion her of broken bits,
> And you've worked yourself into seventeen fits;
> The reason you've failed, to tell you I can,
> It isn't a lady, but only a man.

Some who saw *Nude Descending a Staircase*, however, were inspired. "I laughed out loud when I first saw it, happily, with relief," said the modernist poet William Carlos Williams. The small group that collected modern art in the United States also grasped its significance. Frederic Torrey, a wealthy businessman and art collector in Berkeley, California, snapped up the painting for $324, sight unseen.

On March 4, 1913, the Armory Show welcomed its most distinguished visitor, former president Theodore Roosevelt. It was a notable date: at the time, March 4 was Inauguration Day, and at the very moment Roosevelt was

visiting the armory, clean-shaven Woodrow Wilson was being sworn in as the twenty-eighth president while his mustachioed predecessor, William Howard Taft, looked on. Wilson became the first Democrat to assume the presidency since Grover Cleveland left office sixteen years earlier. The previous November's presidential election had been a bitter contest. Wilson's election was only possible because the Republican vote was split between Roosevelt and Taft. (Eugene V. Debs, the Socialist candidate, though running a distant fourth in the race, still managed to poll more than nine hundred thousand votes, about 6 percent of the total.) Roosevelt had anointed Taft his successor but came to chafe at Taft's less-than-trustbusting approach to governing, and Teddy was unable to resist the urge to run for an unprecedented third term as a third-party candidate.

Clearly Roosevelt had wished to be elsewhere at the moment he visited the armory to spend, as one paper put it, "an hour or two among the weird creations that pass for paintings among the Futurists." Roosevelt's progressive tendencies did not extend into the art world—like Truman, he was fond of Frederic Remington—but the Rough Rider was genuinely curious about this controversial new import from Europe. One reporter noted that T.R. "seemed to take the greatest delight in trying to solve the hidden meanings of the cubic paintings he found there." Standing before one cubist creation, Roosevelt was asked if he'd ever seen anything like it. "The only things I have seen that resembled some of these pictures," replied Roosevelt, "were certain animals in Africa."

"It is true, as the champions of these extremists say, that there can be no life without change, no development without change, and that to be afraid of what is different or unfamiliar is to be afraid of life," Roosevelt later wrote of the show in an essay for the *Outlook* magazine. "It is no less true, however, that change may mean death and not life, and retrogression instead of development." He continues:

> Take the picture which for some reason is called "A Naked Man Going Down Stairs." [sic] There is in my bathroom a really good Navajo rug which, on any proper interpretation of the Cubist theory, is a far more satisfactory and decorative picture. Now, if, for some inscrutable reason, it suited somebody to call this rug a picture of, say, "A Well-Dressed Man Going Up a Ladder," the

name would fit the facts just about as well as in the case of the Cubist picture of the "Naked Man Going Down Stairs." From the standpoint of terminology each name would have whatever merit inheres in a rather cheap straining after effect; and from the standpoint of decorative value, of sincerity, and of artistic merit, the Navajo rug is infinitely ahead of the picture.

Harry Truman could not have failed to take note of the Armory Show. It was covered in all the major national magazines. In addition to Roosevelt's essay in the *Outlook*, there were articles about the show in *Scribner's*, *Century*, *Harper's*, and others. It was covered in the Kansas City papers as well. On Sunday, February 23, 1913, the *Star* published a review of the Armory Show written by Jerome G. Beatty, who was a character in his own right. Born in Lawrence, Kansas, in 1886, he worked for newspapers in Kansas City and New Orleans before moving to New York to work as a freelance critic and publicist. In 1912 he accompanied a woman (frustratingly identified only as "Mrs. David Beach") who walked from New York to Chicago subsisting solely on a diet of raw food. Beatty later published short stories, worked as the director of publicity for Paramount Pictures, and served several terms as a state representative in Connecticut.

"You've heard of the Cubists?" Beatty wrote in his review of the Armory Show for the *Star*. "They're the Frenchmen who draw a hexagon and say 'isn't it a beautiful circle?' and will argue with you until you admit they're right. They see everything in straight lines. The curve means nothing in their lives." Beatty was left shaking his head at the "kaleidoscopic pandemonium" on display:

> Don't think for a minute that these artists who are now in New York do not take themselves seriously. They imagine they are the creators of a new school, that they have discovered an art as distinct as that of music.
>
> Perhaps they have.
>
> But they want the public to be shocked. They know the public cannot appreciate post-impressionism and therefore they want to be vilified, denounced, hooted at. That's what France did.
>
> But New York.
>
> Alas, here's the sad part.

New York is laughing at them.

That's why the imported post-impressionists are sad today. They are being taken no more seriously than the fat lady from Coney Island who is now a feature of one of Broadway's amusement palaces.

This is the kind of writing that informed Harry Truman's opinion of modern art.

4 | MoMA

DESPITE THE SUCCESS OF the Armory Show, it would take another sixteen years before a permanent museum of modern art was established in the United States. The driving forces behind the new museum were three women—Lillie P. Bliss, Abby Aldrich Rockefeller, and Mary Quinn Sullivan—who wanted to "challenge the conservative policies of traditional museums and to establish an institution devoted exclusively to modern art." This formidable triumvirate certainly had the means to fund a revolutionary new enterprise. Bliss was the daughter of Cornelius Newton Bliss, a Boston textile magnate and secretary of the interior in the McKinley administration. Rockefeller was the daughter of a US senator and married to the son of John D. Rockefeller, probably the richest American who ever lived. Sullivan was married to a prominent New York attorney. The Adamantine Ladies, as they came to be known, shared a love of modern art and ruffling feathers. Observing that established museums like the Met were shortchanging modern art, they decided to open their own museum, donating works from their private collections, in addition to money, to get things going.

A board of directors was appointed and tasked with hiring the new museum's director. The board chose Alfred H. Barr Jr., a small, bespectacled man given to an introspection so intense that he would sometimes get lost in his own thoughts in the middle of a conversation. A colleague once remarked that Barr was the only person he knew who, when asked how he was doing, would stop and think for a long moment before answering. While giving a lecture once, Barr read a quotation from a book and then continued to read silently

to himself for a few moments before catching himself and apologizing. Barr was only twenty-seven when he was tapped to oversee the Museum of Modern Art, an institution now popularly known as MoMA, but he was already recognized as one of the United States' leading authorities on modern art. He was also skilled in the cultivation of relationships with rich old ladies, and he would remain with the museum in one capacity or another until 1968. In that time, Barr—with considerable help from his wife, Margaret Scolari Barr, as we shall see—shepherded modern art from the fringes of American culture to the very center of it and, in the process, moved the capital of the international art world from Paris to New York City.

Born in 1902 in Detroit to a Presbyterian minister and a homemaker, Barr was nine when he moved with his parents to Baltimore, where his father became the minister at First Presbyterian Church. Barr attended the Boys' Latin School of Maryland, graduating at the top of his class at sixteen and earning a scholarship to Princeton, where he took his first course in modern art. The professor was Frank Jewett Mather, and the course did not cover anything beyond the nineteenth-century impressionists, to Barr's disappointment. Mather was "extremely conservative," according to Barr biographer Sybil Gordon Kantor, and "looked with disdain" on the postimpressionists—especially the cubists. Of cubism Mather wrote, "Its legacy is merely a tendency to compose in geometric patterns—a harmless and often an amusing expedient, and less novel than it seems." Yet for his conservatism, Mather was refreshingly open-minded, able, as Barr later told him, "to admit the things you don't like might yet have virtue" (a commendable quality also common to Harry Truman).

In 1921 Mather took Barr to New York to see the first exhibition of modern art at the Metropolitan Museum of Art. The show, given the intentionally bland title *Loan Exhibition of Impressionist and Post-Impressionist Paintings*, included works by Cézanne, Degas, Gauguin, Manet, Matisse, Monet, Picasso, Renoir, Seurat, Toulouse-Lautrec, and Van Gogh. Met curator Bryson Burroughs, who just eight years earlier had said Picasso's pictures would never mean anything to the United States, sang a different tune in an essay for the exhibition catalogue. Calling Picasso "an artist of extraordinary skill and powers of assimilation," Burroughs wrote, "He is an inaugurator, a restless experimenter, and painting is to him a kind of game in which he knows no hesitations."

As at the Armory Show, the crowds attending the Met exhibition were sizable, and so was the backlash. A circular mailed to newspapers and leading

figures in the art world "violently" protested the exhibition of "so-called art" at the Met. According to the unsigned screed, modern art was both Bolshevist and satanic. "The philosophy of Bolshevism as applied to all channels of human action is the gospel of mental impotence, sweeping away all standards of discipline and training necessary to the equipment of capable men as well as artists," the pamphlet read. "Hence the Bolshevists would open the gates of the temple of art to the mentally lame, halt and blind of the human race." The circular deemed thirteen works in the exhibition, including two Picassos, "simply pathological in conception, drawing, perspective and color." The circular speculated that the artists were insane because a symptom of insanity is "a deterioration of the optic nerve" (it's not), so "the principle of perspective is completely reversed, and the vanishing point is in the eye of the spectator instead of on the horizon." Predictably, the attack backfired. After the circular was reproduced in the *New York Herald*, there was "a great increase in the number of persons who went to view [the show]."

Alfred Barr circa 1930. *The Museum of Modern Art / Licensed by SCALA / Art Resource, NY*

After earning bachelor's and master's degrees from Princeton, Barr went to Harvard to get his PhD. To help pay his way, he also took a position as an adjunct lecturer at Wellesley, where he taught the first college course on twentieth-century art.

At Harvard one of Barr's professors was Paul J. Sachs, who, in addition to his teaching post, was the assistant curator of Harvard's Fogg Museum. Sachs believed his students should be connoisseurs as well as scholars, and much of his teaching focused on the isms sweeping Europe at the time. It bears noting again the connection between vast wealth and the growth of modern art, especially in the United States. Sachs's father was Samuel Sachs, one of the two founders of the financial behemoth Goldman Sachs. His mother, Louisa Goldman, was the daughter of the firm's other founder. Paul Sachs began collecting art as a Harvard undergrad, but he went into the family business after graduation, eventually becoming a partner. In 1915, when he was thirty-seven, Sachs switched careers and accepted the appointment at the Fogg, whose director was his Harvard classmate Edward Waldo Forbes (yes, one of those Forbeses). Sachs was offered the position despite having no curatorial experience whatsoever. Undoubtedly, Harvard coveted his art collection, much of which, as the college had hoped, Sachs would subsequently donate to the museum. Transactional though his hiring was, Sachs was a superb teacher and was eventually appointed a full professor in the Fine Arts Department.

In 1929 Paul Sachs was one of the seven founding members of MoMA's board and was instrumental in convincing the Adamantine Ladies that Alfred Barr, despite his youth, was the right person for the job of director. Barr abandoned pursuit of his PhD and a career in teaching to take the job. (Harvard would ultimately award him a doctorate in 1946, accepting his book *Picasso: Fifty Years of His Art* in lieu of a dissertation.)

A year after MoMA opened, Alfred Barr married Margaret Scolari in a simple civil ceremony at New York city hall. Margaret, known widely as Marga, was born in Rome in 1901. Her mother was Irish, her father Italian, and she was fluent in English, French, and Spanish as well as Italian. She studied art history at the University of Rome but left before earning a degree to work as a secretary to the naval attaché at the American embassy in the Italian capital. "My mother had become a Christian Scientist and the wife of the then naval attaché, called Captain [Raymond Hasbrouck], was also a Christian Scientist," she recalled many years later. "His wife told my mother that her husband was

looking for a bilingual secretary. I had spoken English before Italian so that I was suitably bilingual." Through connections she made at the embassy, Margaret was hired to teach Italian at Vassar and moved to the United States in 1925.

Four years later, in the autumn of 1929, Marga and a friend, Agnes Rindge, attended the very first exhibition at the new Museum of Modern Art, then occupying a space on the twelfth floor of an office building on Fifth Avenue in Midtown Manhattan. She was immediately struck not just by the paintings themselves—nearly a hundred works by artists including Cézanne, Gauguin, and Van Gogh—but by the way the paintings were displayed. Until then, museums had hung pictures vertically, stacked one above the other, as well as horizontally, practically covering the wall with pictures. And the pictures were usually placed inside ornate frames and hung on walls covered with red, green, or blue brocade. But in that first MoMA show, Marga recalled,

> there were no pictures above other pictures, all the walls were neutral, and the pictures were hung intellectually, chronologically; nevertheless not in such a way that they would clash. In other words, if the colors were not harmonious then they would be separated. But if there were intellectual connections between a large and a small picture they would be hung close to each other so that they could be seen together.

Even the identifying labels were different; they included information beyond simply the name of the work and the artist. The labels also explained the history behind the piece and the materials used to create it. "And this had an extraordinary effect on the public; they were enormously interested," Marga said. "Such a thing had never been done before." Alfred's gift, according to the art historian Gijs van Hensbergen, "was his ability to popularise modern art and make the complex seem simple, without patronising his audience or trivialising the work."

Agnes Rindge, the friend who accompanied Marga to MoMA that day, was friendly with Alfred Barr. When Agnes saw Alfred at the show, she introduced him to Marga. The two hit it off and wed six months later. "I know of no pair more diverse in background, in emotional inheritance, or in outward manner—& more devoted or more reliant upon the well-being of the other," Agnes later wrote a friend. Soon after exchanging vows at city hall, Alfred and

Marga sailed for France to collect works for an upcoming exhibition of art by Jean-Baptiste-Camille Corot and Honoré Daumier. (In deference to Alfred's parents, the couple repeated their vows before a minister in Paris.)

Alfred and Marga traveled to Europe frequently to forage for works to borrow for upcoming shows, with the polyglottic Marga acting as interpreter for Alfred. They witnessed the dying embers of the licentious '20s and the growing flames of totalitarianism in Germany, where modern art had flourished after the First World War, especially at the Bauhaus, an art school in Dessau. Adolf Hitler, the failed artist, was contemptuous of modern art, and its destruction became an explicit goal of his Nazi government. On a trip to Stuttgart in early 1933, the Barrs witnessed firsthand the terrifying rise of Nazism and antisemitism in Germany. "We lived in this very cheap pension," Marga remembered.

> We began to live there, make it around January 15 or 18. Everybody sat at a table that was smaller than this one. The election that brought on Hitler was to take place around January 30. Nobody at the table was going to vote for Hitler's party . . . at all. We all used to talk at [the] table at the same time. But the woman that ran the pension had just bought a radio, a most extraordinary and exceptional thing at that time. And within a fortnight all these people at the table were completely converted to Hitler by the screams and yells that they heard on the radio. . . . We stayed on in Stuttgart until about May [and] saw the first Jewish persecutions. We saw the first yellow buttons. We saw the first department stores closed as Jewish persecution. And we became very ferociously anti-Fascist.

In Stuttgart the Barrs went to see an exhibition of paintings by the Bauhaus artist Oskar Schlemmer at the Württemberg Art Society. They enjoyed it so much they returned a few days later to see it again—but it was gone. The paintings had all been removed. The walls were empty. When Alfred asked the director what had happened, he led the Barrs to two locked rooms in the back of the gallery. There the paintings were stacked on the floor and leaning against the walls. The director explained that he had been forced to close the exhibition because it had been condemned by a Nazi newspaper, which had declared the paintings *Kunstbolschewismus*—Bolshevist art.

From Germany the Barrs moved on to Switzerland, where Alfred began drafting a series of articles about the Nazis. The articles were meant to warn Americans about Hitler's plans to "cleanse" or "purify" German culture, to rid the country of Jewish "contamination," by force if necessary. But Americans, weary of the Depression and bewildered by Franklin Roosevelt's array of social programs known as the New Deal, couldn't be bothered by events in distant Germany. "When he came back to this country he tried to sell them," Marga recalled of Alfred's articles.

> Alfred had always sold every blasted thing he had ever written and he couldn't believe he couldn't sell them to *Harper's*, couldn't sell them to the *Atlantic*, couldn't sell them to the *Times*, couldn't sell them to anyone. . . . Nobody would believe that Hitler was the kind of person that he ultimately turned out to be. Nobody would believe it. Nobody would believe the content of what Alfred wrote.

At the Nuremberg rally in September 1935, Hitler declared war on modern art. "It is not the mission of art," he said, "to wallow in filth for filth's sake, to paint the human being only in a state of putrefaction, to draw cretins as symbols of motherhood, or to present deformed idiots as representatives of manly strength." Later he would declare, "'Works of art' that are not capable of being understood in themselves but need some pretentious instruction book to justify their existence . . . will never again find their way to the German people."

In 1937 the Nazis organized a mocking exhibition called Entartete Kunst—"degenerate art"—that visited thirteen cities in Germany and Austria. Some 650 modernist paintings and sculptures, many confiscated from artists, collectors, and museums, were displayed, including pieces by Marc Chagall, Wassily Kandinsky, Paul Klee, Picasso, and Schlemmer. The exhibition was divided into nine groups: "Jewish trash," "cretinous" art, "Marxist draft-dodging propaganda," "negro" art, etc. One of the groups was devoted entirely to abstract art. "This section can only be entitled 'Sheer Insanity,'" the exhibition guide explained.

> It occupies the largest room in the exhibition and contains a cross section of the abortions produced by all the "isms." . . . In the case of most of the paintings and drawings in this particular chamber

of horrors there is no telling what was in the sick brains of those who wielded the brush or the pencil.

The pictures in the exhibition were hung haphazardly, with labels facetiously "explaining" the works: "The harlot as a moral ideal!" "Painted sabotage of national defense." The goal of the show, according to the guide, was to "reveal the philosophical, political, racial, and moral goals and purposes pursued by those who promoted subversion." More than two million people attended the traveling exhibition.

In the process of systematically murdering millions, the Nazis also looted more than a half million works of art. Many were destroyed. Others were sold abroad to fund the Nazi war machine. Some ended up in American museums, including MoMA, many of which have undertaken provenance research projects to identify art with Nazi connections in their holdings. In a statement on its website, MoMA says it owns "approximately 800 paintings created before 1946 and acquired after 1932 that were or could have been in Continental Europe during the Nazi era":

> Museum researchers have examined, and are continuing to research, the ownership, or provenance, records for artworks that fall within this category. The majority of these works were acquired directly from the artists or have provenance records that are sufficiently complete. Provenance research is an ongoing project, and a priority, at the Museum.

Ironically, Hitler's political opposite shared his hatred of modern art. In 1932 Soviet dictator Joseph Stalin declared modern art bourgeois and *zapretnyy* (forbidden); thereafter, only socialist realism was acceptable. This uniquely Soviet art genre extolled the motherland and the Communist party through glorifying images of factory workers, farmers, and, of course, Stalin himself (it is distinct from American social realism, which addresses social problems; think Dorothea Lange's Dust Bowl portraits). "We must intensify the struggle for a genuinely realistic art," the Russian art journal *Iskusstvo* declared shortly after independent art groups were banned in 1932. "We must fully unmask the remnants of the class enemies in art."

"The highest praise comrade Stalin would give a painting was contained in these two words: 'living people,'" recalled Isaak Brodskii, a prominent practitioner of socialist realism. "In this he saw the greatest merit of a painting. 'A painting must be living and comprehensible'—I have remembered these words of comrade Stalin forever."

When an exhibition called *Fifteen Years of Soviet Art* opened in Moscow in June 1933, the Russian avant-garde artists who had flourished in the decade after the revolution—Wladimir Baranoff-Rossiné, Kazimir Malevich, et al.—were conspicuously absent. The message was unmistakable. In 1937, as Stalin's purges reached their climax, and the same year Entartete Kunst opened in Munich, the journal *Iskusstvo* attacked the "clowns who wallow in different forms of defending the doctrine of 'art for art's sake.'" The people who made modern art, the journal said, "have been very quick to find their way into the Fascist 'cultural' hearts."

"In this way," writes Igor Golomstock in *Totalitarian Art*, "all contemporary art that departed from the standards of Socialist Realism was damned with the most terrible of political labels; what had long since, in Germany, been referred to as 'Kulturbolschewismus' was now, in Russia, given the name of 'Fascist art.'"

As ominous events unfolded across Europe, Picasso, in France, seemed disengaged, uninterested even in the civil war roiling his native country. "In Spain they're killing each other & he wallows in brothels," Margaret Scolari Barr noted bitterly after seeing the artist in Paris. Picasso had never been especially political, and his personal life at the time was even more chaotic than usual. Married but separated from his first wife and juggling two mistresses, he seemed to have little time for politics (though he did manage to squeeze in the brothels). He seemed too self-involved for politics—a "party of one," as one writer put it. But when German and Italian bombers leveled the Basque town of Guernica on April 26, 1937, Picasso was jolted out of his political indifference.

Guernica had been a center of Republican resistance to Francisco Franco's Nationalist forces, so Franco asked his fascist friends Hitler and Mussolini for help. "For three hours, in wave after wave, planes dropped a mixture of 250-kilogram 'splinter' bombs and ECBI thermite incendiary bombs, designed to burn at 2,500°C, transforming the city into an apocalyptic fireball," wrote Gijs van Hensbergen. "Those who managed to escape . . . were strafed from

the air with machine-gun fire." Hundreds were killed, including women and children.

Picasso had promised to create a work for the Spanish pavilion at the world's fair taking place in Paris later that year, but he'd been at a loss for inspiration. As reports and photographs of the total destruction of Guernica emerged, however, Picasso was moved to paint what many consider his masterpiece. "Something about this particular tragedy, this attack on an entire people, had shaken him out of his passivity," writes Hugh Eakin. "The emotional dam that had protected him from the war had suddenly broken."

Picasso covered a massive canvas, twenty-five feet wide and eleven feet high, with stark, haunting images in black and white and shades of gray depicting the horrors of war: people and animals grieving, mutilated, distorted, wailing, anguished. While it is now regarded as the single greatest work of antiwar art ever created, the immediate reaction to the painting, which Picasso titled simply *Guernica*, was muted. One critic who saw it at the Spanish pavilion at the world's fair called it "incomprehensible." The German guidebook to the fair dutifully ridiculed the painting as "the dream of a madman, a hodgepodge of body parts that a four-year-old child could have painted." But Alfred Barr, who, like Alfred Stieglitz, had a genius for recognizing genius, apprehended its importance immediately.

For years Barr had been eager to curate a Picasso retrospective at MoMA but the artist had always been noncommittal, still stinging perhaps from the rebuke of the Stieglitz show in 1911. With war looming, however, Picasso and his dealer, Paul Rosenberg, came to appreciate the advantages of moving some of the artist's major works to the United States for safekeeping. They agreed to lend works to MoMA provided the museum agreed to keep them as long as necessary until they could be safely returned to France. Barr needed no convincing. Picasso sent more than three hundred works, including *Guernica*, to New York. *Picasso: Forty Years of His Art* ran at MoMA from November 15, 1939, to January 7, 1940, and was the museum's most popular show up to that time. More than one hundred thousand people saw it, including Albert Einstein.

Guernica was installed in a room of its own, and it remained at the museum until 1981, when, six years after the death of Franco, it was finally sent to Spain, where it remains today.

Although 1929 had not been a good time to open a new museum—that's the year the stock market crashed, of course—under Alfred Barr's direction and

with Marga Barr's sizeable contributions, MoMA managed to withstand the vicissitudes of the Great Depression. In fact, given the circumstances, MoMA's growth was nothing short of miraculous. When Lillie P. Bliss, one of the three Adamantine Ladies, died of cancer at sixty-six in 1931, she bequeathed 150 priceless works from her collection to MoMA, including pieces by Cézanne, Matisse, and Picasso, forming the basis of the museum's permanent collection. In 1935 construction began on the museum's first purpose-built home, a boxy building on Fifty-Third Street designed by the American architects Philip L. Goodwin and Edward Durell Stone. On May 10, 1939, President Franklin Roosevelt delivered a nationally broadcast radio speech to commemorate the grand opening of the new building. The Second World War would begin in less than four months, and Roosevelt's speech emphasized the indispensability of art in a free society.

> The arts cannot thrive except where men are free to be themselves and to be in charge of the discipline of their own energies and ardors. The conditions for democracy and for art are one and the same. What we call liberty in politics results in freedom in the arts. There can be no vitality in the works gathered in a museum unless there exists the right of spontaneous life in the society in which the arts are nourished.

No doubt listening closely to FDR's speech that night was Harry Truman—now, improbably, a US senator. In the twenty years since marrying Bess Wallace, Harry had owned a haberdashery (which failed) and launched a political career that began modestly as a Jackson County judge but would culminate in the highest office in the land.

PART II

THE GENTLEMAN FROM MICHIGAN

5 | ADVANCING AMERICAN ART

ON OCTOBER 4, 1946, an exhibition of seventy-nine paintings opened at the Metropolitan Museum of Art in New York. The paintings were owned by the US government and all were examples of "advanced creative work"—in other words, the cutting edge of modern art in the United States at the time. Modern American art had come a long way since the Armory Show thirty-three years before, when the Europeans outranked them in every medium: painting, drawing, and sculpture. Since then, a new generation of American artists had come of age, conscious of the European trends but confident in their own abilities. Supported by New Deal programs that, for example, commissioned murals for post offices and other public buildings, American artists like Reginald Marsh, Ben Shahn, and Marguerite Zorach established their reputations in the 1930s and 1940s, although world events largely confined their renown to the United States.

As the Cold War dawned, the United States seemed superior on every front, being the only nation in the world with nuclear weapons, a homeland that had escaped World War II practically unscathed, and an economy strong enough to finance the rebuilding of Europe under the Marshall Plan. In one area, however, the nation was clearly deficient: culture. The rest of the world still regarded the United States as a cultural backwater where profits were prized over paintings, pennies more precious than poetry. The Soviet Union exploited this advantage even while the rubble was still smoldering in Berlin. The Russians organized orchestral performances in the ruined shells of German opera houses to advertise their cultural superiority. "Cultural diplomacy"

became a catchphrase. American diplomats felt an urgent need to respond and demonstrate American accomplishments in the arts and culture. One diplomat in particular hit upon the idea to organize an exhibition of the country's best modern art. The diplomat's name was LeRoy Davidson, and the exhibition that he organized, called Advancing American Art, would, like a nuclear bomb, set off a chain of events that triggered a new kind of war: a culture war at home.

Joseph LeRoy Davidson was born in Cambridge, Massachusetts, in March 1908. His parents were Edward and Mary (née Susser). Edward, according to the *Boston Globe*, was a "well-known Boston import merchant," and the young LeRoy (who went by his middle name and pronounced it luh-ROY) was raised in a comfortable middle-class home in nearby Brookline. In the autumn of 1926, he entered Harvard, where, in addition to playing lacrosse, he studied art history. Like Alfred Barr before him, Davidson was spellbound by Paul J. Sachs, the Fogg Museum curator and modern art apostle.

Davidson graduated from Harvard in 1930. Two years later he married twenty-one-year-old Martha Aginsky, a Radcliffe grad who was very much Davidson's intellectual equal and shared his love of art. She was also a Chinese language scholar who helped compile one of the first Chinese-English dictionaries published in the United States. Like Marga and Alfred Barr, Martha and LeRoy Davidson would work closely together.

The Davidsons moved to New York, and LeRoy earned a master's degree from New York University's Institute of Fine Arts in 1936. Then it was on to Minneapolis, where LeRoy became curator at the Walker Art Center, which, with funding from the Works Progress Administration's Federal Art Project, was undergoing a major transformation from a small gallery to a major museum specializing in contemporary art. Davidson worked under the Walker's charismatic director Daniel Defenbacher. Unlike his boss, however, Davidson did not crave attention. Toiling in relative anonymity, he used his discerning eye to expand the museum's contemporary holdings. He secured the purchase of the German expressionist Franz Marc's *Die grossen blauen Pferde* (*The Large Blue Horses*), a painting now considered a modern masterpiece, and curated shows by several contemporary artists, including Marsden Hartley.

In 1940 Davidson registered for the draft. He was thirty-two years old and, according to his registration card, five feet eight and 151 pounds, with hazel eyes and brown hair. When the US entered the war the following year, there wasn't much use for thirtysomething art history majors on the front lines,

but there were other ways Davidson could contribute to the effort. In 1943 he was assigned to the Army Signal Corps, where he worked in the graphic arts department preparing propaganda materials. It's worth noting that many artists who would later be vilified as communist and anti-American contributed energetically to the war effort, including Ben Shahn and Yasuo Kuniyoshi.

After the war, LeRoy and Martha decided to stay in Washington, and he went to work for the State Department, which had inherited several cultural programs from wartime bureaucracies such as the Office of War Information, combining them into a new cultural affairs bureau. Davidson was put in charge of State's international art program. For years, the department had sponsored exhibitions of American art abroad, but these were conservative affairs, and the planning was usually farmed out to the National Gallery of Art. A typical show might include works by old stalwarts like Gilbert Stuart and Frederic Remington—lots of American Revolution and Wild West stuff—and even old masters from the collections of wealthy Americans, works that, as one critic put it, the "broadest segment of the American public would find accessible and unobjectionable." This left foreigners with the impression that the United States was a cultural wasteland, a nation obsessed with money and technology but indifferent to the arts.

LeRoy Davidson was determined to change that perception. He wanted to put on a traveling show of "creative and experimental work produced in America" to show the world "the United States is a country which produces gifted artists as well as brilliant scientists and technicians." The exhibition would also draw a sharp contrast with the Soviet Union, where only socialist realism was tolerated. Much more than an art show, Advancing American Art was meant to promote core American values: individualism, freedom of expression, and tolerance of dissent.

The Land of the Free would be glorified as a haven for freethinkers.

As he later explained, Davidson felt there was broad demand for contemporary American art overseas. He reached this conclusion based on "reports from the field, conversations with officers brought to Washington for consultation, and studies of foreign press reactions to art exhibits."

Davidson's boss was William Benton, the assistant secretary of state for public affairs. Benton signed off on the project, though he later claimed to be unaware of the particulars. Benton was a political appointee, an advertising executive and entrepreneur who had most recently served as president of Encyclopedia Britannica, a large company that, like many in the United States

at that time, maintained an impressive art collection. Although he was no connoisseur like Davidson, Benton still knew his way around a museum. Born in 1900, he went to Yale and then worked for several advertising agencies in New York and Chicago before founding a firm with his colleague Chester Bowles in 1929. As with the founding of MoMA, the timing wasn't great, but Benton & Bowles flourished in the Great Depression, mainly because they were able to capitalize on the advertising opportunities in a new medium: radio. Benton has been credited with (and blamed for) inventing the advertising jingle as well as the soap opera, the latter conceived purely as a vehicle for marketing his clients' cleaning products. In 1935, at the height of the Depression, Benton sold his share of the company for a cool $1 million and became an entrepreneur. He bought Encyclopedia Britannica and the background-music company Muzak, turning both into hugely profitable enterprises. He made his money by appealing to the masses. The avant-garde was not his thing.

In 1945 Harry Truman appointed Benton assistant secretary of state for public affairs, a position that Benton, a Democrat, envisioned as a stepping stone to a political career. Despite his culturally conservative tastes, Benton was unafraid to tackle big projects, and under his watch the State Department launched the Voice of America radio broadcasts, the Fulbright Program, and LeRoy Davidson's brainchild, a traveling exhibition of modern American art.

It was Davidson who decided to call the exhibition Advancing American Art. The first word could stand as a verb or an adjective. No one was certain what the intended meaning was, as was often the case with modern art itself.

From the outset, two things made the exhibition unusual. For one, Davidson himself would select the paintings, in consultation with other experts in modern art, including his wife, Martha, then a freelance writer for *Art News* (the magazine formerly known as *American Art News*). LeRoy feared a jury or committee would automatically default to the safest works—and he did not intend for this show to be safe.

Second, rather than borrowing the paintings from galleries, the State Department would purchase them outright. The reason for this, Davidson explained in an article in the *Foreign Service Journal*, was purely economical; it was, he argued, actually cheaper to buy the pictures:

> One of the main problems involved in maintaining an art program
> on a worldwide basis is that of controlling sufficient first-rate material

over a considerable period of time. Demands on museums, collectors, and dealers for the loan of art works have become so burdensome that it is increasingly difficult to borrow material for long periods even for exhibition within the United States. A museum director rightfully feels that his immediate obligation is to his community; the collector justifiably wants to enjoy his own acquisitions; while the art dealer complains of inadequate stocks due to recent heavy buying. To the dealer a picture on tour may actually mean a financial loss. Consequently it is only under unusual circumstances that good art works can be borrowed for foreign display, and the most favorable arrangement that can be hoped for is a loan for a year or less. A period of six months is the more common time limitation.

Thus borrowed material can rarely be shown in more than one or two cities within the time limit allotted. Costs of specially designed packing cases and insurance charges on borrowed works become excessive, while return shipping expenses to this country account for a too large proportion of the costs. When material is the property of the Government it may be used indefinitely. Packing and shipping costs are reduced to a minimum, and insurance charges are eliminated by Government risk. Furthermore, a maximum of flexibility in scheduling is achievable. For example, an urgent plea for a priority showing can be acted upon promptly without protracted negotiations with numerous lenders.

Given a budget of about $50,000, Davidson began scouring galleries in New York, often appealing to the patriotism of dealers and artists to receive a substantial discount on the works—he later estimated that on average the price he paid for each painting was 25 percent below the listed price. In all, Davidson purchased 117 oil paintings and watercolors by 47 artists. The artists, many of whom were either immigrants or first-generation Americans, represented a broad swath of American modernists at the time. "Some excellent but conservative painters have been omitted, while almost all the leading exponents of modern trends are included," wrote Davidson in the *Foreign Service Journal*. "The range of styles extends from the precise renderings of Charles Sheeler to the explosive colorism of Abraham Rattner; from the human commentary of Gregorio Prestopino to the intellectual abstractism of I. Rice Pereira; from the social criticism of Philip

Evergood to the whimsy of Loren MacIver." All the artists save one (Marsden Hartley) were still living. In a statement, the State Department acknowledged that the selections were "weighted on the side of experimental and creative work," but added that "only in a democracy where the full development of the individual is not only permitted but fostered could such an exhibition be assembled."

The plan was to divide the collection into two parts, one to tour Europe, the other Latin America. The preview at the Met in the autumn of 1946 received almost unanimous praise from critics. *Art News* proclaimed it "the most significant modern exhibition" of 1946 in the United States. The critic and king-maker Clement Greenberg, who later championed Jackson Pollock, called it "the best group show of this nature to be held in New York for years" and lauded Davidson for assembling pictures "in which there is some relationship to be discerned between the bad and the good; they are not thrown together helter-skelter by a jury whose only connection between members is one of time and place; they have an organic relation to each other that is enlightening in itself." But some critics anticipated the hackles the show would raise. "The pictures make a beautiful show, vital, imaginative, representative of the most progressive trends in American art today," Emily Genauer wrote in the *Ladies' Home Journal*. "But I've a notion some of the stuffier gentlemen in Congress, the ones who haven't been to an art exhibition since their school days and consequently know all about art, won't like it. They'll fill the air with their lamentations for the poor taxpayer and his money."

Indeed, even before the show moved overseas there were already rumblings of discontent on the right. Four times that fall—October 4, November 19, November 26, and December 3—the Hearst newspaper chain ran scathing features about Advancing American Art. Although William Randolph Hearst, who never met a communist he didn't hate, was now in his eighties, his papers still carried the old man's water and never missed an opportunity to vilify anyone or anything on the left. Each article about the exhibition included low-quality black-and-white reproductions of a few of the pictures in the show, and each work was labeled with a sarcastic caption, as in the Nazis' degenerate art show:

> GIVING US THE BIRD—This is a t-u-r-k-e-y. A t-u-r-k-e-y is a b-i-r-d. It is an impressionist turkey, by Everett Spruce, an abstract turkey, maybe, or even a cubistic turkey. It is not good eating. Is it good painting? The State Department says yes.

While the preview was ongoing at the Met, an event took place that would have grave implications for the Advancing American Art exhibition—and modern American art in general for the decade to come. On November 5 the first national election since the end of the war took place, and Republicans won control of both the House and the Senate for the first time since FDR's first election victory in 1932. After fourteen long years in the political wilderness, the Republicans were eager to wield their power ferociously, something that President Truman, eyeing his own reelection in two years, was acutely aware of. He would have to pick his fights with Congress very judiciously. The class of incoming freshman included representatives John Kennedy of Massachusetts and Richard Nixon of California, as well as a new senator from Wisconsin, Joseph McCarthy.

On November 6, the day after the election, the American Artists Professional League (AAPL), a conservative art group aligned with the National Academy, sent a letter to Secretary of State James F. Byrnes complaining about the Advancing American Art exhibition. In the letter, AAPL vice president Albert T. Reid said the exhibition was "strongly marked with the radicalism of the new trends of European art," which "is not indigenous to our soil." The AAPL also encouraged its members to write their representatives in Congress to protest the exhibition.

Then in February 1947, *Look* magazine published a two-page spread about the exhibition. Titled "Your Money Bought These Paintings," the article was accompanied by large color reproductions of some of the most provocative paintings in the exhibition, including Ben Shahn's *Hunger*, depicting an emaciated boy seemingly begging for food, and Yasuo Kuniyoshi's *Circus Girl Resting*, which would come to symbolize Advancing American Art much as *Nude Descending a Staircase* had come to epitomize the Armory Show.

Circus Girl Resting depicts a young woman with short dark hair seated on a chair next to a bowl containing bananas and grapes. The painting was unconventional, in part, because of the woman's skimpy attire and her size: This circus girl did not conform to the conventional standards of feminine beauty then prevailing. She was big. The *Chicago Tribune* said Kuniyoshi's painting "portrays a beefy female in a state of undress, seated on a chair, leering at whoever stops to look at the painting." The *Washington Post* said it looked like "something between Primo Carnera taking an enforced siesta and the product of an early Easter Islander after a bad night." (Primo Carnera was a popular heavyweight boxer at the time.) You get the idea.

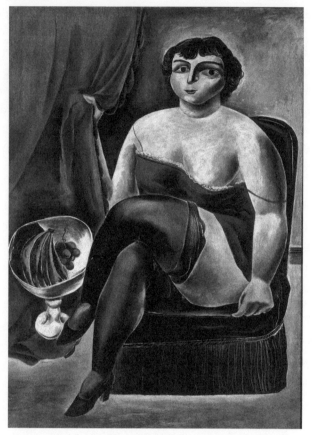

Yasuo Kuniyoshi, *Circus Girl Resting*, 1925. *© 2022 Estate of Yasuo Kuniyoshi / Artists Rights Society (ARS), New York*

The artist at the center of this storm was born in Okayama, Japan, in 1889. Yasuo Kuniyoshi immigrated to the United States in 1906, intending to stay long enough only to perfect his English then return home to work as a translator. He worked odd jobs in Spokane and Seattle before moving to Los Angeles, where he enrolled in a public school. One of his teachers encouraged him to go to art school, so he took classes at the Los Angeles School of Art and Design. "While going to art school I earned my living by doing various odd jobs, such as working in the field of the Imperial Valley picking cantaloupes; picking grapes in Fresno, during the summer," Kuniyoshi remembered. "In the winter I worked as a bell-hop in a hotel. It was not what I wanted to do, but I didn't mind since it enabled me to go to art school." In late 1909 or early

1910, he moved to New York to pursue a career in art. Naturally gregarious, he made many friends in the city's art world and in 1922 had his first solo show, at the Daniel Gallery. He eventually settled in upstate Woodstock. Because he was born in Japan, Kuniyoshi was prohibited from obtaining American citizenship and regularly faced discrimination.

"Being a stranger in a strange country is very difficult," he once wrote.

> Sometime ago when I was in subway waiting for train—station wasn't so crowded—I saw a stranger, looked like out-of-town man, was lost in the subway, didn't know which was uptown or downtown or which train he should take.
>
> I knew he was lost because he looked at me with inquiring gesture, then he went to man standing next to me. He was asking how to get to Bronx with Middle West accent. The man next to me, he was a white man, but he was apparently stranger to this country, and not only stranger in New York City but he couldn't speak a word of English. So when question was asked, he didn't know what it was all about.
>
> I felt rather silly. I knew what train he should take and which side was uptown train going by but I felt hurt because being Oriental they dismiss altogether as though we don't understand English. But I felt kind of sorry for him so I gave him direction. He was rather dumbfounded but I felt kind of good.

Yasuo Kuniyoshi.
Wikimedia Commons

After the attack on Pearl Harbor, Kuniyoshi, like all Japanese Americans, was the object of constant surveillance and suspicion. He enlisted his friends in the art world to write letters of reference for him—Carnegie Art Museum director Homer Saint-Gaudens said he was "one of the very best artists in our land and wholly and entirely American," and MoMA's Alfred Barr called him "an integral part of the cultural life of this country"—but Kuniyoshi was still considered an "enemy alien." Unlike Japanese Americans on the West Coast, he was not forced into an internment camp during the war, but his cameras were confiscated, his home was searched, and he was required to obtain written permission from the War Department to travel. He joined Artists for Victory, but when he tried to enter the group's war poster competition, he was told "no members of the nations of our enemies" were eligible. He tried to enlist in the US Army but was rejected because he was too old and did not possess "technical and specialized skills needed by the Army."

"My life and my interest lies in this country," he wrote in a letter to Secretary of War Henry Stimson. "I should be glad to contribute my services within my limitations as an artist, if they can be of any help to the U.S. government." Kuniyoshi helped by writing scripts for *Japan Versus Japan*, a Japanese-language shortwave radio program produced by William "Wild Bill" Donovan's Office of the Coordinator of Information and beamed into Japan, and designing Japanese-language propaganda posters for the Office of War Information.

Kuniyoshi painted *Circus Girl Resting* in 1925. Women and circuses were two of his favorite subjects. "It's the idea of a woman that I like to paint, a woman to represent all women," he wrote. "It seems of greater value to me to paint my conception of a woman . . . than the physical aspects of any individual." His interest in circuses was piqued by Walter Kuhn, one of the organizers of the Armory Show, whom Kuniyoshi met after settling in New York. (Kuhn's infatuation with the circus is well documented; he called it "the most fascinating business in the world" and painted many circus pictures himself.)

Kuniyoshi's *Circus Girl Resting* languished in obscurity until LeRoy Davidson purchased it for $700 for Advancing American Art. Then it became, for a brief time anyway, the most famous painting in the United States. "No wonder foreigners think Americans are crazy," said Representative Karl Stefan when he saw *Circus Girl Resting* in *Look*. Stefan's opinion was not unimportant; the Nebraska Republican was the new chair of a House subcommittee that funded

the State Department. Stefan said his office had received a lot of mail from constituents indignant about the exhibit. He quoted one correspondent who said the circus girl looked like "a Chicago Bears tackle taking it easy during a time-out." Stefan said his constituents "objected . . . to any inference that the typical American girl is better equipped to move a piano than play one." Stefan added ominously that future State Department requests for funding would be "closely scrutinized."

The Republican chair of the House Appropriations Committee, John Taber, also chimed in. "The paintings are a travesty upon art," he complained in a letter to George C. Marshall, who replaced James Byrnes as secretary of state in January 1947. "They were evidently gotten up by people whose object was apparently to, (1) To [sic] make the United States appear ridiculous in the eyes of foreign countries, and to (2) Establish ill-will towards the United States." The national loyalty of the artists was also called into question. It turned out that the names of eighteen of the forty-seven artists in the exhibition appeared in the records of the House Un-American Activities Committee; three were reported to have been members of the Communist Party.

Shortly after the *Look* article came out, Harry Truman unveiled a painting recently purchased for the White House: *The Peacemakers* by George Peter Alexander Healy. A picture very much of the academic, realistic variety, it depicts Sherman, Grant, Lincoln, and Admiral David D. Porter on the Union steamer *River Queen*. This was Truman's kind of art. The president told reporters that a New York art dealer had wanted $18,000 for the picture but he managed to talk him down to $10,000. In his widely syndicated newspaper column, The Washington Merry-Go-Round, Drew Pearson explained what happened next:

> While in his office, newsmen were shown some of the art the chief executive despises most. He produced a spread of modern paintings from a magazine, which apparently he had been saving for just such occasion.
>
> "This is what I mean by ham-and-eggs art," he told the reporters, pointing to a painting of a fat semi-nude circus performer.
>
> "I've been to a million circuses, and I've never seen a performer who looked like her," he said. "The artist must have stood off from the canvas and thrown paint at it. If that's art, then I'm a Hottentot."

Truman's press secretary Charles Ross (pointing) shows reporters *The Peacemakers*, a painting Truman had recently purchased for the White House.
Harry S. Truman Presidential Library & Museum

Hottentot was the name Dutch settlers gave to the Khoekhoen people of southwestern Africa. Over time the word become an epithet for native Africans generally. Truman's use of it was telling. It was, writes Kuniyoshi biographer ShiPu Wang, "Truman's way of belittling the painting as 'primitive,' obviously a derisive term in his use. In essence Truman dismissed the supposed artistic value of Kuniyoshi's work and ridiculed the idea that such a painting could represent the highly civilized and cultured American society." Truman's comments were also blithely dismissive of the Advancing American Art exhibition, which was scheduled to open in Prague just weeks later. Clearly this was not a fight the president was willing to pick with the new Republican Congress.

Truman's comments won him favor with at least one constituency. In what was no doubt a publicity stunt, the "aerialists, riders and showgirls" of Ringling Bros. and Barnum & Bailey Circus sent the president a telegram thanking him for his "defense of the circus girl." Truman replied with a telegram of his own: "I am delighted to have my judgment verified by experts," he wrote. "Hearty greetings and good wishes to all."

Advancing American Art was in danger of turning into a circus in its own right. The pictures were overseas now, one group in Europe, the other in Port-au-Prince.

After another well-received preview in Paris, the European edition of Advancing American Art officially opened in Prague on March 6, 1947. It was to be the first stop on an expected five-year tour. At the time, Czechoslovakia was not yet in the Soviet sphere, and nowhere was the Cold War battle for hearts and minds more ferocious. Founded out of the ashes of the Austro-Hungarian Empire in 1918, Czechoslovakia had ceased to exist during the Second World War when Nazi Germany occupied it. Reestablished in 1945, the country's postwar government was an uneasy coalition of communist and anticommunist parties. Czechoslovakia's president, Edvard Beneš, hoped the country could act as a bridge between the East and the West. The three-week show in Prague was a resounding success, with more than eight thousand people attending. Even President Beneš came, on March 25, and he ended up staying for more than ninety minutes, examining the pictures closely. The exhibition then moved on to two more cities in Czechoslovakia, Brno and Bratislava, where it also proved popular.

The show was so successful that the USSR felt compelled to respond. The Soviets hastily arranged their own art show in Prague, called the *Soviet Exhibition of the Works of National Artists*, a collection of "state art." The exhibition was well attended—partly because the Soviets dropped free tickets from airplanes flying over the city—but the reviews were bad. One newspaper in Prague said the two exhibitions "could not be spoken of in the same breath since the American was obviously the product of genuine artistic creative ability while the other portrayed 'popular state art.'"

Advancing American Art was equally well received in the West. In Port-au-Prince "the public streamed to see it," and one Cuban art critic said the show proved the United States "is able to contribute to the spiritual riches of man in general in the same way in which its machinery, its railroads, its refrigerators, and its radios have contributed to enrich and to make more comfortable the life of the common man."

Artistically and diplomatically, the show was a smashing success in both hemispheres. Back home, however, the political attacks against it were growing fiercer. Republicans were threatening to withhold the $31 million the Truman administration had requested for State Department information programs,

including Voice of America, as punishment for sending modern American art abroad. Clearly tiring of the controversy, Truman fired off a letter on April 2, 1947, to Assistant Secretary of State William Benton, the encyclopedia and Muzak maven who was LeRoy Davidson's boss:

> I don't pretend to be an artist or a judge of art, but I am of the opinion that so-called modern art is merely the vaporings of half-baked lazy people. An artistic production is one which shows infinite ability for taking pains and if any of these so-called modern paintings show any such infinite ability, I am very much mistaken.
>
> There are a great many American artists who still believe that the ability to make things look as they are is the first requisite of a great artist—they do not belong to the so-called modern school. There is no art at all in connection with the modernists, in my opinion.

Republicans continued to bash the program. "The paintings would not appear to have their roots in America but rather in the alien cultures, ideas, philosophies and sickness of Europe," said Representative Marion T. Bennett of Missouri. "They give the impression that America is a drab and ugly place, filled with drab and ugly people."

In early May, Secretary of State George Marshall pulled the plug on Advancing American Art. Appearing before a House committee, he told lawmakers the pictures would be recalled to Washington and auctioned off. The State Department was getting out of the modern art business. LeRoy Davidson would be dismissed, his position abolished. There would be no more government-funded exhibitions of modern art. "I know nothing about art," Marshall told the committee. "And when I find that something is said to be particularly good in modern art, I seldom can understand it at all."

"As far as future circus ladies go," he added, "that is a closed shop."

The Republican Congress still ended up slashing the State Department's budget for information programs to $10.8 million, less than half the amount the administration requested.

The State Department's total capitulation outraged many artists, critics, and museum directors. "Freedom of expression for artists is in danger," an editorial in the *Magazine of Art* said, "and although the present victims are exclusively modernists whom some people might feel more comfortable without,

the historic pattern of censorship guarantees no amnesty to academicians [i.e., academic painters] in the future."

LeRoy Davidson maintained a stoic silence throughout the ordeal, but his old boss at the Walker, Daniel Defenbacher, spoke out in a blistering letter to Secretary of State Marshall that reflected the views of many in the art world at the time:

> It is strange that a nation shouting freedom of political expression should turn dictatorial in its cultural activities.
>
> You, in reaction to protests of untutored and technically deficient laymen, have killed the most progressive governmental art project of our time. Your action is based on an arbitrary judgment of what art is and means. In making your decision you have evidently ignored the fact that the state department collection has received almost an ovation from the professional art world. Instead, you have permitted yourself to be influenced by sentimental, romantic and uneducated opinion.
>
> The most terrifying aspect of your decision is your disregard for freedom of expression. You have, in effect, decided that artists must create in bondage to preconceived ideas. It is not exactly immaterial that the preconceived ideas to which, by indirection, you have enslaved these artists are outdated, invalid and dehumanized.
>
> This is 1947. Intelligent creators whether in science, education or art cannot limit themselves to the ideology of 1847. In fact they cannot and must not limit themselves or be limited to any ideology. Progressive art is probably less understood than progressive science, but you must certainly know that without progressiveness either would become useless.

Even columnist Drew Pearson, who was nobody's idea of a radical, defended the canceled exhibition. "In all the sarcastic cross-examination of the State Department's art program," he wrote, "it is interesting that no Congressman ever bothered to inquire about the effectiveness of these art exhibits in building friendship abroad." Pearson also pointed out that President Truman— "who thinks no art after 1800 is really worth considering"—had recently spent

$10,000 in taxpayers' money for the *Peacemakers* painting, which Pearson said some critics considered an artistic atrocity.

Amid the controversy over Advancing American Art, Alfred Barr tried to convince Harry Truman of modern art's merits. In May 1947 Barr sent the president a book about modern art. The title has been lost to history; no evidence of it survives in either the Barr or Truman papers.* But Truman's response does. He was not impressed, and he replied to Barr with a letter that was characteristically blunt:

> I appreciated very much your note of the second enclosing me a book on modern painting. It is exceedingly interesting. I still get in almost the same frame of mind as after I have a nightmare when I look at these paintings.
>
> Some of them are all right—at least you can tell what the painter had in mind. Some of them are really the "ham and egg" style.
>
> I do appreciate highly your interest in trying to convert me to the modern viewpoint in art but I just can't appreciate it, much to my regret.

Soon after he was fired, LeRoy Davidson and his wife, Martha, left Washington. LeRoy went back to college. He earned a PhD in art history from Yale in 1951 and later became the head of the art department at UCLA. He specialized in Chinese and Indian art. His 1954 book, *The Lotus Sutra in Chinese Art: A Study in Buddhist Art to the Year 1000*, is still considered an important work in the field. Martha continued to work as an art critic and coedited *Arts of the United States*, a massive pictorial history of American art published in 1960. LeRoy died in 1980, Martha in 1993.

The works in the Advancing American Art exhibition were auctioned off in 1948. Considered government surplus, the pictures were sold at a steep discount. The rules of the auction stipulated that educational institutions were eligible for a 95 percent reduction in the amount of their winning bids. The collection was appraised at $80,000, but due to the bidding rules, the

* It may well have been Barr's book *What Is Modern Painting?*, the third edition of which had recently been published.

government collected just $5,544 for the works. An O'Keeffe fetched just $50. Republicans of course made much of this fact, saying it proved the pictures were worthless, while ignoring the fact that their appraised value had actually increased 60 percent since the State Department purchased them. The bulk of the pictures went to Alabama Polytechnic Institute (now Auburn University) and the University of Oklahoma. *Circus Girl Resting* went to Auburn for $100, and there she resides today.

Shortly before the auction, the artist at the center of the storm, Yasuo Kuniyoshi, addressed the controversy publicly for the first time. "The withdrawal of these paintings is most humiliating to American artists in the eyes of the world," he said at a meeting of artists and art dealers in New York. "The United States is the only major country in the world without a sponsored cultural program."

In 1952 Congress passed a law that finally allowed people born in Japan to become American citizens. Kuniyoshi requested an application for citizenship but died of cancer in May 1953, before he could submit it. He was sixty-three. On an estate tax form submitted to the IRS, his citizenship is listed as "Stateless, formerly Japanese."

William Benton left the State Department in September 1947. Benton would later call the Advancing American Art fiasco "the single worst mistake" in his tenure as assistant secretary of state. The problem, he said, was that the State Department had not anticipated the fierce opposition the exhibition received on Capitol Hill. "This particular exhibit is in fact indefensible, regardless of its impact abroad," he wrote in a memo. "Anything that upsets every member of Congress in this matter [manner?] is impracticable and indefensible."

In 1949 Benton's old business partner from his advertising days, Chester Bowles, who was now governor of Connecticut, appointed him to fill a vacant seat in the US Senate. Republican senator Raymond Baldwin resigned in December 1949 to take a seat on Connecticut's highest court. Bowles appointed Benton to replace him, and then Benton won a special election in 1950 to finish Baldwin's term, defeating the Republican nominee, Prescott Bush (father of George H. W. and grandfather of George W). Benton distinguished himself in the Senate as the archenemy of red-baiting senator Joseph McCarthy. In 1951 Benton introduced a resolution to expel McCarthy from the Senate. The resolution failed, and McCarthy made it a personal mission to keep Benton from getting reelected in 1952. McCarthy succeeded. President Kennedy later

appointed Benton ambassador to the UNESCO mission in Paris. Benton died in 1973. The art museum at the University of Connecticut is named in his honor.

Despite the furor over Advancing American Art, the executive branch did not give up on promoting modern art abroad. Enlisting help from MoMA and other museums, the Central Intelligence Agency launched a covert operation to stage exhibitions similar to Advancing American Art all over the world. Using a front called the Congress for Cultural Freedom, the agency heavily promoted modern painters, especially abstract impressionists. "The Central Intelligence Agency used American modern art—including the works of such artists as Jackson Pollock, Robert Motherwell, Willem de Kooning and Mark Rothko—as a weapon in the Cold War," the historian Frances Stonor Saunders writes. "In the manner of a Renaissance prince—except that it acted secretly—the CIA fostered and promoted American Abstract Expressionist painting around the world."

The secret program began in 1950, during the presidency of Harry Truman.

6 | STALWART REPUBLICAN

GEORGE ANTHONY DONDERO, THE man who would become modern art's scourge in the middle of the twentieth century, was born in December 1883, just five months before Harry Truman. Dondero and Truman had a lot in common, at least in their early lives. Both were born into meager circumstances, deeply involved in the Masons, and active in local politics. Both campaigned for good roads early in their political careers. But they would travel in very different ideological directions.

Dondero was born in Wayne County, Michigan, on the outskirts of Detroit, and grew up on a farm in neighboring Oakland County. His parents were immigrants. His father, Luigi (or Louis), was born in Genoa in 1838, and his mother, Caroline Truthern, was born in what is now eastern Germany in 1843. Luigi and Caroline met in Hartford, Connecticut, were married there in 1863, and moved to Michigan after the Civil War. George, the youngest of their four children, was exceptionally bright. An eleventh-grade report card shows him earning grades of 99 or 100 in every category except "Deport-ment," where his highest grade was 94. He was the president of his senior class at Royal Oak High. The graduation ceremony was held on the evening of Wednesday, June 17, 1903—the day after Henry Ford founded his motor company in nearby Detroit.

Dondero then spent four years teaching in one-room schoolhouses in Oak-land County, saving enough money to enroll in the Detroit College of Law. He graduated with a bachelor of law degree in 1910 and opened his own practice

in Royal Oak.* He identified himself as a "stalwart Republican" and launched his political career even before he finished law school, holding a string of offices in Royal Oak: clerk, treasurer, assessor, village attorney. When Royal Oak was incorporated as a city in 1921, he was elected its first mayor.

Dondero married Adele Roegner on June 28, 1913, six years to the day before Harry married Bess. George and Adele had three children, the youngest of whom, Robert Lincoln Dondero, born in 1923, was named after Abraham Lincoln's only surviving son, Robert Todd Lincoln. As the *Detroit Free Press* noted at the time, "Mayor Dondero is a deep student of Abraham Lincoln, and recently made a trip to Washington to visit Robert Todd Lincoln, surviving son of the great emancipator, that he might gather new material for his address at the Lincoln day banquet in Pontiac."

How George Dondero came to know Robert Lincoln so well is a mystery. Dondero was a small-town lawyer and local politician. Robert Todd Lincoln, in addition to being the son of a revered president, was also a former secretary of war, minister to the United Kingdom, and president of the Pullman Palace Car Company—as well as forty years Dondero's senior. In fact, Dondero ingratiated himself with several descendants of Lincoln, not just Robert. He also befriended Emilie Todd Helm, Mary Todd Lincoln's last surviving sister. And after Robert Todd Lincoln died in 1926, Dondero inserted himself into the life of Robert's grandson, Robert Todd Lincoln Beckwith. Known as Bob, Beckwith was the last direct descendant of the sixteenth president and a bit of a cad. In 1929, when he was twenty-five, Bob married Hazel Wilson, a widow in her early thirties with two children. Bob and Hazel never had children of their own. Bob was not a faithful husband, and in January 1963, Hazel wrote a letter to Dondero, telling him that Bob had left her for a younger woman. "As to Bob," she wrote, "this woman has him completely under her spell."

"Your letter saddened me," Dondero replied, "because I know you people so well; and the fame that attaches to Bob as one of the three living great-grandchildren of Lincoln makes it doubly sad to me."

Hazel died in 1966, and Bob married Annemarie Hoffman, a twenty-seven-year-old woman from Germany, the following year. In 1968 Hoffman gave birth

* At the time, many states permitted students who earned an undergraduate law degree (LLB) to sit for the bar exam. The LLB was phased out by the early 1970s. Now a graduate degree (JD) is required.

to a boy, but Bob denied paternity, claiming he'd had a vasectomy years prior. When Bob died in 1985, his obituaries mentioned that he was the last direct descendant of Abraham Lincoln, as neither of Robert Todd Lincoln's other two grandchildren, now deceased, had had children. But if Bob did father the boy born to Hoffman in 1968, the Lincoln line is still alive and well. (That boy, now a man in his fifties, has avoided public attention, and the question of his paternity has never been resolved conclusively.) Which is all to say the Lincoln family saga got pretty messy, and George Dondero managed to make himself a bit player in the drama. Through these connections, Dondero also acquired a considerable quantity of Lincoln memorabilia and established himself as a Lincoln scholar, "a recognized authority on the life of Lincoln" and "one of the most sought-after speakers for Lincoln Day celebrations throughout the country."

In 1932 Dondero, like his hero Lincoln, ran for Congress. (Abe served a single term in the House from 1847 to 1849.) The election was for Michigan's seventeenth district, a newly created district that encompassed all of Oakland County and the western edge of Detroit. It was not a great year to run as a stalwart Republican—the Democratic presidential candidate, Franklin Roosevelt, was elected to the White House with 57 percent of the popular vote that fall—but Dondero still managed to win his race with 52 percent of the vote. He would be reelected eleven more times, serving twenty-four consecutive years in the House, through the entirety of the Roosevelt and Truman administrations and Eisenhower's first term.*

Deeply conservative, Dondero voted against almost every New Deal program, and he came to be closely associated with the Reverend Charles Coughlin, the so-called Radio Priest and an important figure of the Far Right. Coughlin was a Roman Catholic priest who was assigned to a parish in Dondero's hometown of Royal Oak in 1926. He began broadcasting his sermons on the Detroit radio station WJR that same year. His folksy manner made him a popular personality, and by 1929 Coughlin's weekly *Golden Hour* was being carried on eighteen stations. In 1930 CBS picked up the program and Coughlin was reaching forty million listeners a week.

As the Depression deepened, Coughlin's sermons became more political. Coughlin supported FDR at first. "The New Deal is Christ's Deal," he told

* Due to redistricting, Dondero represented the eighteenth district for his final two terms.

his listeners. But after FDR recognized the Soviet Union in November 1933, Coughlin, who was vehemently anticommunist, turned on the president, calling him a "liar" and "betrayer." Coughlin supported Nazi Germany and fascist Italy as bulwarks against Communist Russia, and he was openly antisemitic. On Sunday, November 20, 1938—two weeks after the Nazis' Kristallnacht pogrom and a day that Christian and Jewish religious leaders in the United States had designated as a day of prayer for the victims of political persecution in Europe— Coughlin told his millions of listeners, "Nazism was conceived as a political defense mechanism against Communism and was ushered into existence as a result of Communism. And Communism itself was regarded by the rising generation of Germans as a product not of Russia but of a group of Jews who dominated the destinies of Russia." Two weeks later, on December 4, 1938, Coughlin asserted falsely that "Jewish International Bankers" had financed the Russian revolution and communism.

By 1939 CBS had dropped the program, and Coughlin was forced to pay stations to carry it. The following year, the National Association of Broadcasters adopted a code of conduct that prohibited stations from selling airtime "for presenting controversial issues," except at elections. The code also banned "attacks upon another's race or religion." This effectively ended Coughlin's broadcasting career, and he died in relative obscurity in Bloomfield Hills, Michigan, in October 1979 at the age of eighty-eight.

Although he attended a Methodist church, George Dondero found much to admire in the reactionary Catholic priest who lived in his district, especially his opposition to communism. The feeling was mutual.

In February 1936 two Roman Catholic members of the House, Patrick J. Boland of Pennsylvania and John J. O'Connor of New York, took to the floor to castigate Coughlin. Boland called Coughlin an "unprincipled, self-seeking demagogue, who would betray America as Judas betrayed the Redeemer for 30 pieces of silver." When the speeches ended, the *Detroit Free Press* noted, only three members failed to join the standing ovation. One of them was George Dondero.

Later that year, Coughlin saved Dondero's political career. The Depression was at its worst, and with Roosevelt running for a second term, all Republicans faced steep odds that fall. Dondero's Democratic opponent was Draper Allen, a popular businessman from Birmingham, Michigan. Coughlin quietly supported a third-party candidate, Maynard Seibert, to siphon votes away from Allen. It

worked. Dondero won 47.7 percent of the vote. Allen finished second with 46.6 percent. Seibert came in a distant third with 5.2 percent, but that was enough to keep Allen from winning, and Dondero was reelected.

Dondero and Coughlin, along with other Far Right figures such as the anti-immigration activist Walter Steele and the antisemitic evangelist Gerald Burton Winrod, believed FDR's progressive agenda was the first step toward establishing a communist dictatorship in the United States. Antisemitism and a sympathy for Hitler and Nazism animated them before the Second World War; a malignant hatred of communism and anything they perceived to be associated with it animated them after.

Tall, *gallant*, and *courtly* were words often used to describe George Dondero. The punctilious pol regularly lectured the House on matters of etiquette: no feet on desks, no smoking or reading of newspapers on the floor. And woe to any member who casually addressed another representative on the floor as "you" instead of the "gentleman (or gentlewoman) from" Some representatives called him the "Emily Post of the House." On Lincoln's birthday every year, he would read the Gettysburg Address and Lincoln's second inaugural to his colleagues. He was known for the consideration he showed his fellow members. He drove two colleagues, Joseph W. Martin (a future Speaker) and Clare Booth Luce, to his cousin's farm in Virginia one weekend because, he explained, "they are both lonely." He wasn't flashy and had no wish to be. He was the rare politician who didn't care

Congressman

GEORGE A. DONDERO

18th DISTRICT—OAKLAND COUNTY

FIGHT	Corruption in Government!
FIGHT	Wasteful Government Spending!
FIGHT	Communism at home and abroad!

VOTE DONDERO!
VOTE REPUBLICAN!

A George Dondero congressional campaign brochure, ca. 1950. *Burton Historical Collection, Detroit Public Library*

if his name was in the papers or not. His specialty was constituent services, helping people cut through government red tape to get emergency passports, ration cards, and the like. "Dondero fathers his constituents when they come to Washington, whether they be old folks or youngsters," read a 1942 profile of the congressman in the *Detroit Free Press*. "He frequently is seen herding groups of tourists through the halls of the Capitol, and don't think this isn't smart politics. He goes out of his way to give personal attention to the folks from his district, and there are 418,000 persons in that district."

At the Harry S. Truman Presidential Library & Museum, I found just one letter from Dondero to Truman, dated April 16, 1945, four days after Roosevelt died and Truman ascended to the presidency:

> My dear Mr. President:
> In your every effort for the vigorous prosecution of the war, you shall have my sincere and unstinted support.
>
> In your every effort to preserve representative government under our Constitution and our American way of life under it, our free institutions and free enterprise, I pledge you my enthusiastic support.
>
> In your every effort to establish economy in government and to protect the economic structure of the country, [and] the sovereignty of the States, you shall have my complete support.
>
> In short, in your every effort to preserve the United States of America, with freedom as it was handed down to us by our forebears, you can depend upon my full support.
>
> May a just God guide and direct you in leading America in this critical period, is my sincere prayer and hope.
> Most cordially,
> George A. Dondero, M.C.

The tone of the letter is vaguely threatening. Dondero seems to be saying, *If you do the things I want you to do, I will support you,* the implication of course being that Dondero's support was contingent upon the president's cooperation. The mention of the "sovereignty of the States" is especially glaring. By now Dondero had begun aligning himself more openly with conservative Southern Democrats such as Howard W. Smith of Virginia, who supported segregation.

Truman's reply to Dondero, dated nine days later, is as brief as it is generic:

My dear Mr. Dondero:
Your letter of April sixteenth assuring me of your full support in the days ahead gives me real strength and inspiration. I am more than grateful for these expressions of loyalty.
Very sincerely yours,
Harry S. Truman

In his later terms, Dondero served as either chair or ranking member on the powerful House Public Works Committee, and in this capacity he achieved his greatest legislative victory: passage of the bill that authorized construction of the St. Lawrence Seaway. I will spare readers a long sidebar on the seaway, but it really is one of the amazing feats of engineering in the twentieth century. Or any century, really. It connects the five Great Lakes to the Atlantic Ocean via a system of locks, canals, and shipping channels, mostly along the St. Lawrence River. The seaway opened the heart of North America to ocean shipping, connecting ports in Chicago, Detroit, Duluth, and Milwaukee to the rest of the world. Winning passage of the bill required a delicate political dance. Huge eastern seaports like Baltimore, Boston, New York, and Philadelphia bitterly opposed it, as did railroad and trucking interests. In a speech imploring his colleagues to support the measure, Dondero quoted Daniel Webster: "Let us develop the resources of our land. Call forth its power, build its institutions, promote all its great interests and see whether we, also, in our day and generation, may not perform something worthy to be remembered."

The bill authorizing the seaway's construction was called the Wiley-Dondero Act, after its principal sponsors in the Senate (Alexander Wiley of Wisconsin) and the House. Dondero sat at Eisenhower's elbow when the president signed it into law on May 13, 1954. The seaway opened in 1959. It cost about $460 million, of which the US government paid $130 million.

Until the Cold War, George Dondero seems to have expressed no interest in art whatsoever. Given the role he would play in future modern art controversies, Dondero was surprisingly quiet about the Advancing American Art controversy in 1947. I was unable to find his name mentioned in connection with the exhibition in the *Congressional Record*, Detroit area newspapers, or his personal papers at the Detroit Public Library. Maybe his new role as chair of the House Public Works Committee demanded too much of his time and attention. After all, he was trying to get the St. Lawrence Seaway built, surely

a time-consuming project. But he was clearly paying attention to the debate about modern art.

7 | GALLERY ON WHEELS

THE JANUARY 15, 1949, issue of the *Art Digest* carried a small item about an unusual art show scheduled to begin two days later at St. Albans Naval Hospital on Long Island. The Hospital Fine Arts Exhibition would comprise forty-four paintings mounted on "roller galleries" that could easily be moved into the wards of bedridden patients, many of whom were paralyzed by wounds suffered in the war. "Capt. William H. H. Turville, United States Navy, commanding officer of the hospital, feels that the patients will derive valuable educational and therapeutic benefits from the exhibit," the article explained. "He has great faith in the morale-building results derived through awakening a self-creative urge in his patients."

The exhibition was the brainchild of Henrietta Sharon Aument, a onetime "society gal" who became an advocate for American soldiers wounded in battle. Born Henrietta Bruce Sharon in 1910, she was the daughter of Frederic Sharon, a "real estate man" and past president of the Kansas City Chamber of Commerce, and Mary Bruce Sharon, who came from a wealthy Kentucky family. When she was five years old, Henrietta was stricken with spinal tuberculosis. For nearly three years she was unable to get out of bed. "She learned to draw, and found out she could draw quite well," a *Kansas City Star* profile later noted. "By the time she was permitted to get out of bed and learn to walk again, she had learned a lot about pluck, patience and sympathy for other people."

When she was in her teens, Henrietta moved with her family to Boston and came to be known as "Shary" (a diminutive of her surname). She was an active member of the Junior League of Boston and wrote occasional feature

stories for the *Boston Globe*. But her primary interest was volunteering. In 1942 Shary began visiting Lovell General Hospital at Fort Devens, about thirty miles northwest of Boston, where she would sketch portraits of the wounded soldiers, who would often send the pictures back home. "You aren't there to plumb his mental depths, take his temperature, pity him, or deluge him with good cheer," she explained of her project. "So he can relax. His ego is flattered and his pattern of monotony is broken. He has the sketch (it's his possession, and he has so few), good or bad—and he usually thinks it is good—to send home to his girl. It's a healing process. I've seen it work." She would complete five or six sketches an hour. "Most of them were bad sketches, but those boys—some of them too sick to sit up—were so grateful it didn't matter. It was the human contact that was important."

Shary recruited other artists and expanded the project to military hospitals in Boston and New York. Among those who volunteered for the project were some of the country's most famous illustrators, including Rube Goldberg and Al Hirschfeld. She also organized a writing program, the Author's Workshop for Veterans, persuading prominent editors and authors such as Frederick Lewis Allen, John Hersey, and Paul Gallico to speak to disabled veterans in military hospitals. The program encouraged returning servicemen to write about their experiences in war and launched many literary careers.

In October 1947 Shary married Carroll Miller Aument Jr., a twenty-five-year-old graduate of the Yale School of Art who had served as an ambulance driver for the American Field Service in Italy and North Africa during the war. Aument was an abstract artist and a teacher at a prep school in New York City, where the couple settled. Although the war was over, Shary Aument continued to volunteer in military hospitals, and in 1948 she conceived the idea for what came to be known as the Gallery on Wheels:

> The idea for an exhibition of paintings in a military hospital came from an invitation we extended to several ambulatory patients from St. Albans Naval Hospital to view some of my husband's paintings. To our surprise their reaction was enthusiastic. None of them, they said, had ever seen real paintings close to before. Going to a gallery or museum was, they explained, too much like work, and besides they hadn't expected to like or understand art. Now, however, they asked

why we didn't bring some pictures out to the hospital for others to look at.

So the idea began to take shape.

Aument said the exhibition would have both therapeutic and educational benefits. "Seeing paintings, talking with some of the artists and finding out how it was done, might, I thought, encourage some of the patients to experiment themselves with drawing, painting and so on," she wrote. "At the very least, the paintings would bring color and beauty into the monotonous anonymity of the hospital wards."

Shary began contacting artists in the New York area, inviting them to participate. Nineteen agreed to lend pictures, including some of the leading lights of contemporary painting in the United States at that time: Joseph Hirsch, Yasuo Kuniyoshi, Reginald Marsh, Sol Wilson. Seven of the artists also agreed to go to St. Albans to answer patients' questions about their pictures. Carroll designed the roller galleries, which were built in the hospital's workshop. The couple borrowed a station wagon from the Red Cross to drive around the city and collect the paintings from various galleries.

By all measures the show was a resounding success. Over its two-week run, around seven hundred ambulatory patients came to see the exhibition when it was set up in the hospital's library. Some two hundred bedridden patients saw it when it was rolled into their wards. One of the patients, paralyzed from the waist down, was inspired to become an artist himself. Shary arranged for him to be mentored by "one of the most prominent of the artists" in the exhibition. He told Shary and Carroll Aument the exhibition was "the greatest thing that ever happened to me." The exhibition received positive coverage in the press. "There was a party atmosphere in the ward when the Auments wheeled paintings in on mobile units," *Look* magazine noted in a two-page spread illustrated with five photographs. (Ironically, *Look* was the magazine that had vilified Advancing American Art two years earlier.) "Pictures, many by well-known artists, were taken to beds and explained. The men talk of them weeks afterward, ask constantly to see more."

Buoyed by the resounding success of the exhibition at St. Albans, Shary began making plans to take art into military hospitals nationwide. She hoped the venture would be supported with funding from the Veterans Administration, the Red Cross, and art groups including Artists Equity and the American

Federation of Arts. "We are firmly convinced that to possess the wholeness of life people need art and the reactions we encountered in the hospital reaffirmed our conviction that most people respond to art when they can be brought to look at it," Shary wrote. "As one patient in a T.B. ward told us, 'I didn't know art was like that. Hell! it's swell!'"

But George Dondero didn't think it was swell.

In 1949 Dondero was serving his ninth term in Congress. Apart from the St. Lawrence Seaway project, he had done little to distinguish himself nationally, but his attention to his constituents enabled him to keep getting reelected, usually by a comfortable margin. Dondero's name was unlikely to appear in Drew Pearson's political gossip column, or on the pages of the weekly newsmagazines, but he never much cared for self-promotion, which makes his assault on modern art all the more baffling. Did he truly believe, as he once said, that all modern art was communistic? Was he merely invoking hyperbole in what he believed to be a righteous cause? Or did he realize what he was saying was preposterous, even racist, but didn't care? We can never know the answers. We can only take him at his word, which appears time and again in the *Congressional Record*.

Somebody brought that small *Art Digest* item about Shary Aument's hospital art program to Dondero's attention—the congressman himself certainly wasn't a subscriber—and on March 11 he took to the House floor to execrate it. Dondero titled the speech "Communist Art in Government Hospitals."

"The Members of Congress should accept this basic truth," he said,

> that radical, left wing art cannot survive of itself. It does not have merit, and its creators do not have the real talent to cause sufficient demand for their product from the public. If they had to live on what they can earn from their work they would cease very soon to be a menace to some of our dearest traditions. The members of this left wing art movement are constantly scheming to get their hands on public funds, and even private philanthropies, in order to grow.

The latest example, Dondero said, was "this 'gallery-on-wheels' exhibit." By his calculation, of the seventeen participating artists named in the *Art Digest*, "nearly all are individuals of known radical affiliation." Nine of the seventeen,

he pointed out, had been included in the Advancing American Art exhibition—prima facie evidence of un-Americanism. Dondero read the names of the seventeen artists into the record, cataloguing the political errors of each (except two, Eugene Berman and Roberto Matta, of whom Dondero admitted, "I have no facts"). He painted people red with a broad brush. Most of the artists named had committed the sin of having their work "favorably reviewed" in *New Masses*, a left-wing magazine that was widely associated with the Communist Party of the United States of America (CPUSA). Six of the artists were guilty of signing a public letter of support for Henry Wallace, the Progressive Party candidate for president in 1948. How could it be considered a crime against the United States to support a legitimate presidential candidate whose name appeared on the ballot in forty-five of the forty-eight states and who received more than 1.1 million votes? It couldn't, of course, but the United States was entering a dark period when simply refusing to condemn the Soviet Union—a US ally in the recent war—could be considered treasonous. "Our platform called for an end to racial discrimination and supported antilynching and antisegregation legislation," wrote Wallace's running mate on the Progressive Party ticket, Democratic senator Glen Hearst Taylor of Idaho, a former singing cowboy and future hairpiece entrepreneur. "Voting rights for eighteen-year-olds was also promised. We advocated a national health insurance program, a one-hundred-dollar-a-month old age pension, an increase in the minimum wage to one dollar an hour, and repeal of the recently enacted peacetime draft. Boy, we were a radical outfit!"

The CPUSA endorsed the Wallace-Taylor ticket, an endorsement that surely ranks as one of the least helpful in American history, and many members of the CPUSA worked on their campaign. The full extent of communist influence on the Progressive Party is still debated today, but the fact that Wallace and Taylor, a former US vice president and a sitting US senator, were labeled communists by both major party candidates, Harry Truman and Thomas Dewey, as well as many newspapers, resulted in public opinion turning against them. A Gallup poll in July 1948 found that 51 percent of those polled believed the Progressive Party was dominated by communists.

Dondero condemned supposed communists with impunity, hunting imaginary witches while protected by the cloak of congressional immunity. Members of Congress cannot be held liable for their comments on the House and Senate floors. None of Dondero's targets were permitted to rebut the charges in

a forum equivalent to the US House of Representatives. Dondero insinuated that the artists in the Gallery on Wheels could be spies. "I do know that these individuals—radicals all—spending two weeks in an important naval hospital explaining their theories to an audience who could not get away from them, had a great opportunity not only to spread their propaganda, but to engage in espionage, if they were inclined to do so," the congressman said. "Furthermore, I cannot for one minute believe that they devoted all this time and energy as a pure philanthropy, and I would like to know how much they were paid, and by whom they were paid to put across this propaganda undertaking in a government institution."

Of course it was a pure philanthropy. Apart from donated supplies and that station wagon borrowed from the Red Cross, Shary wrote, "We operated the show alone—without committees, organizations, sponsors, or money to cover the expenses." Implicated by association in Dondero's attack was Shary Aument herself, but this daughter of a Kansas City Chamber of Commerce president was certainly no commie. She'd once written an article for the *Junior League Magazine* titled "Russia's War with God!" "There was no romance in the Russian revolution," she wrote, "it was grim and sordid."

When Dondero finished his speech, his Republican colleague, Gordon Canfield of New Jersey, rose to speak.

> CANFIELD: Mr. Speaker, will the gentleman yield?
> DONDERO: I yield.
> CANFIELD: Does the gentleman know, perchance, that one of those pictures was a picture of a red herring?
> DONDERO: I am not too familiar with the subject of red herrings.

Canfield belonged to that now-extinct species known as *Liberalis republicanus*. He would vote in favor of the Civil Rights Acts of 1957 and 1960. A number of liberal Republicans would rise to modern art's defense in the following years, most notably Nelson Rockefeller, whose mother, Abby Aldrich Rockefeller, was one of the three Adamantine Ladies who founded the Museum of Modern Art. Nelson himself was on MoMA's board of directors from 1932 until his death in 1979.

Another Republican congressman who spoke out against Dondero was Jacob Javits of New York. Javits, who went on to serve four terms in the Senate

(1957–1981), supported civil rights and labor unions and would oppose the war in Vietnam. "Certainly the art exhibits [in military hospitals] can serve an excellent purpose and should be continued," he said. "This can be done without lending them to political propaganda, but without art censorship." On April 29, 1949, Javits placed into the congressional record a letter from a group of St. Albans patients. "We can truthfully say that most of the fellows who saw the show were very interested in the paintings and found that once they were explained, they were also very educational," the patients wrote. "At no time did any of the artists try to inject any kind of communistic propaganda."

But the damage had been done. Dondero's speech garnered plenty of headlines—U.S. Sponsors Leftist Painting Exhibits, Dondero Alleges; Charges "Pink" Painters Smear U.S. in Art Talks; Left Wing Art on Tour Again—and effectively killed the Gallery on Wheels program, thereby ensuring that soldiers who had survived being wounded in battle would not be exposed to the horrors of modern art.

Gallery on Wheels was dead, but Dondero was just getting started. Two months later, on May 17, 1949, he delivered another broadside. The speech ("Communism in the Heart of American Art—What to Do About It") centered on the ACA Gallery in New York, which was "a spearhead of radical influence," according to Dondero.

> ACA stands for American Contemporary Art. I might go so far as to say that not only is the word *contemporary* stolen and misapplied, but so are the other two words, in that this so-called art is no more American than it is Russian; it is no more contemporary in the true sense than smallpox, cancer, and bubonic plague are contemporary. It just happens that the human race is afflicted with such ailments in our present day. I might say further that it is not art in its true sense. It signifies a caricature of art, art that is abortive, that is distorted, and that is repulsive. The word *contemporary* has been stolen, as the word *modern* has been stolen, by the same Marxist advocates, but it would be truer to say that the art of the Communist and the Marxist is the art of perversion, just as communism itself is political perversion, and as depravity is moral perversion. God forbid that I should admit or charge for one instant that the great throng of illustrious, competent,

distinguished, patriotic American artists, modern and contemporary in the true sense of the word, are afflicted with this Marxist disease of art perversion.

On he went for more than ten thousand words, listing the names of the artists whose work the gallery had shown and their supposed links to communism. Toward the end of the speech, however, Dondero veered off in a new direction: he criticized the critics who had had the audacity to review ACA shows favorably. He named nine newspapers and magazines that had published positive reviews of six shows at the gallery in 1945, including the *New York Times, New York Herald Tribune, New York Sun, New Yorker, Art News*, and *Art Digest*. He singled out the *New York World-Telegram* for special animadversion. "It is an amazing condition," he said, "to discover that the *World-Telegram*, which has fought communism and Communist infiltration in an outstanding manner, to win the applause of the entire nation, gave not one single review . . . which was in any degree unfavorable; in fact, the publicity varied from favorable to very favorable."

> It is not my purpose to suggest that newspapers should clap censorship on their art critics, but I do say that, if this condition of overemphasis and an attempt to glorify the vulgar, distorted, and the perverted has come about due to neglect of proper supervision, then it is high time that some of our newspapers start cleaning house in the smaller compartments of their organizations.

This was an explicit call for newspapers to fire critics who reviewed modern art favorably. And at least one obliged. Shortly after Dondero's speech, the owner of the *World-Telegram*, Roy Howard, summoned the paper's art critic, Emily Genauer, to his office. Howard ordered Genauer to stop writing about modern art. Genauer refused and resigned on the spot. Then she asked if she could borrow Howard's phone to make a call. She dialed the editor of one of the *World-Telegram*'s fiercest rivals, the *Herald Tribune*, who immediately offered her a job.

Emily Genauer was not a critic to be trifled with. Born in 1911 in Staten Island, she began writing for the *New York World* when she was just eighteen. When the *World* merged with the *Telegram* in 1931, Genauer was one of the

few lucky *World* employees to keep her job. In 1932 she was named the paper's art critic. Her love of art came from her father, who owned several delicatessens but was also an avid sculptor. Although the *World-Telegram* was a conservative paper, Genauer was toiling in one of the organization's "smaller compartments" and worked largely undisturbed until Dondero painted her pink.

In June 1949 Genauer went to Washington to interview the man who'd gotten her fired. She recounted her encounter with Dondero in an article for *Harper's Magazine* titled "Still Life with Red Herring."

> It seemed to me that to understand what the Congressman really had in mind it would be a good idea to talk with him about his ideas about art, and I was granted an interview with him in Washington in June. "Modern art," he told me, "is communistic because it is distorted and ugly, because it does not glorify our beautiful country, our cheerful and smiling people, and our great material progress. Art which does not portray our beautiful country in plain, simple terms that everyone can understand breeds dissatisfaction. It is therefore opposed to our government, and those who create and promote it are our enemies."

Genauer said Dondero told her, "It is up to the art critics to police the painters," to ensure they are loyal Americans. When Genauer asked how it would be possible for critics to "keep tabs on the political ideas of the hundreds of artists who exhibit each year," Dondero suggested they keep lists of the artists who were in the Advancing American Art and Gallery on Wheels shows. There was also a handy booklet published by

Emily Genauer. *Lucy Roche*

the government listing all organizations and publications that were "communist or [a] communist front."

George Dondero's hatred of modern art was visceral, almost pathological. Why? Why did this erudite and proper man from Middle America so despise pictures that did not "glorify our beautiful country"? It was a question that Genauer was unable to answer. "What lies behind the Congressman's attack on art is largely a matter of supposition," she wrote.

> He does not pretend to be an art expert, and yet many of his statements have the flavor of someone who has either spent a good deal of time looking at pictures or has been carefully briefed. The Congressman admits he rarely goes into a museum or an art gallery. He also admits that his interest in the whole question was aroused by groups of artists and by individuals who are fearful, or profess to be fearful, of the politically subversive quality of modern painting.

One of those groups of artists was the American Artists Professional League, the same group that led the protest against the Advancing American Art exhibition.

After Genauer's article was published, Dondero was furious. He wrote *Harper's* a long letter—Dondero was incurably verbose—but when the magazine refused to publish it in its entirety, he entered it into the *Congressional Record* instead. In the letter, Dondero claims that he was misquoted but never gives a direct example. Instead, he attacks Genauer. "She has distorted before, and she distorts further in the article you have published," Dondero writes, "but there is nothing remarkable about this, because distortion, ridicule, and the warping of values is typical of the art, the so-called modern and contemporary art, which Miss Genauer has so persistently championed and promoted in her literary work." ("Miss Genauer" had in fact been married to Frederick Gash, a business executive, for twenty-three years, though she never changed her byline.)

On Tuesday, August 16, 1949, Dondero delivered his third major address attacking modern art. "Modern Art Shackled to Communism" was the congressman at his most unhinged, declaiming for thirty minutes, often in terms similar to those Hitler had used to describe modern art. Artists who created modern art, Dondero said, were "termites" and "vermin," "destroy[ing] the

high standards and priceless traditions of academic art," and promoting "the isms of depravity, decadence, and destruction."

"I call the roll of infamy without claim that my list is all-inclusive: dadaism, futurism, constructionism, suprematism, cubism, expressionism, surrealism, and abstractionism," the congressman continued.

> Cubism aims to destroy by designed disorder.
>
> Futurism aims to destroy by the machine myth. The futur- ist leader, Marinetti, said: "Man has no more significance than a stone."
>
> Dadaism aims to destroy by ridicule.
>
> Expressionism aims to destroy by aping the primitive and insane. Klee, one of its three founders, went to the insane asylums for inspiration.
>
> Abstractionism aims to destroy by the creation of brainstorms.
>
> Surrealism aims to destroy by the denial of reason.

For the first time, Dondero's charges elicited a sustained counterattack. On August 23 Jacob Javits took to the House floor to rebut Dondero. "My colleague's personal opinion of modern art is his privilege, but my colleague's suggestion that it should all be lumped together and discredited—perhaps sup- pressed—because he believes it is being used by some—even many—artists to infiltrate Communist ideas is a very dangerous use of the word *communism*," Javits said. "The very point which distinguishes our form of free expression from communism is the fact that modern art can live and flourish here with- out state authority or censorship and be accepted by Americans who think well of it."

Newspapers began to editorialize in support of modern art. "These new critics of modernism brand Picasso's art as Communist, when as far back as 1945 his art was denounced by the Moscow press and has been blacklisted by the Italian communists," art critic Howard Devree wrote in the *New York Times*. "Is it just possible that the word 'Communist' has been so generally employed in polemics, to indicate anything that the speaker dislikes at the moment, that it has begun to lose its meaning?" The *Des Moines Tribune* reprinted an article that had appeared in a Soviet journal the previous January:

> The year 1949 must be a year of further struggle by all the creative Soviet intellectuals in carrying out the decisions of the Party's Central Committee on ideological questions. They must go further still to uproot formalism, modernism, and other harmful bourgeois influences, and to confirm the principles of socialist realism in artistic creation and criticism.

If George Dondero were capable of appreciating irony, these replies might have made an impression.

But he wasn't.

Three years later, on March 17, 1952, Dondero aimed his wrath at museums. In this forty-five-minute speech ("Communist Conspiracy in Art Threatens American Museums"), the gentleman from Michigan claimed without evidence that museums that promoted modern art were part of a conspiracy to destroy the United States from within. "At a time when our nation needs positive artistic expressions of true American ideals and aims, we are flooded with a horde of determined leftists parading as artists who are in fact cultural saboteurs." Dondero outlined a convoluted conspiracy that led directly from a meeting of communist artists and writers in Kharkiv, USSR, in 1930 to Artists Equity Association, a New York–based group that he claimed was "a communist front," to American museums whose collections included works by members of AEA, including the Met and MoMA. Communist artists were infiltrating American museums to destroy the republic from within. It was a "Marxist cultural conspiracy," and art museums were the "cat's-paws of Reds." Wild stuff! And how, precisely, were communists using art to indoctrinate guileless Americans? "In every single picture they paint contained somewhere in it is the symbol of this foreign ideology," Dondero explained, "and they are trying to create the impression amongst the American people that our legitimate art as you and I have always understood it has been supplanted by this new form. In my opinion it is just a lot of senseless slush."

"A lot of senseless slush" could also describe Dondero's argument. Alfred Barr, MoMA's founding director, who had seen firsthand the Nazis' attacks on modern art in the preceding decade, had held his tongue long enough. Dondero's assault on American museums demanded a response, and in December 1952 he published a long article in the *New York Times Magazine* pointing out once again that modern art had been demonized and outlawed in both

Communist Russia and Nazi Germany. Barr wrote that it was "obvious that those who equate modern art with totalitarianism are ignorant of the facts."

> To call modern art communistic is bizarre as well as very damaging to modern artists; yet it is an accusation frequently made. Most people are merely expressing a common dislike by means of a common prejudice. But this is a point of view which is encouraged by the more reckless and resentful academic artists and their political mouthpieces in Congress and elsewhere.

8 | THE PATRIOTIC COUNCIL

ON JANUARY 31, 1956, about 150 people gathered inside the auditorium of the Highland Park, Texas, town hall. The lovely Spanish colonial–style building had been designed by two immigrants, Otto H. Lang and Frank O. Witchell, whose Dallas architectural firm built some of the most prominent buildings in Texas in the first three decades of the twentieth century. The purpose of the gathering on that cool Tuesday evening was ostensibly a discussion about art—though, in fact, it was really a discussion against art.

The event was organized by the Dallas County Patriotic Council, a loose confederation of some sixteen civic groups, including local chapters of the American Legion, Daughters of the American Revolution, and Veterans of Foreign Wars. All the groups shared a belief that communism was an existential threat to the United States—and to North Texas in particular. The immediate focus of the Patriotic Council's attention—and the subject of that evening's meeting—was an exhibition called *Sport in Art* that was scheduled to open in two months at the Dallas Museum of Fine Arts, a publicly funded institution under the auspices of the county parks board. Four artists whose work would appear in the exhibition were, according to the Patriotic Council, "Communists or members of Communist-front organizations." The artists were Leon Kroll, Yasuo Kuniyoshi, Ben Shahn, and William Zorach. Their pictures depicted, respectively, a winter scene, ice skaters, a baseball game, and an old man fishing. All were, according to the *Washington Post*, "among the most distinguished of contemporary American painters," though all save Kroll were born abroad and all but Kuniyoshi were Jewish.

"In fact, of course, none of the artists in question has ever been proved to be a Communist," the art critic Aline B. Saarinen noted in the *New York Times*; "none has refused to answer questions of a congressional committee."

Sport in Art was in reality an anodyne collection of more than a hundred paintings and drawings depicting sport, broadly defined. American stalwarts such as Thomas Eakins and Winslow Homer were included. It was a traveling exhibition sponsored by *Sports Illustrated*, which was owned by Time Inc., which was owned by Henry R. Luce, whose conservative bona fides were unimpeachable. *Sport in Art* had already appeared at museums in Boston, Washington, and Louisville to positive reviews and no controversy, and the US State Department planned to send the exhibition on a tour of Australia that fall to coincide with the Summer Olympics taking place there (owing to the austral seasons, the 1956 Summer Games were held from November 22 to December 8).

But as far as the Dallas County Patriotic Council was concerned, *Sport in Art* was nothing less than an attempt to "brainwash and create public attitudes that are soft toward communism," and modern art was part of an international conspiracy to destroy "traditional Western culture" and install a one-world government controlled by Marxists and Jews. John O. Beaty, a Southern Methodist University professor whose wife was the president of the Matheon Club, one of the groups that comprised the Dallas County Patriotic Council, laid out one version of the theory in his 1951 book *The Iron Curtain over America*. Beaty's theory, which is as convoluted as it is cockamamie, posits that the descendants of Russian Jews had taken control of the Democratic Party and manipulated to their advantage global events from the Bolshevik Revolution to the Korean War. Even a reviewer for the strenuously conservative *Chicago Tribune* called it "a rambling, disjointed book, in which sound points of criticism of the foreign policy of the Roosevelt and Truman administrations are obscured and vitiated by the author's violent prejudice against aliens in general and Jews in particular." The Anti-Defamation League described Beaty as "an 'intellectual' peddler of bigotry" and his book as "one of the most viciously anti-Semitic publications to appear in years." *The Iron Curtain over America* was a bestseller and went through fourteen editions.

The origins of the Dallas County Patriotic Council are murky, but it appears the organization's leader was Alvin Mansfield Owsley, a sixty-eight-year-old native Texan, corporate lawyer, and First World War veteran. Owsley

was a conservative Democrat whose noteworthy oratorial skills were put to use in support of Franklin Roosevelt's first two presidential campaigns. For this, Owsley was rewarded with ambassadorships to Romania (1933–35), Ireland (1935–37), and Denmark (1937–39). When FDR announced he would run for an unprecedented third term, however, Owsley bolted the party and campaigned for Wendell Willkie in 1940. For this, he was rewarded with a job in his father-in-law's glass factory in Muncie, Indiana. In 1944 Owsley moved to Dallas, where he became active in that city's notorious Far Right fringe and frequently appeared as a guest on local radio and television programs, becoming a minor local celebrity.

Alvin Mansfield Owsley. *Library of Congress*

Owsley was the featured speaker in the auditorium at the Highland Park town hall on that Tuesday night. "The Reds are moving in upon us," he warned darkly as the crowd cheered and pumped their fists. "The works of the Red hand and the black heart hating America do not deserve to be exhibited to our citizenship." Artistic considerations meant nothing. Censorship was a small price to pay to save North Texas from communism. "Let those who would paint a Red picture supplant it with the Red, White and Blue," he concluded to thunderous applause. "White for purity, blue for fidelity as blue as our Texas bluebonnets."

The Patriotic Council waged an intense campaign of public pressure to force the museum to remove the offending pictures. Supporters badgered elected officials and slipped leaflets under the windshield wipers of cars parked in the museum's lot. "Your tax money is going through the Park Board to the museum for the aid, comfort, and prestige of your enemies," the leaflet read. "Don't you think it's time to cut off Park Board funds from the Dallas Museum of Fine(?) Arts?"

The museum's trustees, known as the Dallas Art Association, resisted the pressure and rejected the Patriotic Council's demands. The *Sport in Art* exhibition would proceed as planned, including the pieces by the four artists targeted by the group. The trustees pointed out that *Sports Illustrated* had "cleared the four accused artists of any known communistic activities." In a letter to the *New York Times*, trustees Jerome K. Crossman, Gerald C. Mann, and Waldo Stewart explained:

> The fundamental issue at stake is that of Freedom and Liberty—not just for the Dallas Museum of Fine Arts, but eventually for our school system, our free press, our library, our orchestra, and the many other institutions of our society. We believe that democracy cannot survive if subjected to book-burning, thought control, condemnation without trial, proclamation of guilt by association—the very techniques of the Communist and fascist regimes.

The museum's stand was lauded by liberals as a victory for free speech. "The courageous stand of the Dallas Art Association is of benefit not only to the Texas museum," Aline B. Saarinen wrote, "but also for every other cultural institution and for every creative person in the land."

But the liberals' joy was short lived. Just three months later, in May 1956, the State Department abruptly announced that it was canceling the *Sport in Art* tour of Australia, citing "budgetary considerations"—but everybody knew the real reason. When a reporter asked a State Department spokesman if the Dallas controversy had anything to do with the cancellation, the spokesman replied, "No comment."

"The patriots saved our allies, the Australians, and others from seeing Communist inspired pictures of ball games, children playing, skaters, fishermen, boxers, horse racing and other subversion," Jonathan Marshall, the editor of the *Art Digest*'s successor *Arts Magazine*, noted wryly.

"It may not be unpatriotic to point out that this sort of episode makes foreigners laugh at us," the *New York Times* editorialized, "and even when we are laughed at by people unfortunate and unwise enough to be foreigners, still the laughter hurts."

Congressman George Dondero, however, was triumphant—practically giddy. In a speech on the House floor on June 14, the congressman from Royal Oak heaped praise on the "alert" and "well-informed citizens" of the Dallas County Patriotic Council and scorn on the "so-called liberal press," the "slick-magazine press," and "the left culture bund." Dondero continued to insist the four artists were communists, and he mocked the Time corporation's finding to the contrary. "It is an outrage that the loyal citizens of Dallas in the Dallas County Patriotic Council should be subject to nationwide vituperation and ridicule as a result of a valueless, so-called clearance initiating from *Sports Illustrated*, of Time Inc."

After the Dallas kerfuffle, William Zorach lost a $124,755 commission to create three huge sculptured panels for the exterior of the new Bank of the Southwest headquarters in downtown Houston (the bank said the panels were "too modern"). Zorach, who was born in Lithuania but immigrated to Cleveland with his family when he was a small boy and now lived much of the year on the Maine coast, responded by hiring a lawyer. Employing one of the favorite tactics of capitalists, Zorach sued the bank for breach of contract. He was awarded $56,515.

In November 1956 the Dallas Public Library put on a small display of textiles and paintings by contemporary artists that included two works by Picasso: a painting and a rug he designed. Soon after the exhibition opened, the library was inundated with telephone calls complaining about the inclusion

of Picasso's works, a campaign no doubt orchestrated by the Dallas County Patriotic Council. Library officials quietly removed the two Picassos from the display. "We just took the Picasso rug and picture down rather than stir up a lot of controversy," city librarian James Meeks explained to a reporter. "It is not that we surrender in principle. We just don't think it worth the effort to go through a siege of petitions, board meetings and periods of tension at this stage of the library's organization and development."

That fall, George Dondero, a son of immigrants, who had risen to the highest levels of government, announced he would not be running for reelection after serving twelve consecutive terms in the House. But his obloquy of modern art would not abate, even in retirement. In March 1957 Dondero delivered what amounted to his valedictory as the keynote speaker at the annual meeting of the American Artists Professional League, the group that had organized the protests against the Advancing American Art exhibition a decade earlier.

> The practice of sending abroad secondhand radical destructive art manifestations and works by Communists and Communist-fronters as examples of American art and culture to combat Communism's cultural offensive abroad is absurd. This is just the way the Soviets would like it, "Heads, I win. Tails, you lose." But it is not the way Americans like it. Dallas, Texas, proved that. And the legitimate American Artists back them up.
>
> In my opinion, until our government and also certain interests using the prestige of our government as a front desist in their efforts to mislabel as American Art the moth-eaten relics of cultural bolshevism and their imitations, we will continue to be defeated in our purpose of putting our best aesthetic foot forward.

George Dondero, once one of the most powerful members of Congress, died in 1968. Outside of his descendants (several of whom I attempted to contact but was unable to reach), Dondero is little remembered today. A canal along the St. Lawrence Seaway in Upstate New York is named in his honor. A high school in Royal Oak, Michigan, was named after him, but due to declining enrollment it was consolidated with another high school in the city in 2007, and the new merged school is named simply Royal Oak High School.

But a restaurant owner in Salina, Kansas, knows who George Dondero was, and he doesn't like him. Duane Billings says Dondero stole a valuable heirloom from his family in the 1930s, and he wants it back. The heirloom is a letter Billings's great-grandmother, Grace Bedell, wrote to Abraham Lincoln in 1860, when she was eleven years old. It's a rather famous letter: little Grace tells Abe, "If you let your whiskers grow . . . you would look a great deal better for your face is so thin." Lincoln followed Grace's advice, of course, and the rest is history. The letter stayed in the Lincoln family, and after Robert Todd Lincoln died in 1926, his widow, Mary Harlan Lincoln, asked George Dondero to track down Grace Bedell and return the letter to her. It took some searching, but in the early 1930s Dondero found Grace, now an old woman known as Grace Billings, living in Delphos, Kansas. Dondero went there with the letter. What happened next is in dispute. Dondero said Grace let him keep the letter "for posterity." In a speech on the House floor on February 12, 1934—Lincoln's birthday—Dondero said, "From the hand of Mrs. Robert Todd Lincoln, he who relates this story received that letter to be returned to Grace Bedell, who wrote it, and through her generous act it has become my sacred possession." Dondero's version of events was codified in the *Congressional Record*.

But Duane Billings says his father, who was raised by Grace, told him Dondero actually stole the letter. I spoke with him at his restaurant in downtown Salina, the Scheme, which claims to sell "the best pizza in the universe" (and it might be). We sat at a table under a mounted buffalo head. "Dondero bowed unctuously and talked directly into Grace and [her husband] George's ears," Duane told me. "George didn't like him right away. Dondero stayed for three days, then left with the letter when Grace was out. He gave that little speech in Congress to cover his ass." Duane says Grace was distraught after Dondero left and "cried for days."

"He was a crook, a terrible crook," Duane says of Dondero. "A crook of the highest order."

After George Dondero died, his son Robert Lincoln Dondero donated the letter to the Detroit Public Library. Valued at between $100,000 and $500,000, the letter is kept inside a vault and is rarely removed for public viewing. Duane Billings has asked the library to return the letter to his family. In December 2022, a library spokesperson said, "The Library does not have any comment or statement on the matter."

PART III

HARRY TRUMAN'S EUROPEAN ADVENTURE

9 | SAM AND DOROTHY

BY 1958 HARRY AND Bess Truman had been out of the White House for five years and had settled into a comfortable, if modest, retirement in Independence, Missouri. The Truman Library had opened the previous summer, marking the culmination of Truman's immediate postpresidential ambitions. Now Harry's days were more relaxed. When the weather was nice, he would walk the mile or so from his and Bess's big house on North Delaware Street to the library, a low-slung white building where he kept an office and delighted visitors by popping into the museum to answer their questions and surprised callers by occasionally picking up the phone himself. Bess, meanwhile, was content to stay home and read her beloved mysteries and listen to Kansas City A's ballgames on the radio.*

When he first left the presidency, Harry imagined he and Bess would simply slip back into civilian life without missing a beat, like the Roman general Cincinnatus returning to his farm. Hours after Eisenhower was sworn in on January 20, 1953, the couple boarded a train at Union Station and traveled back to Missouri by themselves. When the train made a brief stopover the next morning—in Cincinnati, as it happened—Harry got off and waited in line at the station's newsstand to buy the morning papers, just like the other passengers. When a newspaper photographer on the platform addressed him

* The Trumans' lives after the White House are well described in Hamby, *Man of the People*, and McCullough, *Truman*. Truman himself wrote about his postpresidential life in *Mr. Citizen*.

as Mr. President, Truman corrected him. "It's not 'Mr. President' anymore," he explained. "It's just plain Harry Truman."

But a cross-country car trip the couple took a few months later disabused Truman of the notion that he and Bess could travel around the country like ordinary Americans. Driving from Independence to New York and back again, the former president and first lady were swarmed by crowds seeking hand-shakes and autographs everywhere they went; in roadside diners they struggled just to finish their meals in peace. As Truman later confessed in a letter to a friend, it was impossible for him and Bess "to get from under that awful glare that shines on the White House."

Indigency, at least, was no longer a worry. For the first time in their thirty-nine years of marriage, Harry and Bess Truman were financially secure. Although Harry's only regular income was his army pension for service in the First World War ($111.96 a month), a book deal had recently netted him about $200,000, though he would later say he ultimately realized just a small fraction of that amount after paying an army of researchers and ghostwriters. More important, Congress was considering a presidential pension bill that offered the prospect of permanent financial security.*

Flush with a bit of cash in early 1958, the Trumans decided to splurge and do something that many retired couples still do today: go on a summer cruise. They would sail to Europe, where it might be a little easier to escape the "awful glare." The couple had been there just two years earlier, but that was a valedictory tour filled with speeches and honorary degrees and official engagements: an audience with the pope, lunch with Queen Elizabeth. This would be a purely private affair, a pleasure cruise. And what fun is a cruise without friends?

So the Trumans invited Sam and Dorothy Rosenman to accompany them.

Samuel Irving Rosenman was born in San Antonio, Texas, on February 13, 1896, the youngest of Solomon and Ethel Rosenman's five children and the only one to be born in the United States. The parents and the four older children had fled Kobryn, a city that was then part of Russia but is now part of Belarus, in 1894 to escape antisemitic violence. In 1905, when Sam was

* Dwight Eisenhower would sign the first presidential pension act into law on August 25, 1958. It provided former presidents with an annual pension of $25,000, as well as $50,000 for office expenses and free postage.

nine, the family moved to New York City, where Solomon found work in the garment industry. Sam was an excellent student, graduating from high school at sixteen and Columbia University, where he was a standout on the debate team, at nineteen. After serving a year stateside in the army during the First World War, he returned to Columbia for law school, graduated in 1920, and the following year, at just twenty-five, ran for a seat in the New York State Assembly as a Democrat and won. One of his campaign volunteers was a young woman named Dorothy Reuben, a politically active Montessori school teacher whom he would marry in 1924.

After serving five one-year terms in the state legislature, Sam declined to run for a sixth. Instead, he accepted an appointment to the state Legislative Bill Drafting Commission, which helped lawmakers write the bills they introduced.

Sam Rosenman. *Author's collection*

This necessarily brought him into close contact with the governor, Al Smith, and Smith's young protégé, Franklin Roosevelt. In 1928 Smith ran for president, and Roosevelt ran to replace him as governor. "Roosevelt, recognizing that he was not adequately familiar with the details of the recent legislative history of both parties in New York State, asked Maurice Bloch, his campaign manager and the Democratic leader in the Assembly, to find someone to go with him on his campaign trip who could give him such information, and also help him in the preparation of his campaign speeches," Sam recalled. "Bloch suggested me." So began Sam's long association with Roosevelt.

After Roosevelt won, he appointed Sam governor's counsel, and the two men became so close that Sam eventually moved into the governor's mansion in Albany. When Roosevelt won the Democratic presidential nomination in 1932, Sam drafted the acceptance speech for the Democratic convention in Chicago, the speech in which FDR pledged "a New Deal for the American people."

Sam will forever be known as the man who gave the New Deal its name, though the enduring popularity of the phrase mystified him. "I have often tried to find reasons why those two simple words became so quickly and so universally symbolic of the great program of social revolution which was ushered in by President Roosevelt," he wrote. "I have never been able to do so to my own satisfaction. It was simply one of those phrases that catch public fancy and survive—short, concise, and yet comprehensive enough to cover a great many different concepts." Sam was appointed to the New York State Supreme Court in 1936 but continued to advise Roosevelt as a member of the president's vaunted Brain Trust. In 1943 he stepped down from the court to become Roosevelt's White House counsel.

Dorothy Rosenman, meanwhile, embarked on a noteworthy career of her own as an advocate for affordable housing. "My husband said to me after our second son was born, 'You'd better find something to do or you will get very bored with life,'" she told an interviewer in 1976. "So it was that sort of a relationship that we had with each other, delighting in the fact that each of us was doing something." Dorothy was a pioneer in the settlement movement, which provided housing and social services for immigrant families. During the Second World War she served as chair of the National Committee on Housing, providing accommodations for workers in essential war industries, and in 1945 she published a book, *A Million Homes a Year*, which addressed the critical need for housing in the postwar United States.

Dorothy Rosenman. *Author's collection*

When Harry Truman became president in April 1945, he asked Sam Rosenman to stay on as White House counsel. Sam frequently traveled with Truman, and the two men became quite close—much closer, Sam recalled, than he and Truman's predecessor had been:

> With Roosevelt, you could never forget the majesty of the office, and in a sense the majesty of the person. He was always cordial, affable, but he was never really familiar, except on very rare occasions when he'd go on picnics or when he'd be off on the boat. You never really could forget that this was the President of the United States.
>
> On the other hand, Truman was such a humble, affable, sociable man, especially on vacations, while he was President, that it

was a much more pleasant experience—pleasant in the sense that he would provide the kind of companionship that you would find in any ordinary individual.

In April 1946 Sam resigned as White House counsel and moved back to New York to practice law, though Truman often asked him to return to Washington. "After V-J Day, I knew my job was over and I had to get out and make a living again," he said at the time. "Government salaries are absurd—either you're independently wealthy or you make sacrifices." He became a partner in a law firm that came to be known as Rosenman, Goldmark, Colin & Kaye, with offices at 165 Broadway, just a stone's throw from Wall Street. The firm's clients included CBS and Benny Goodman, though Sam specialized in estate and trust law—not flashy but still lucrative.

After Truman left the White House in 1953, Sam became his personal attorney, literary agent, financial planner, and all-around advisor. Sam even helped edit Truman's turgid memoirs. "I do not see the significance of the second paragraph about MacArthur's shirt and cap," Sam wrote in his notes for the chapter discussing the president's controversial firing of the general. "It might be considered by some that this is being unduly critical." (The offending line—"His shirt was unbuttoned, and he was wearing a cap that had evidently seen a good deal of use"—stayed in the final manuscript.) For his services, Sam billed Truman irregularly and with no expectation of payment. "As I have told you on several occasions, so far as I am concerned, you need not pay for these services or you can pay any amount therefor you desire," Sam explained. "I am going to leave the whole thing up to you, and will be perfectly satisfied with whatever you decide."

One of Sam's partners at the law firm was Ralph Colin, whose main interest outside the law was modern art. In fact, Colin's collection of modern art was so comprehensive that he often lent paintings to MoMA, where he served as a trustee and vice president. Encouraged by Colin, Sam and Dorothy Rosenman began to take an interest in modern art as well. Colin later remembered Sam asking him to make him and Dorothy "knowledgeable about art."

> I said the first thing you've got to do is learn to sit down and look at the picture because you can't have an opinion about it until you've looked at it. And whether you like it or not is not impor-

tant. Look at it. And I made him go into a gallery and sit down. I put a picture in front of him and made him look at it for fifteen minutes and not say a world. . . . So this is the way I tackled Sam Rosenman. I made him just sit down and learn to look at a picture.

By 1958 Sam and Dorothy finally began easing into a kind of semiretirement. Sam and Harry Truman's friendship, freed from the constraining protocols of the Oval Office, flowered fully. Their wives were friendly too, and Harry, Bess, Sam, and Dorothy formed a convivial quartet who enjoyed spending time together. Coincidentally, Sam and Bess shared a birthday. "Those two people, whose birthdays are Feb. 13th have been my greatest assets," Harry wrote in a birthday note to Sam in 1959.

When the Trumans asked the Rosenmans if they would like to accompany them on their trip to Europe, Sam and Dorothy happily agreed. The couples would sail from New York in late May on an American Export Lines ocean liner appropriately named the *Independence*, stop in Naples and Genoa, then disembark in Cannes and spend a month on the Riviera relaxing and sightseeing. Harry was adamant that this trip would be a strictly private affair—just two older couples (Harry and Bess were seventy-four and seventy-three, Sam and Dorothy sixty-two and fifty-eight) enjoying a leisurely vacation.

In order to maintain some semblance of privacy, Sam and Dorothy planned the trip clandestinely. Sam had a friend who could help with the operation—and not just any friend: Pierre Wertheimer was one of the richest men in France. Pierre and his brother Paul had taken over their father's makeup business in 1917 and expanded it to include perfume. In 1924 the brothers reached an agreement with Coco Chanel to sell her popular fragrance Chanel No. 5. The deal gave Chanel a 10 percent stake in the company, but when the Wertheimers turned her simple perfume into a global brand she grew resentful, feeling she'd been shortchanged. When the Nazis occupied France in 1940 and imposed so-called Aryan laws that barred Jews from owning businesses, Chanel, a Nazi sympathizer, swooped in to claim total control of the Wertheimers' company. But the brothers threw her off the scent, as it were: they had already transferred ownership of the company to a friend and business partner who was a Christian. After the war, the Wertheimers resumed control, and in a gesture that was both magnanimous and shrewd, they agreed to support Coco Chanel financially for the rest of her life and even paid her $9 million for royalties

earned during the war, despite her underhanded effort to highjack their empire. The Wertheimer family still owns Chanel, still two brothers in fact, Alain and Gérard Wertheimer, who today are two of the ten richest people in France.

The Wertheimers had considerable business interests in the United States, including a factory in Upstate New York, and Sam Rosenman may have become acquainted with them through his law firm. In any event, it would have been hard to find a trip planner with better resources than Pierre Wertheimer. When Sam asked him to make some discreet inquiries about where he and his "friend" might spend a couple weeks with their wives on the Riviera, Wertheimer immediately dispatched Monsieur Camilli, his "representative in Grasse," to scout locations.

Camilli reported back to Wertheimer in March that he had found the perfect place, Château Saint-Martin, a relatively new hotel built on the ruins of a hillside fortress overlooking the town of Vence:

> It is rather like a private house of high class. Splendid view. Ideal climate. Altitude 500 meters (about 1700 ft.), 3.1/2 miles from the sea.
>
> There are only 15 rooms, each one bearing a name. A luxurious two bed room with big parlour, situated facing the sun, with a large terrace. It has got a private entry, allowing to enter the apartment without going through the hall.
>
> Price is of 10.000 francs per day, taxes and service included.
>
> Next to this apartment there is another room, also with bathroom, same exposition, having also a terrace. This room without the parlour would be Frs. 6.875. So the price for the two double bed rooms and a big parlour in the middle would be Frs. 16.875.

"The strictest incognito is the rule of the house," Camilli added. "The owner is quite willing to register your names under any name that you would give him. The personnel only know the customers by the name of their apartments." Wertheimer forwarded this report to Sam Rosenman with a handwritten addendum: "The owner M. Geneve knows this arrangement would be for your friend the President and his wife and you and your wife."

On April 8 Sam wrote Monsieur Geneve to confirm the arrangement: "We would like very much to reserve the parlor and two bedrooms which you showed [Camilli]. I understand that the price for the three rooms will be 16,875

francs per day, and that any meals we take at the Chateau will be additional. . . . We are looking forward with pleasure to this journey, and I know that I can count upon you to keep confidential the identity of our friends."

The rooms weren't cheap—16,875 francs was some $35, about $350 today— but the couples were willing to pay a little extra for some privacy.

Dorothy Rosenman booked the couples' passage on the *Independence* for the outbound journey and the *Constitution* for the return trip. Inevitably, word that the Trumans would be sailing on their ships reached the head office at American Export Lines, and in April the company's vice president W. H. McConnell wrote the Trumans "regarding the matter of passenger fares."

"This subject has been reviewed by our Principals with the Chairman of our Executive Committee, Mrs. Charles Ulrick Bay, whose late husband was your very popular Ambassador to Norway for many years," McConnell wrote. "Mrs. Bay would like to have the privilege of extending passage to President and Mrs. Truman with her compliments and we are very hopeful that this will be quite acceptable to you."

"Mrs. Bay" was Josephine Perfect Bay, who, in addition to owning a controlling share of American Export Lines, also owned the investment firm A. M. Kidder. Born in Anamosa, Iowa, in 1900, Josephine Perfect was forty-two when she married fifty-six-year-old Charles Ulrick Bay in 1942. It was the first marriage for both. Charles was a son of Norwegian immigrants in Upstate New York. He'd made a fortune manufacturing medical supplies and parlayed that into a bigger fortune in oil, banking, and railroads, as well as ownership of American Export Lines, A. M. Kidder, and a stable of thoroughbreds. During the war, Bay served on a War Department committee that streamlined the military's procurement process. He made connections in government that led to his appointment, by Truman, in 1946 as the US ambassador to Norway, the country where his parents were born. He served more than six years in that post, during which he and Josephine adopted three Norwegian children orphaned by the war.

Charles Bay died on New Year's Eve 1955, leaving Josephine a widow with three children—and a fortune estimated at $10 million. Many expected her to liquidate the assets and "sink into the languorous life of a coupon-clipper." Instead, she assumed control of all her late husband's assets. As president of A. M. Kidder, she became the first woman to run a company listed on the New York Stock Exchange (though she was, like all women at the time, still

barred from holding a seat on the exchange itself and trading shares directly). "I am firmly convinced—despite some cartoons in the New Yorker—that the average woman really knows how to handle money," she told the *New York Daily News* for a profile headlined "This Wealthy Widow Went to Wall Street." "The woman of the family is usually the keeper of the budget."

But even within American Export Lines, a company she owned, she was still known not by her given name but as Mrs. Charles Ulrick Bay.

Josephine Perfect Bay's offer of complimentary passage was generous. A first-class cabin on an AEL liner cost $715. The Trumans accepted the offer. "Mrs. Truman and I are deeply grateful to you for your courtesy regarding our proposed trip to the Mediterranean" wrote Harry in a letter to the financier. "My association with you and your husband during my tour of duty in the White House was a highly pleasant one. You and he were very cooperative and made a great and favorable impression for the United States in Norway while he was Ambassador to that country."

It also didn't take long for word to reach Alfred Barr at the Museum of Modern Art that the Trumans and the Rosenmans were planning a Mediterranean cruise. After all, Sam Rosenman's law partner, Ralph Colin, was one of MoMA's trustees. When Barr learned the couples would be stopping in Cannes on their trip, he sensed another chance to get Harry Truman interested in modern art. Cannes just happened to be where Pablo Picasso lived. Who better to win Truman over to the wonders of modern art than the man who practically invented it?

10 | "COME ON UP"

SHORTLY BEFORE LEAVING INDEPENDENCE for the cruise on the *Independence*, Harry Truman received an unexpected invitation from his successor, Dwight Eisenhower. Truman and Eisenhower had had a falling out over the 1952 election, when Republicans accused Truman, who campaigned vigorously for the Democratic nominee, Adlai Stevenson, of being "soft on communism." Truman was especially incensed by Eisenhower's refusal to disavow Joseph McCarthy, who said the Truman administration was "almost completely morally degenerate." Ever pugnacious, Truman responded by calling Eisenhower a "five star front man" who "doesn't know any more about politics than a pig knows about Sunday." It was rancorous stuff, and the thirty-third and thirty-fourth presidents, once friendly, became antagonists. Shortly after his inauguration, Eisenhower wrote Truman to thank him for allowing Eisenhower's son John, an army officer stationed in Korea, to attend the ceremony. After that, the two men ceased communication.

So it must have come as a surprise to Harry when he went through his mail at home one day and found this letter from Ike dated May 20, 1958:

> Dear President Truman:
> I am in the midst of making arrangements for the official ceremonies this coming May thirtieth at Arlington National Cemetery to honor the Unknowns of World War II and the Korean Conflict. It occurred to me that because, though in different capacities, we both bore heavy responsibilities during critical periods of those conflicts, it would be

117

only fitting and proper for us, together, to attend these solemn ceremonies. I should feel honored by your participation.

If this suggestion appeals to you—and I greatly hope that it will—I suggest that Mrs. Truman and you join Mrs. Eisenhower and me for a one-thirty luncheon at the White House before the four of us travel together to Arlington for the ceremonies.

If your plans permit your coming, we can consult later on how best to handle any necessary public announcement.

With good wishes,

Sincerely,

Dwight D. Eisenhower

The invitation was a bit last minute, and Truman certainly wasn't going to postpone his European vacation to have lunch with Eisenhower, however solemn the occasion. Still, it was a magnanimous gesture and Truman replied with a telegram that was brief but gracious:

YOUR LETTER AND INVITATION TO ATTEND THE MEMORIAL DAY CEREMONIES AT ARLINGTON NATIONAL CEMETERY WERE HIGHLY APPRECIATED AND I REGRET VERY MUCH THAT MRS TRUMAN AND I CANNOT BE THERE. UNFORTUNATELY WE WILL BE OUT OF THE COUNTRY AT THAT TIME.

HARRY S TRUMAN

Truman and Eisenhower began a protracted reconciliation the following year, when they met and shook hands at the funeral for former secretary of state George Marshall in Virginia.

Bess Truman didn't like to fly, so she and Harry were taking the train from Kansas City to New York, where they would spend two days with their daughter and her husband, Margaret and Clifton Daniel, and the couple's eleven-month-old son, Clifton Truman Daniel, the Trumans' first grandchild, who would turn one while they were in Europe. On the way to New York, the Trumans stopped in Chicago for two days so Harry could deliver a speech at a meeting of Cook County Democrats. In Chicago Truman also crossed paths with Dale Pontius, an eccentric college professor whose life intersected with many of the major events and figures of the twentieth century.

By the time he died in 2011, at the age of 104, Dale Pontius had witnessed firsthand the rise of Hitler while studying in Germany; served on the staff of Douglas MacArthur in the Pacific Theater during the Second World War; been arrested for "disorderly conduct" when he heckled Senator Joseph McCarthy during a speech; lectured in Moscow, earning himself a front-page headline in the *New York Times*; been arrested again, this time for protesting the Vietnam War; marched with Martin Luther King Jr.; and run for Congress as a peace candidate (unsuccessfully, it practically goes without saying). Even into his tenth decade, he was still active in liberal causes. "If I didn't agree with something, I would say so," he told an interviewer in 2006, the year he turned one hundred. "I have never regretted saying what I thought was right." The interviewer noted that, despite his age, Pontius was still tall and wiry and had "no trouble taking the stairs to his third-floor walk-up apartment in Hyde Park."

Born on a farm outside Columbus, Ohio, in 1906, Dale Pontius earned degrees from Ohio State, Harvard, and Stanford but was most proud of his association with Roosevelt University in Chicago, where he was a political science professor for twenty-six years. The school was founded in April 1945 as Roosevelt College, named in honor of the president who died that month. Its faculty, including Pontius, had resigned from Chicago's Central YMCA College en masse to protest its attempt to put a quota on the number of Black and Jewish students. Roosevelt was founded as a college for nontraditional students. Classes were offered at night and on weekends for students who worked full time. The college accepted for admission "any man or woman who, through an entrance examination, demonstrates ability to benefit from college training," regardless of race, class, religion, gender, or age.

Nearly all who attended were first-generation college students, the sons and daughters of immigrant and working-class parents, pursuing the American Dream. Students paid what they could. The rest of the cost was absorbed by contributions, and over the years luminaries such as Pearl S. Buck, Albert Einstein, Albert Schweitzer, Thomas Mann, and Eleanor Roosevelt offered their support. In October 1945 a newspaper columnist who visited the school noted with some amazement what he saw in one classroom: "There were Chinese, Japanese, Negroes, Levantines, Jews, Catholics and down east Yankees."

But even at such a liberal institution of higher learning, Professor Pontius could be a pain in the butt. He tended to bring the kind of attention to the school that led to charges that it was a haven for communists. The McCarthy

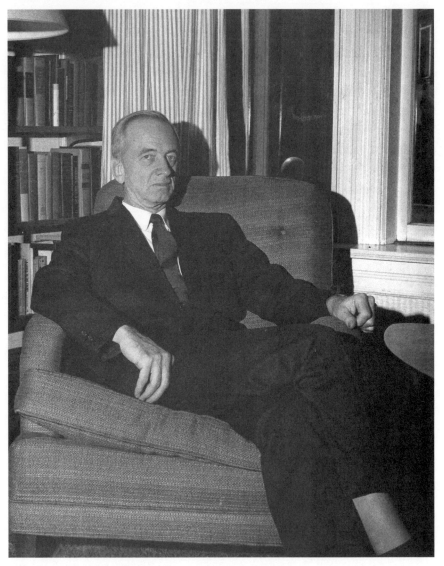

Dale Pontius. *Eliot M. Pontius*

incident was one such case. On the evening of Tuesday, October 28, 1952, exactly one week before that year's presidential election, the Republican senator from Wisconsin gave a speech in the ballroom of the Palmer House hotel in Chicago that was carried live on more than fifty television stations and more than five hundred radio stations nationwide. In the speech, McCarthy

accused the Democratic presidential candidate, Adlai Stevenson, of giving aid to Communist causes. At one point, McCarthy waved a photograph of a barn in Massachusetts, where, he claimed, an organization called the Institute of Pacific Relations, which many on the right blamed for the "fall" of China, had "hidden" documents. Hearing this, the six-foot-four Pontius, who was standing in the back of the ballroom, shouted, "They weren't hidden!" The crowd shushed him, but Pontius continued: "How many Republicans were in that [organization]?" Here four cops hustled him out of the ballroom and arrested him for "disorderly conduct." He spent that night in jail.

Roosevelt College's president, Edward J. Sparling, was forced to issue a statement clarifying that Pontius's heckling was not condoned by the college. "Because we believe in freedom of speech for all persons we strongly regret any attempt by any person to interrupt that right." But Pontius was unrepentant. "I happen to be a political science teacher, trying to teach my students what democracy means," he explained when he was hauled before a municipal court judge. "I am alarmed at what seems to be creeping fascism in this country. That's the reason I interrupted Sen. McCarthy." The judge released Pontius on a ten-dollar bond. He was later found guilty and fined one dollar.

Pontius gave the college more heartburn in 1962 when he agreed to speak at an international "peace conference" in Moscow that was little more than an exercise in Soviet propaganda. But Pontius flipped the script on the Russians. In a speech before two thousand at the conference's opening session, he excoriated the Soviets for their domination of Eastern Europe: "Colonization of two kinds exist, not only that variety found in Africa and Asia." He also criticized the Soviet Union for refusing to allow international arms inspectors into the country: "Not all inspection is equivalent to espionage." His remarks, according to one account, were met with "only scattered applause or embarrassed silence."

"It was one of the few times in the memory of Moscow observers," the New York Times reported, "that an American had spoken in such a manner at a meeting designed essentially to advance the Soviet point of view."

Dale Pontius was not timid. So in May 1958, when he heard that former president Harry Truman was in town, he thought it would be a swell idea to invite him to speak to his political science class at Roosevelt. The Trumans were staying at the Blackstone Hotel on Michigan Avenue—just two blocks from the Roosevelt campus—so Pontius walked down there and called the former

president's room. "Mr. Truman told me he couldn't come to the class when I telephoned to his room in the hotel, but he said, 'Come on up,'" Pontius recalled many years later. "I went to his suite, and had a delightful conversation for 45 minutes or so. In that conversation, I learned that he and Mrs. Truman were going to call upon Picasso during their visit to France."

Well, it just so happened that Pontius had long wanted to interest Picasso in painting a mural at Roosevelt University. (This, he noted, was "an unofficial and unauthorized initiative from the standpoint of R.U.") So he asked Truman if he would mention the idea to Picasso when they met. "He promised that he would do so if I sent him some material to France," Pontius remembered. "After the visit in the Blackstone Hotel, I bought a newly published paperback on Picasso, and returned to the hotel, to leave it as a present for Mrs. Truman."

11 | DISTRACTING VISITORS

HARRY TRUMAN HATED MODERN art, but Alfred Barr knew he hated the people who wanted to censor it even more. As the *New Yorker* noted in a 1953 profile of the MoMA icon, "[Barr] has remarked that, while both Stalin and Truman are on record as disliking modern art, the former translated that personal opinion into governmental repression while the latter did not." Barr had to figure out a way to bring together Truman and Picasso, two spirited septuagenarians whose tastes in politics, art, and life were diametrically opposed and whose personalities were nearly as big as their influence on the twentieth century.

It's worth noting that Barr undertook this project amid a major crisis at MoMA. A fire at the museum on Tuesday, April 15, 1958, killed one person, injured twenty-five, destroyed a Monet (from his Water Lilies series), and severely damaged five other paintings, including a Pollock (*Number 1A, 1948*). Other works were saved when museum staff and firefighters formed a bucket brigade to pass the paintings down a stairwell to safety. By this manner some $4 million in art was rescued, including Seurat's *A Sunday Afternoon on the Island of La Grande Jatte*, on loan from the Art Institute of Chicago (which has never loaned it again, understandably). The fire started when workers upgrading the museum's air-conditioning system stopped for a smoke break on the second floor and a drop cloth caught fire. The flames spread to open paint cans and smoke filled the upper floors. Barr was one of twelve employees trapped in an office on the fifth floor. He smashed a plate-glass window with a chair, and according to a report in the next day's *New York Times*, the twelve were able

123

to "squirm out the window and then drop four feet to the roof of the five-story brownstone house at 7 West Fifty-third Street." Barr and the others then helped catch "a number of women and children who dropped down to them from the museum roof." Although he was no longer the museum's director—in 1943 he was stripped of the title and later reassigned, controversially, to director of collections—Barr was still intimately involved in the museum's day-to-day operations, which the fire, of course, interrupted. But in the six weeks after the disaster, he still found time to organize a Truman-Picasso summit.

What was the impetus for arranging it? Barr clearly appreciated the optics of the meeting: the nation's most famous hater of modern art breaking bread with the world's most famous modern artist. But was it arranged on Barr's initiative? Barr's correspondence in the MoMA archives indicates that it was. The plan was hatched at some point in late April or early May 1958. The idea may have originated with Barr, or it may have come from Sam and Dorothy Rosenman, who by now were very much modern art enthusiasts (they would later donate several pieces to MoMA). In either case, the go-between was Ralph Colin, Sam Rosenman's law partner, who was a MoMA trustee. Maybe Barr asked Colin to ask Rosenman to ask Truman if he would be amenable to meeting with Picasso when he was in France. Truman's reaction to this request was likely unfavorable. The European vacation was supposed to be a quiet affair. Getting wrapped up in controversy was the last thing he wanted, and meeting with the world's most famous communist after Khrushchev would be controversial. Then there was the delicate matter of Picasso's thirty-one-year-old *compagne*, Jacqueline Roque. The couple lived together but were not married. Mmes Truman and Rosenman wouldn't be wild about that. But, like Barr, Truman appreciated the symbolic importance of the meeting: it would show his support for the freedom he cherished most, the freedom of speech, and it would rebuke Far Right politicians like George Dondero who had demonized artists like Picasso. Besides, the Rosenmans were eager to meet the famous painter.

Truman consented to the rendezvous.

Now Barr just had to get Picasso to agree.

Picasso didn't like having company, but Barr had known him for more than twenty years and had almost single-handedly introduced his work to American collectors. Barr also had a personal relationship with the artist. In 1956 he and Marga had visited Picasso and Roque at Villa La Californie, their home in Cannes.

On May 26, 1958, the same day the Trumans and Rosenmans embarked on the *Independence* in New York, Barr wrote the great artist.

> Dear M. Picasso:
> I enclose a copy of a letter introducing two famous gentlemen whom I believe you will find both interesting and entertaining. I hope you will be able to see them.
> With my kindest regards to Jacqueline.
> Sincerely,
> Alfred H. Barr, Jr.

The enclosed letter read:

> Dear M. Picasso,
> Very rarely do I agree to give letters of introduction to you because I know how distracting visitors can be. Yet, I believe that you would be very pleased indeed to receive the two gentlemen to whom I have given this letter. One of them really needs no introduction, since he is the Honorable Harry S. Truman, ex-President of the United States. His companion, Judge Samuel Rosenman, was for many years a close friend and adviser to President Roosevelt and subsequently to President Truman.
> These gentlemen are spending some time on the Riviera and are eager to pay you a visit. I hope that you may receive them.
> My warmest greetings to you.
> Sincerely,
> Alfred H. Barr, Jr.

Truman wasn't eager to pay Picasso a visit; in fact, he would later claim that it was Picasso who had requested the meeting. In any event, Barr sent a copy of the letter of introduction to Ralph Colin, with instructions for him to forward it to Rosenman and Truman. He also provided instructions for calling on Picasso:

> May I suggest that they phone or have someone phone Madame Jacqueline Roque at Picasso's residence. The phone number is Cannes 9-0182, the address, the Villa Californie, Avenue Costebelle, Cannes.

The best time to phone is around eleven in the morning. Madame Roque speaks English quite well. In any case, she and Picasso have a copy of the letter as a harbinger so that they will expect the call.

12 | AT SEA

ON THE SUNNY AFTERNOON of Monday, May 26, 1958, Harry and Bess Truman and Sam and Dorothy Rosenman boarded SS *Independence* at pier 84 in New York and set sail for Europe. The twenty-three-thousand-ton *Independence*, which launched in June 1950, and its sister ship the *Constitution*, which launched three months later, were the flagships of American Export Lines. Both ships were built at Bethlehem Steel's Quincy, Massachusetts, shipyard for a total cost of $25 million, though the US government footed 45 percent of the bill since the ships could be quickly converted into transports capable of carrying five thousand troops each in wartime.

In peacetime the *Independence* could accommodate one thousand passengers in three classes (first, cabin, and tourist), as well as a crew of 578 and 2,580 tons of cargo. Newspapers struggled to come up with superlatives to describe the stupendous vessel, which was propelled by two twenty-seven-ton propellers and capable of speeds in excess of twenty-six knots (thirty miles per hour). Although the *Independence* was not the biggest ocean liner—the eighty-one-thousand-ton *Queen Mary* retained that title—it was the most spacious. With nine decks, the ship boasted more room per passenger than any other ocean liner ever built. All first- and cabin-class rooms included private baths (as did 40 percent of those in tourist class). Every room included a bedside phone "from which a passenger can phone anyone within 5,000 miles." All the enclosed interior spaces were air conditioned, including an observation deck that afforded passengers 270-degree views through massive Thermopane windows. There were nineteen lounges and bars, two swimming pools, a gymnasium, a library, a theater, and a shopping mall with "several swank 5th Ave. shops." It was pure luxury.

SS *Independence*, circa 1950. *Wikimedia Commons*

The interior—everything from the deck chairs to the ashtrays—was designed by Henry Dreyfuss, a high school dropout and industrial-design genius who designed the Western Electric model 500 telephone, Honeywell's round thermostat, a series of Hoover vacuum cleaners, the Polaroid SX-70 Land camera, and countless other products that were staples of American life in the second half of the twentieth century. The beds in each cabin on the *Independence* could either be folded into the wall or converted into a couch. One breathless newspaper account noted that everything on the ship was fireproof: "curtains, lamp shades, furniture, carpets and rugs"—asbestos is incredible indeed. It is also deadly, of course, and in the following decades the death toll among workers in shipyards from asbestos-related illnesses—mesothelioma, asbestosis, lung cancer—would number in the tens of thousands.

When the *Independence* entered New York Harbor for its maiden voyage on January 22, 1951, the ship received "a really royal welcome." "Airplanes and helicopters circled overhead," one reporter marveled. "Tugboats, ferries and ocean liners let loose with all the steam they could pour into their whistles." New York mayor Vincent Impellitteri went on board to present the crew with a copy of the Declaration of Independence and an American flag. But even as the airplanes circled and the ferries whistled and the mayor posed for photographs, the magnificent *Independence* was destined for obsolescence. The golden age of the ocean liner was about to end.

Between 1850 and 1920, more than thirty million people immigrated from Europe to the United States, and millions would make the return trip—all by boat. This was a lucrative source of income for shipping companies, but

that spigot was turned off when President Coolidge signed the Immigration Act of 1924, which imposed strict quotas on immigration from Europe (and banned immigration from Asia altogether). The Great Depression further reduced revenue, and in 1934 Britain's two giants of the industry, Cunard and White Star, were forced to merge. Practically all ocean liners were requisitioned for military use by combatants on both sides during the Second World War, mostly for transporting troops. After the war, the industry temporarily rebounded as the global economy recovered and people were free to travel for pleasure once again. In 1951, the year after American Export Lines launched the *Independence* and the *Constitution*, the company's chief domestic rival, United States Lines, launched its flagship, SS *United States*, a luxury liner that still holds the record for the fastest Atlantic crossing by a commercial vessel (from New York to England in three days, ten hours, and forty minutes). Even as these majestic ships sailed the ocean in unprecedented speed and luxury, however, there was something in the air, literally, that would spell their doom.

Pan American Airways began transatlantic passenger air service with the legendary Boeing 314 seaplane in June 1939. It wasn't especially fast or cheap—the trip from New York to Marseilles took twenty-nine hours, including refueling stops, and the cost of a one-way ticket was $375 (more than $7,000 today)—but the shipping companies could read the writing on the wall. American Export Lines had founded an aviation subsidiary, American Export Airlines (known as Am Ex) in 1937. But the US government, fearing a company that combined steamship and air services would stifle competition, ordered AEL to divest itself of its aviation division, and Am Ex was sold to American Airlines in 1945.

The Second World War momentarily stifled the development of commercial airlines but rapidly advanced the development of aircraft. By war's end, a whole new fleet of big, fast planes had been designed, and these were easily modified for civilian use. Originally built to be a military transport, the Douglas DC-6 was in service on transatlantic passenger routes for several airlines by 1949. Then came the jet age. Boeing's 707 made its maiden flight on December 20, 1957. Douglas's DC-8 took to the skies for the first time on May 30, 1958, while the Trumans and Rosenmans were steaming across the Atlantic on the *Independence*. Five months later, in October 1958, Pan Am began daily jet service between New York and Paris. A one-way ticket in economy class cost

$272 (about $2,500 today). Meals were provided by Maxim's, the legendary Paris restaurant. Flight time: seven hours.

But even if ocean liners were transportation dinosaurs destined for extinction, they still retained their romance. When Grace Kelly traveled to Monaco in April 1956 to marry Prince Rainier, she didn't fly—she sailed on the *Constitution*. In a 1956 episode of *I Love Lucy*, Lucy and Ricky sailed to Europe on the *Constitution* as well. "Every Voyage a Gay Cruise," an AEL brochure promised. Cruise liners catered to passengers who could afford not only the price of a ticket but also the time it took to cross the ocean at sea level.

At sea the Trumans, the Rosenmans, and all the other passengers on the *Independence* reveled in the many amenities on board. Harry no doubt made use of the library and, as he was an avid swimmer, the pools. The couples also enjoyed sumptuous meals prepared in the ship's state-of-the-art kitchen by chef de cuisine Giacomo Carisio, a native of Italy who had previously supervised kitchens at popular New York clubs such as the Casbah and the 1-2-3. The Trumans saved nearly every menu from the trip, and they are now in the archives at the Truman Library. So we know that for dinner at the end of their first full day at sea, May 27, they could choose from breast of guinea hen, roast baron of veal, or larded tenderloin of beef.

The Trumans' cabin on the *Independence* was S3, the John Penn suite. (Each suite on the ship was named after a signer of the Declaration of Independence; John Penn was a lawyer from North Carolina and a member of the Continental Congress.) In the mornings, Harry adhered to his usual custom and took a walk, usually around the sun deck. The other passengers gawked at the former president, of course, and many approached him for a handshake or an autograph, requests he always accommodated. "Our crossing was a most pleasant one," he wrote later. "The sun shone nearly every day, the passengers were considerate and agreeable. Signed many autographs and posed for many pictures but altogether it was a pleasant trip."

In Harry's papers at the Truman Library, there are five thick folders labeled "1958 European Trip." The Trumans were savers, apparently, because in addition to all the menus, these folders contain receipts, guidebooks, brochures, maps, and other ephemera from the trip. Among this trove of goodies are the passenger lists for the *Independence* and the *Constitution*. Each passenger was given this list. The Trumans were identified as "The Hon. Harry S. Truman" and "Mrs. Truman."

Since they identified children by name and age, the lists also made it possible for me, more than six decades later, to track down a handful of people who sailed to Europe with the Trumans on the *Independence* or back home on the *Constitution*. Their stories offer a little window into life in 1958, when the world was a very different place. Julie Obarski (now Simpson) was eight years old when she joined her parents and two younger sisters, Susan (four) and Carol (eight months) for the voyage to Europe on the *Independence*. Her father, Major Stanley Obarski, was an army pilot transferring to a new assignment at the American base in Torrejón de Ardoz, near Madrid. Spain, still ruled by Franco, was isolated in the early years of the Cold War. Having taken power with support from Hitler and Mussolini, Franco was ostracized by both Washington and Moscow. Spain received no Marshall Plan money and was not invited to join the United Nations. But as the Cold War progressed, the United States began to soften its position. Spain's strategic location at the edge of Europe and Franco's opposition to communism made the country an attractive strategic partner. In 1953 the United States and Spain signed the Pact of Madrid, with the United States offering economic and military aid in exchange for access to four military bases in Spain, including Torrejón. In 1955 Spain was finally admitted to the UN, and by 1958, American servicemen like Stanley Obarski were routinely stationed in the country.

Originally the Obarskis had been booked to fly, but at the last minute, Stanley's travel orders were changed, and the family was assigned space on the *Independence*. It's likely that American Export Lines had an agreement with the Defense Department to make unsold cabins available to transferring service members. Julie still remembers the fanfare that accompanied their departure from New York. Her mom dressed her and her sisters in their finest. "We even wore hats," she tells me. "My parents wanted us to look right." As the ship eased away from the pier, she remembers waving to her grandmother, whom she wouldn't see for another four years. On the ship there was a playroom with a padded floor, where she played with some "bratty boys" who were also Americans from a military family. She has no firsthand memories of seeing Truman on the ship, but she knows her family met the former president, because a story that has become family legend has it that when Harry picked up baby Carol, she peed on him. "Either her diaper leaked or she urinated," Julie tells me. "Mother was mortified, of course, but it became a funny family

story." The former president's response to this accidental dowsing has, unfortunately, been lost to history.

That pattern would repeat itself on the *Independence* and on the trip home on the *Constitution*—not Harry getting peed on but ordinary Americans having casual encounters with their former president in a way that is practically impossible today. Frank Hoose Sr., a Second World War veteran who worked for the State Department, was on the *Constitution*, returning from an assignment in Germany with his wife, Harriet, and their three children, Linda (thirteen), Frank Jr. (nine), and Tom (one). Although too young to remember the trip himself, Tom tells me his mother often recalled it. "Mom said that she liked to walk the deck of the ship with me, to get some air, and to calm a small child," Tom says.

> And, as you already know, President Truman liked to go for a good walk. Before long it was a regular routine for Mom and President Truman, and they walked and talked—would be interesting to know what topics! Mom and Dad always said that one of the things that impressed them most about Truman was that he was not pretentious. He had no problem walking with folks and talking about what comes to mind, and even listening. And he certainly had no problem walking with a small child (me) who likely fussed at times!

Some of Harry's fellow passengers were noteworthy in their own right. The violin virtuoso Jascha Heifetz was on the *Constitution* on his way home to Los Angeles, where he would open the Hollywood Bowl's summer season as the featured soloist accompanying the Philadelphia Orchestra performing Tchaikovsky's Violin Concerto in D Major. Although he was known to be irascible, Heifetz generously acquiesced to the captain's request to play for the passengers. According to one account, Heifetz and Harry Truman played a duet for passengers, with Harry on the piano.*

* Heifetz, incidentally, was an early advocate of electric vehicles—in 1967 he converted his Renault to run on rechargeable batteries—and the 911 emergency phone system.

Linda Hoose and Frank Hoose Jr. pose with Harry Truman during a lifeboat drill on the *Constitution*. In the background on the right are the children's parents: Harriet, holding Tom, and Frank Sr. *Frank J. Hoose Jr.*

Also on the *Constitution* was another musician, a cellist named Robert (Reuben) Hofmekler, who was returning to the United States with his wife and son. Hofmekler was born into a Jewish family of musicians in Lithuania in 1905. His father was an acclaimed cellist, and his brother Michael (Moishe) became an accomplished violinist. Robert immigrated to the United States in 1938 and joined the Pittsburgh Symphony Orchestra. He was drafted into the US Army in early 1941 and served with the Ninth Infantry and Tenth Armored Division in Europe. Everyone in his immediate family perished in the Holocaust, with the sole exception of Michael, who somehow survived Dachau. Robert and Michael were reunited in June 1945 at a displaced persons' camp in Germany.

After the war, Robert Hofmekler went on to work for various American government agencies overseas, and later in life he became a beloved (if strict) cello teacher in northern Virginia. (One student remembered how he would slap her hand with a ruler if she was out of tune.) Robert Hofmekler's son, also

named Robert, was only eight years old when he sailed on the *Constitution*, but he has a vivid memory of seeing Harry Truman in an elevator on the ship. "He looked down at me with such a warm smile," he tells me. "He had such a welcoming energy; it was really remarkable." Robert's other vivid memory from the trip is the sherbet served after dinner every night: "I loved it!"

Sailing to Europe on the *Independence*, passengers kept up with current events through the *Sun-Lane News*, the ship's daily newspaper. (The name came from one of the company's slogans: "The sun is never out of season on the sun-lane to Europe!") Every major ocean liner contained a small print shop that, in addition to a daily newspaper, churned out menus, event calendars, concert programs, official orders, and other documents. The *Sun-Lane News* published information about onboard activities as well as wire-service news reports received over the ship's radio. The paper was typeset and printed over-night and delivered to the passengers each morning with breakfast.

On the morning of Friday, May 30, 1958, the *Sun-Lane* carried the dramatic news that Charles de Gaulle, the former leader of France, had returned to power the previous day in a bloodless coup. The event was the culmination of what is now known in France as *la crise de mai 1958* (the May 1958 crisis). Right-wing officers in the French army had come to believe the French government was not fully committed to defeating the rebels fighting for independence in Algeria, so in early 1958 they began plotting to return de Gaulle to power after an absence of twelve years. De Gaulle agreed to the extraconstitutional scheme. "If I should be led to assume or be delegated powers to meet an exceptional situation, this could not be done by the usual rights," he announced on May 19. "An exceptional procedure would be required for investiture." Ten days later, on May 29, French president René Coty, under pressure from the coup leaders and fearful of a civil war, agreed to step down. Amid bitter left-wing street protests, de Gaulle assumed power that night, and he would hold it until April 1969. The coup sent shock waves through the international com-munity—and complicated Harry Truman's travel plans.

On Sunday, June 1, after five days at sea, the *Independence* reached Europe, docking on the Bay of Gibraltar at the Spanish port of Algeciras. This was only a two-hour layover to resupply the ship, but a few reporters managed to get on board and track down the former president to get his reaction to the coup in France. In de Gaulle, he said, "France has found the man who will save her." This was a diplomatic answer. Truman gave the impression he thought quite

highly of the French general when he actually detested him. In the late stages of the Second World War, de Gaulle had barred French troops in Germany from transferring control of territory they occupied to American forces. De Gaulle only backed down after Truman threatened to cut off supplies to the French troops. To his staff, Truman referred to the French general as a "son of a bitch." De Gaulle, for his part, never forgave Truman for refusing to invite him to attend the Potsdam Conference, where the Allied powers discussed terms for ending the war.

What interested Truman more than de Gaulle the was the fabled Rock of Gibraltar, visible in the bay. The rock was familiar to Truman and practically every other American as the symbol of the Prudential Insurance Company. Digression: The company that became Prudential was founded by a thirtysomething Yale dropout named John Fairfield Dryden in Newark, New Jersey, in 1875. To drum up business, Dryden decided the company needed a symbol, "some sign of lasting, enduring strength." He hired the J. Walter Thompson advertising agency, where a young account executive, Mortimer Remington, hit on an idea: What was more enduring than . . . a rock? Gibraltar, considered the most impregnable military fortress in the world, was the logical choice. Remington commissioned an illustration depicting the rock's northern cliff face, an illustration, with occasional updates, still in use today. He also came up with a slogan: "The Prudential Has the Strength of Gibraltar." The rock appeared in a Prudential advertisement for the first time in the August 27, 1896, issue of *Leslie's Weekly*. "The campaign which introduced the symbol was one of the first great advertising campaigns in the nation," wrote Earl Chapin May and Will Oursler in *The Prudential*, their (quite interesting) history of the insurance company. "Through magazine advertisements, newspapers, posters, and direct mail, it made Prudential and the Rock of Gibraltar synonymous words in virtually every home in the land."

Harry Truman had been seeing that rock in Prudential ads since he was twelve years old. When he saw it in person for the first time, sixty-two years later, he was, to put it mildly, underwhelmed. "Arrived at the port on the Spanish coast across from Gibraltar," he wrote.

> Had a press conference of no consequence, looked at the "Rock" and remembered the insurance company advertisement. It would be hard to recognize the place from the advertisement. But that is

true of most ads. They are made to make a sale. Take pictures of resorts. California, Colorado, Arizona, Florida, Maine and Massachusetts. They [use] pictures to draw unsuspecting travelers just as do these Riviera French ads. Never expect to see what the advertisements put in their pictures and there will be no disappointment.

13 | NAPLES

THE *INDEPENDENCE* ENTERED THE Bay of Naples on the afternoon of Tuesday, June 3, 1958, eight days after departing New York. In the harbor, the ship happened to pass two French navy vessels, the decks of both lined with sailors wearing their traditional hats with red pompoms—the *pompon rouge*. The sailors recognized Truman, who was surveying the scene from the first-class deck, and waved at the former president en masse. Truman, smiling broadly, responded by removing the handkerchief from his coat pocket and waving it high in the air. Reporters on shore noticed the exchange and began to debate its meaning: Was this a signal of support for the French in their war against the Algerian rebels? A show of support for de Gaulle? It was, of course, nothing more than a friendly gesture on Truman's part, but as he had learned by now, under the awful glare of public scrutiny a former president's every word and gesture, especially overseas, was parsed for deeper meanings and open to misinterpretation.

The *Independence* docked at wharf no. 9 shortly before three o'clock. The American consul in Naples, James E. Henderson, had arranged a small welcoming party that included himself and several local dignitaries. Accompanied by a pack of reporters, photographers, and newsreel camera operators eager to ask the eminently quotable former president questions, the party met Truman next to the pool on the sun deck. As would become customary on this trip, Truman held an impromptu press conference to announce he didn't like holding press conferences, then fielded reporters' questions for twenty minutes as deftly as Willie Mays chasing down a long fly in center field.

On the situation in France: "I hope that the French can resolve their differences," he said, adding that he still intended to sail on to Cannes as planned "if the situation in France remained quiet."

On the recent Italian elections, in which the Communists had been defeated soundly by the center-left Christian Democrats: "I'd just like to say that I'm glad the Communists didn't win!"

On his travel plans: "The only reason for my trip is to escape photographers, journalists and autograph hunters. I would like to rest in order to face the election campaign of the Democratic Party next November in good health. In France, I hope to be able to sleep for a whole week. I will leave for the United States around the beginning of July."

Other questions about international affairs—a nuclear arms treaty, a possible East-West summit—he nimbly deflected by insisting he was merely "a private citizen from Missouri."

Finally, Truman was asked whether he thought Italy's improving economy could lead the United States to increase the quota on Italian immigrants. The Immigration and Nationality Act of 1952 capped annual immigration from most nations, including Italy, at one-sixth of 1 percent of the number of people in the 1920 census who were born in that country. That meant immigration from Italy was limited to fewer than six thousand people a year. Truman had vetoed the bill. "The bill would continue, practically without change, the national origins quota system, which was enacted into law in 1924, and put into effect in 1929," he wrote in his veto message to Congress. "This quota system—always based upon assumptions at variance with our American ideals—is long since out of date and more than ever unrealistic in the face of present world conditions." Truman said the bill discriminated against US allies:

> Today, we have entered into an alliance, the North Atlantic Treaty, with Italy, Greece, and Turkey against one of the most terrible threats mankind has ever faced. We are asking them to join with us in protecting the peace of the world. We are helping them to build their defenses, and train their men, in the common cause. But, through this bill we say to their people: You are less worthy to come to this country than Englishmen or Irishmen; you Italians, who need to find homes abroad in the hundreds of thousands— you shall have a quota of 5,645; you Greeks, struggling to assist the

helpless victims of a communist civil war—you shall have a quota of 308; and you Turks, you are brave defenders of the Eastern flank, but you shall have a quota of only 225!

Although Democrats controlled both houses of Congress, Truman's veto was overridden, and the law went into effect without his signature. (George Dondero, of course, voted in favor of the override.) Unsurprisingly, Truman told the reporters on the *Independence* that he hoped "with all my heart" that the immigration quota would be raised. "After all, everyone in America is well disposed towards an increase in Italian immigration," he said. "This is because we appreciate the work and contribution that your compatriots make to the prosperity of the United States." (The Immigration and Nationality Act of 1965 would finally abolish quotas based on national origin, effective July 1, 1968. Under current immigration law, however, no single country can account for more than 7 percent of the total number of immigrants in any fiscal year.)

Italy's economic recovery after the war was remarkable indeed. Having switched sides in the middle of the conflict, the country was pummeled by both Allied and Axis bombers. By the end, an estimated 70 percent of its roads and 45 percent of its rail system were destroyed. According to economic historians Nicola Bianchi and Michela Giorcelli, in 1945 "Italian GDP per capita was 38 percent lower than the value observed in 1938, while industrial production was 66 percent lower." Reconstruction was funded largely by the Marshall Plan, a product of Truman's State Department under Secretary of State George Marshall. Between 1948 and 1952, the United States transferred more than $13 billion to seventeen nations in western and southern Europe to help them rebuild. (Eastern European nations under the aegis of the USSR were offered aid but declined.) In 1948 the expenditures represented about 5 percent of the United States' GDP. Italy was the third largest recipient of aid (behind the United Kingdom and West Germany), receiving $1.5 billion over the program's five years. The Marshall Plan helped Italy rebuild factories, roads, bridges, and ports and supercharged the country's economy. Between 1950 and 1963, Italy's GDP rose by an average of nearly 6 percent annually. Between 1958 and 1963—a period referred to as Italy's economic miracle—industrial output grew by as much as 10 percent annually, a rate surpassed only by Japan and West Germany. Italian products flooded world markets, with Fiat automobiles and Olivetti typewriters leading the charge.

The improvements in infrastructure funded by the Marshall Plan also invigorated another important sector of the Italian economy: tourism. Pilgrims began making their way to Rome along the Via Francigena as early as the eighth century, but it wasn't until the Grand Tour became fashionable in the late seventeenth century that tourism was recognized as an integral part of the country's economy. Aristocrats from across Europe, and later their equivalents in the United States—rich White people with their families, servants, and chaperones—began touring the continent on extended vacations like the one William Rockhill Nelson and his wife undertook in 1895. Italy was a favored destination. Venice, Milan, Florence, Rome, and Naples offered many splendors, including history, art, culture, and cuisine—not to mention natural beauty and an enviable climate. By the late nineteenth century, affordable rail travel made it possible for even the hoi polloi to become tourists, albeit on a less grand scale. Then came the automobile, improved roads, and that most American invention: the motor hotel, or motel. The two world wars interrupted this burgeoning industry, but peace, along with the dawning jet age and global economic growth, poised Italy for an unprecedented tourism boom.

In 1958 Italy welcomed more foreign tourists than any other nation, more than fifteen million, who pumped nearly $500 million into the country's economy. Americans accounted for 6 percent of all tourists (813,000) but more than 20 percent of the money tourists spent ($112 million). In 2019, the last full year before the pandemic, Italy greeted sixty-five million tourists, of whom more than 6 million (9 percent) were Americans. Italy is the fifth most visited country in the world (after France, Spain, the United States, and China), and tourism accounts for about 5 percent of the country's GDP.

Truman was in a good mood, and when the press conference ended, he agreed to be photographed, dapper in a blue suit and smiling broadly, posed next to the pool looking at an Italian newspaper (which, of course, he was unable to read).

Word of Truman's visit to Naples had spread among the Americans in the city, and many made their way to the port, hoping to catch a glimpse of their onetime head of state. Among them was twenty-eight-year-old Joyce Ronald, an aspiring artist from Mitchell, South Dakota. After receiving an MFA from the University of Kansas in 1956, Ronald moved to Germany to continue her studies at the Landeskunstschule Hamburg. In February 1958 she moved to Florence to bask in that city's renowned art and architecture and to explore

the rest of Italy. Ronald sent occasional dispatches about her adventures to her hometown paper, the *Daily Republic*, which was owned by her family. In one missive, she said she sometimes felt overwhelmed living in Italy. "Coming from America where we aren't accustomed to actually living in an environment full of classical artistic masterpieces, I find that I am unable to spread myself too thin when it comes to seeing things here in Italy," she wrote. "I can only take a little at a time, look at it, kind of get used to it, think about it a while and then several days later investigate something else."

Ronald shared an apartment in Florence with a friend from Germany named Vera and a friend from back home, Lu Hiller. Many of her reports for the *Daily Republic* mention the young women's regular encounters with aggressive Italian men. "All Italian men LOVE foreign women," she wrote in one account. "The young Italian women, by custom, lead very sheltered lives until they are married or engaged and are not allowed to go out with young men in the evening or unaccompanied by relatives. So the Italian men are very unsubtle in their approach to foreign women."

> Vera, Lu and I have decided that all this business about Italian men being so fascinating and interesting is a bunch of bosh. Last night we found ourselves literally having to "beat them off." After dinner we went to a movie and afterwards, while walking home, they collected in hoards [*sic*] and were very unsubtle and obnoxious. After swearing at them in German and English, we took to swinging our purses at them. The complaint is not an egotistical one, but happens to all foreign women who visit here, whether they be beauties or beasts. And the men aren't harmful but just do a lot of very annoying verbalizing.

Men harassing foreign women was a tradition so ingrained in the culture that the Italians had a word for it: *gallismo*—"roosterism." In 1959 an Italian senator warned that *gallismo* was hurting the country's tourist industry. "No one who has been to Italy will be ignorant of what the senator means," wrote the *Baltimore Sun* in an editorial: "the infinitely unemployed young men who follow ladies in the street, pay audible compliments, sigh obvious sighs and pop up mysteriously in cafes, only to disappear as abruptly when the bill has to be paid." An Italian company even manufactured an "anti-masher gun"

for foreign women (*masher* is a somewhat dated term for a man who makes unwanted sexual advances). It was a water pistol that dispensed a foul-smelling dye. "Firing the pistol at an accoster not only wards off his attentions but leaves him marked for the police," one report on the device noted. "The user can arm her pistol with a distinctive dye, eliminating argument about whose pistol fingered the masher." In a demonstration of its effectiveness, the manufacturer armed "a bevy of buxom blondes" with the device and sent them all over the country. "All reported that timely use of the pistol had again and again spared them distress—if not disaster."

When the Trumans arrived in Naples on June 3, 1958, Joyce Ronald and her friend Lu happened to be visiting the city for a few days of sightseeing. They took a long walk that Tuesday morning, then bought a copy of the *International Herald Tribune* and went back to their hotel room to rest. "Lu was browsing through the paper and said, 'Gosh, Harry Truman is coming to Naples today aboard the *Independence*. Think we ought to go to see him?' 'Gee, I don't know, Lu—I'm pretty tired but I sure would like to see Harry and Bess. Let's go down to the desk and see if we can find out where to go,' says I." The concierge informed the two women that a bus would soon be leaving for the port to pick up passengers.

> We drove right through the gates and up to the dock. After we had stopped, the bus man asked us if we had a pass. We said no and he replied, "Oh well, you've gotten this far without one, you might as well go on in."
>
> We went through many more gates but were finally temporarily rebuffed at the final one. At this gate was a very firm Italian policeman. We decided to be very sweet, helpless and very unhappy about not seeing Harry.
>
> After 20 minutes of persuading him in bad Italian, he let us in. We felt this was an accomplishment because there were crowds of people waiting behind various other gates we had breezed through. We walked right up to the first class gang plank and were the only females amidst the dignitaries, political looking men and gentlemen with swords—all waiting for Harry.
>
> After a suspense mounting half hour, out came Bess and Harry. We were so excited we didn't do anything at first. Then

we ran up to where they were, all prepared to welcome them to Italy. Lu was so flustered she couldn't say anything. I managed to blurt out, "Hello Harry!" And I received what seemed to me a typical Truman answer: "Hello there Sissy."

Harry Truman was not the first former president to visit Naples. In December 1877 Ulysses S. Grant visited the city on his postpresidential world tour, and in April 1910 Theodore Roosevelt stopped by on his way home from a yearlong safari in Africa. Grant was welcomed by "a regiment of Bersaglieri," the Italian army's elite sharpshooters, famous for their wide-brimmed hats adorned with black grouse feathers. Teddy was "accorded a welcome by the thousands that crowded the piers that bore out everything ever said regarding the volatile character of the Latins." Truman himself had visited Naples briefly two years earlier as part of his whirlwind European tour. But that had been a more formal affair complete with attendants, official visits, and military escorts.

This time, however, Truman entered Italy as, he liked to say, an ordinary American—albeit one with a diplomatic passport, a courtesy routinely extended former presidents. Bess was on his passport too. At the time, most married couples were issued a joint passport, even if they used to live the White House. While married women were permitted to request a separate passport beginning in 1935, so-called family passports continued to be issued until 1981.

From the *Independence*, the Trumans and Rosenmans walked into the Stazione Marittima to undergo the formalities of entering the country. Opened in 1936, the maritime terminal was commissioned by Mussolini, who was determined to turn Naples into a center of tourism and trade on the Mediterranean. It was built in the monumental style popular among twentieth-century fascist dictators, imposing and boxy and festooned with allegorical figures in bronze, including the twin Greek gods Castor and Pollux, the patrons of sailors. Remarkably, it survived unscathed repeated bombings of the port in the Second World War.

Emerging from the building, the two couples saw before them Castel Nuovo, or the New Castle—built in the late thirteenth century—and behind it, high up on Vomero Hill, Castel Sant'Elmo, a hexagonal fortress that has loomed over the city since the sixteenth century. Then the two couples were whisked away in cars provided by the American consulate for a quick sightseeing tour of Naples, followed by a drive down the coast to view the ancient ruins at Herculaneum.

Harry Truman's diplomatic passport. Unlike most passports, Harry's was personally signed on page 2 by the secretary of state, John Foster Dulles. Bess was on the passport as well—under "Amendments." *Photos by author, courtesy Harry S. Truman Presidential Library & Museum*

Attempting to retrace Truman's route, I flew into Naples on a discount carrier in June 2022. Crossing the Atlantic on a luxury liner was unnecessary since, at the time, I was living in Sarajevo, where my wife, a US Foreign Service officer, was then posted. After checking into my Airbnb in the city center, I made my way down to the port. The Stazione Marittima looks almost exactly as it did when Truman came here. Transatlantic ocean liners rarely call on the city anymore—the RMS *Queen Mary 2* is the only liner still running a regular transatlantic schedule, and its usual eastern port of call is Southampton, England—but massive cruise ships are regular visitors. In 2019 Naples welcomed more than 1.3 million cruise ship passengers.

While ocean liners keep a sleek, low profile better equipped for traversing oceans, modern cruise ships are big boxy things, floating apartment blocks designed for navigating the calmer waters near coastlines. Notably less glamorous but markedly more affordable, cruise ships have democratized travel by ship, but at a cost. Friends of the Earth calls cruise ships "a catastrophe for the environment":

> They dump toxic waste into our waters, fill the planet with carbon dioxide, and kill marine wildlife. Cruise ships' environmental impact is never ending, and they continue to get bigger. They once were small ships, around 30,000 tons. Now, corporations are building billion-dollar cruise ships to hold more than 9,000 people. They're doing everything they can to pack these floating cities full of tourists while polluting everything in their path.

At wharf no. 9, where the *Independence* had docked, a cruise ship called the *Marella Discovery 2* was tied up. Launched in 1994, the *MD2* is, by today's standards, a relatively small ship, with room on board for just two thousand passengers—but that's still twice as many as the *Independence* carried. The *MD2* plies the waters of the Mediterranean, calling on ports in southern Europe, northern Africa, and the Middle East.

The newspapers make no mention of the sites the Trumans and Rosenmans visited in Naples, and Truman's papers offer no clues either. Surely they stopped by the Duomo, Naples's historic cathedral (Cattedrale di Santa Maria Assunta), which is famous for a miracle that occurs three times a year, when the dried blood of Saint Januarius miraculously liquifies in its small vial. It's likely they also visited San Domenico Maggiore, a breathtaking Gothic church built in the thirteenth and fourteenth centuries and the final resting place of the first bishop of New York, Richard Luke Concanen, who took Goethe's admonition *"vedi Napoli e poi muori"* ("see Naples and die") a little too literally. Pope Pius VII appointed Concanen bishop of the newly created diocese of New York in 1808, but embargoes imposed as a result of the Napoleonic Wars prevented him from crossing the Atlantic. Stuck in Naples, he administered the diocese by mail; you might say he worked remotely. Concanen died in Naples in 1810, having never set foot in his bishopric.

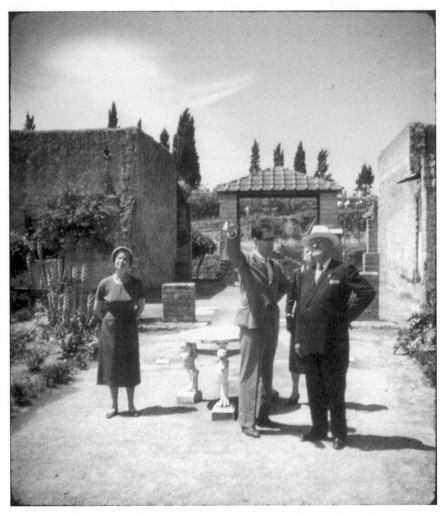

A guide points out a feature to Harry Truman at the ruins at Herculaneum. *Harry S. Truman Presidential Library & Museum*

From Naples the Trumans and Rosenmans went on a quick drive down the coast to visit the ruins at Herculaneum, the ancient Roman town that 1,879 years earlier—in the year 79 CE—was buried in a mudslide caused by the eruption of Mount Vesuvius. Most residents had time to escape, but the town they abandoned was hermetically sealed under thirty meters of debris and remained buried for fifteen centuries. Full-scale excavations did not begin until the nineteenth century. While nearby Pompeii is larger and more famous,

it was largely destroyed by fire before it was buried. Herculaneum, on the other hand, was left spectacularly intact, with frescoes and mosaics and even papyrus records surviving.

Still in his blue suit—no cargo shorts for this tourist—Harry, along with his companions, was given a guided tour of the ruins. Sam Rosenman was an avid photographer, and he took more than two hundred pictures during his and Dorothy's six weeks with the Trumans in Europe, using a Wollensak stereoscopic camera. These images, generously made available to me by the Rosenmans' grandson Robert Rowen, are a priceless document of the trip, as are the notes that Dorothy Rosenman later wrote on the slides.

In a photo taken at Herculaneum, the Truman party is standing in the courtyard of the Casa dei Cervi, the House of the Deer. It was a Roman noble family's home, built about twenty-five years before the eruption. The name comes from a marble sculpture in the courtyard depicting two stags being torn to pieces by dogs. Another sculpture in the courtyard depicts a very fat and drunk Hercules urinating (or attempting to). I bet Harry liked that one.

14 | GENOA

ON THE MORNING OF Thursday, June 5, 1958, the *Independence* reached Genoa, the great Italian port that gave the world Christopher Columbus and venture capitalists. With only seven hours to explore a city he had never before visited, Harry didn't waste any time. In another car provided by the American consulate, the two couples raced from site to site, guided by a local official named Giuseppe Lercaro. By the time the ship sailed for Cannes that afternoon, the couples had racked up an impressive number of sites, including the Christopher Columbus house, the Cattedrale di San Lorenzo, the skyscraper Torre Piacentini, and the Staglieno monumental cemetery.

A *La Stampa* reporter who seemed accustomed to more peremptory leaders shadowed the Truman party that day:

> Harry Truman has the virtue of smiling continuously and amiably when he is in public. The ex-President of the United States, after having been one of the protagonists of contemporary history, is today a modest but jovial gentleman of medium height, with white hair; his gray eyes always laugh behind two lenses supported by an economical frame. But as soon as he withdraws from the public, the hard aspect reappears, his eyes become cold: a simple funny guy would certainly not have been able to win so many political battles. But the signs of the battles, to tell the truth, have not remained in his physique: at 74 he is flexible, quick, as they have always shown us in the photographs.

With my guide and interpreter, Alessandra, I wanted to retrace Harry's steps through Genoa. But first we stopped at the city library to look up old newspaper articles about the visit. After reading through a few of them, Alessandra said Harry reminded her of a Genoese saying: *È buono come il pane*—He is as good as bread. I thought it was a nice way to describe him. From the library we zipped around the zigzag city, its ancient narrow streets intentionally convoluted to confuse enemy invaders, with Alessandra behind the wheel of her tiny Fiat, navigating through swarms of motorbikes buzzing like bees, and me watching my life flash before my eyes as every roundabout, crosswalk, and intersection seemed to promise a fatal collision.

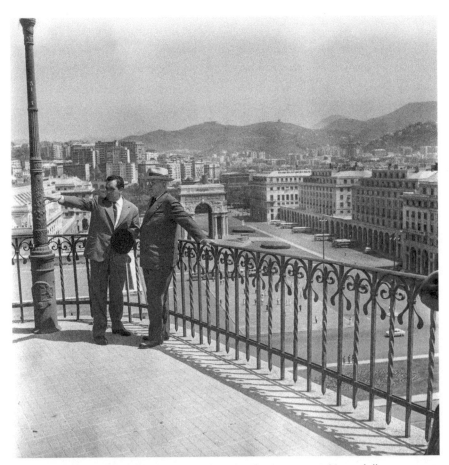

Truman and his guide Giuseppe Lercaro on the terrace at Mura delle Cappuccine. *Archivio Publifoto Genova*

We visited the Columbus house (an eighteenth-century reconstruction, alas) and the terrace at Mura delle Cappuccine that overlooks the city, where Harry was photographed chatting with his guide Giuseppe Lercaro. Then on to Staglieno, one of the most remarkable cemeteries in the world. Opened in 1851, it has expanded exponentially over the years and now covers a square kilometer, about 250 acres, making it one of the largest in Europe. It is also one of the grandest. In the nineteenth century the dearly departed began attempting to outdo each other in posthumous glorification. Long rows of graves are topped with ornate marble sculptures depicting angels, the deceased in life, or the family left behind in grief. Hence Staglieno is a monumental cemetery in both senses of the word. You can't take your money to the grave, but you can leave it at the door.

In 1867, ninety-one years before Harry visited, that other famous Missourian, Mark Twain, stopped by Staglieno on his Great Pleasure Excursion to Europe and the Holy Land aboard the ship *Quaker City*. In *The Innocents Abroad*, his otherwise cutting account of the trip, Staglieno is one of the few sites that escapes his withering criticism. Of it he writes:

> Our last sight was the cemetery (a burial place intended to accommodate 60,000 bodies,) and we shall continue to remember it after we shall have forgotten the palaces. It is a vast marble collonaded [sic] corridor extending around a great unoccupied square of ground; its broad floor is marble, and on every slab is an inscription—for every slab covers a corpse. On either side, as one walks down the middle of the passage, are monuments, tombs, and sculptured figures that are exquisitely wrought and are full of grace and beauty. They are new and snowy; every outline is perfect, every feature guiltless of mutilation, flaw, or blemish; and therefore, to us these far-reaching ranks of bewitching forms are a hundred fold more lovely than the damaged and dingy statuary they have saved from the wreck of ancient art and set up in the galleries of Paris for the worship of the world.

Harry and Bess at the Staglieno monumental cemetery. *Archivio Publifoto Genova*

When Harry visited, a photographer captured him striding past a long line of monuments in the colonnaded corridor like the one that Twain mentions, looking like he's inspecting an honor guard. Harry was never one for ostentatious displays of wealth, pre- or posthumous. The marker on his own grave is a simple, flat gray stone. But he could certainly appreciate the detail in these sculpted renderings: the lace on the grieving widows' collars, the folds in the angels' wings. This was real art.

The cemetery continues to do brisk business. When Alessandra and I pulled up on a Wednesday morning in April 2022, three gleaming new black Mercedes hearses were lined up at the front gate. Clutching a copy of the picture of Harry inspecting the monuments, I went with Alessandra in search of the spot where it was taken. We soon encountered a groundskeeper in a

long gray smock with a name tag that identified him as Angelo—pretty much the perfect name for a cemetery caretaker. Alessandra showed him the picture and asked him if he knew where it was shot. Angelo, a small, bald man with a thin mustache, was smoking a long, skinny cigarette. He took the photograph and studied it carefully, taking a long drag. There are now more than one hundred thousand graves at Staglieno, so finding one is getting close to needle-haystack territory. The pattern on the marble floor in the photograph, Angelo said, looked like it might be from the western arcade. But he needed to get another opinion.

He stubbed out the cigarette but kept the butt between his fingers, and we followed him into a small office where three other workers were taking a break, and the foursome gathered around a large map of the cemetery, passing the photograph among themselves and debating loudly the various possible locations. None of this was intelligible to me, and at times it seemed to me the discussion was on the verge of turning combative, but Alessandra was sanguine, and the two of us just lay back to let the men hash things out. In due time Angelo handed the photograph back to us and declared, a little proudly, that it had been agreed he was correct: the photo was taken in the western arcade.

We found the spot quickly, surprisingly.

The plaque on the wall to Harry's right reads:

IL 9 GIUGNO 1861
GIOVANNI PAGANO QUI POSE
LE SALME DELLA SPOSA LEONILDA
E D'ADRIA CHE NATA APPENA
SEGUE IN CIELO LA MADRE

Alessandra translated the text for me: "On the ninth of June 1861, Giovanni Pagano here placed the bodies of his wife Leonilda and of Adria, who, just after birth, followed her mother to heaven."

Not far from Leonilda and Adria, I noticed a marker for a Picasso who'd recently been laid to rest. It read simply, PAOLO PICASSO (1933–2021). Picasso is a common last name in this part of Italy. The artist took his mother's surname, and it's likely that his maternal ancestors once called Genoa home. According to an obituary on the Genoa newspaper *Il Secolo XIX*'s website, Paolo, the recently departed Picasso, was survived by his wife, three children,

and three grandchildren. A nephew who posted a comment on the site called Paolo the "unforgettable uncle" and "backbone of our family." He may not have been an international celebrity like his artistic namesake, but even based on this scanty research, it seems Paolo was a better husband and father, which certainly counts for something.

After the cemetery, we visited Cattedrale di San Lorenzo, a spectacular example of Gothic architecture and human perseverance: it took five hundred years to complete. What probably caught Harry's eye is the bomb in the nave. Launched by a British battleship during the siege of Genoa in February 1941, the shell crashed into the church but failed to explode. The bomb (now disarmed, presumably) is still on display. A sign thanks the Virgin Mary for intervening to spare the cathedral.

Our final stop was Torre Piacentini, a thirty-one-story building that was the tallest in Europe when it was completed in 1940, a title it held until the Kotelnicheskaya apartment tower in Moscow opened in 1952. By today's standards, Piacentini (now known as the Terrazza Martini Tower, after the Italian beverage company) isn't much of a skyscraper; at 381 feet, it wouldn't even be the tallest building in Salt Lake City (Wells Fargo Center, 422 feet). But when Harry visited, it was still the tallest building in Europe west of Moscow, with an observatory on the top floor offering spectacular views of the city and the Ligurian Sea.

It was here that one of the more amusing episodes of Truman's trip occurred, for when he went up to the observatory, Harry got his Vince Vaughn on and crashed a wedding. It turns out the observatory wasn't just a popular tourist attraction; it was also a popular venue for wedding receptions. A former president of the United States accidentally attending a Genoese couple's wedding celebration was unusual to say the least, but the bride and groom, Marisa Maffei and Tullio Vivaldi, were delighted, and Harry was, as usual, a good sport about it, posing for pictures with the bride and gratefully accepting the traditional sugar almonds that were offered him. The Genoa papers made much of this incident:

> When Truman entered, there was a wedding celebration and the former president of the United States, after having taken part in the celebration for some time, wanted to pose for photographers with the bride and groom, who will thus have a completely unexpected memory of their wedding.

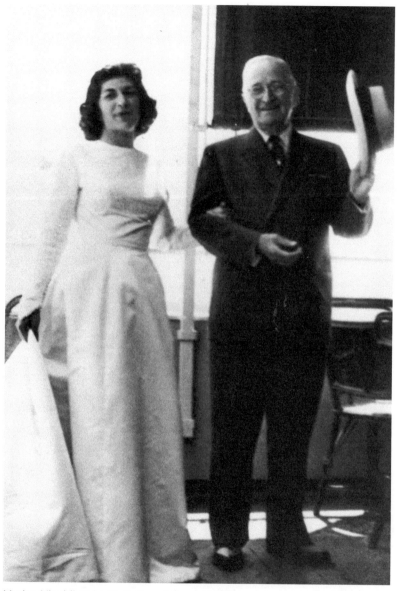

Marisa Vivaldi (née Maffei) and Harry Truman. *Harry S. Truman Presidential Library & Museum*

My attempts to find Mr. and Mrs. Vivaldi or their relatives were fruitless. If you can help, please let me know. I would love to find out how things turned out for them.

15 | LE FERMIER

FROM GENOA THE *INDEPENDENCE* sailed for Cannes. With France still coming to grips with de Gaulle's return, Truman had a decision to make: continue with the vacation and stay in France as planned, or abandon it and head straight home on the *Independence*. Fortunately, the situation in the country had stabilized in the week since de Gaulle returned to power. The general had appointed a "Cabinet of national unity" that included three former premiers, all of whom pledged to continue France's membership in NATO and the European Economic Community (the forerunner of the European Union). So, when the ship reached Cannes on the evening of Thursday, June 5, 1958, the Trumans and Rosenmans disembarked and, with their thirty-five trunks and suitcases, were whisked to Château Saint-Martin about twenty miles north in the hills above Vence.

"The first night we were at [Château Saint-Martin], we had dinner there," Dorothy Rosenman recalled many years later. "At breakfast the next morning, Sam said, 'Now where shall we go for lunch, and where shall we go for dinner?' The president said, 'It was very nice here. Why shouldn't we eat here?' Every place we went the next day and at least for a week, it would be the same answer, 'Well, it was very nice at the hotel; why don't we go back there?'"

Château Saint-Martin is still in business and still very much a luxury resort. A cheap room will set you back $500 a night. My wife and I splurged and booked a partially tax-deductible weekend there in June 2021. I told the concierge why we'd come, and after dinner one night he brought to our table a thick book filled with autographs from the hotel's many illustrious guests

over the years: Man Ray, Gene Kelly, Valéry Giscard d'Estaing, Art Garfunkel, Mel Brooks and Anne Bancroft, all four members of Pink Floyd, and, close to the front since he was a guest soon after the hotel opened, Harry Truman: "Kindest regards to M. and Madame Geneve from Harry Truman 6/30/58."

When Frank Sinatra learned the Trumans were staying in Vence, he wanted to invite them to a shindig he was planning in Monaco on June 14. Princess Grace—the former Grace Kelly of Philadelphia who had starred with Sinatra in *High Society*—had asked Frank to help her plan a big fundraiser for the United Nations International Children's Emergency Fund (UNICEF). The evening would begin with a special screening of Sinatra's latest film, *Kings Go Forth*. Then there would be a concert, with Sinatra performing. Then a party with dancing until the wee hours. Noël Coward was coming, and Somerset Maugham, and Peter Lawford. Of course, Prince Rainier and Princess Grace would be in attendance. Sinatra promised it would be a "swinging night." But Harry wasn't a swinger. He declined the opportunity to dance with the stars. He and Bess went to the opera house in Nice that night to enjoy, instead of Sinatra's singing, a concert of classical music—"real music, not noise," as he'd once put it.

Maybe the coolest thing Harry Truman ever did was say no to Sinatra.

Another cool thing he did was help Robert A. Carlone.

Château Saint-Martin today. Harry, Sam, and Dorothy hiked to the top of the mountain behind the resort. Bess did not. @chateaustmartin

In June 1958 Carlone was a twenty-nine-year-old US Air Force captain in Spain getting ready to transfer back to the States—always a hectic time. Carlone was a graduate of West Point, class of '52. He'd built model airplanes since he was eleven and long dreamed of becoming a pilot, but when he graduated, it was discovered he had a temporary vision problem, and the army wouldn't grant him a waiver to attend flight school. He was prepared to abandon his military career, but a chance encounter with a Pentagon official at the naval officers' club in Brooklyn resulted in him getting a waiver to enroll in the air force's pilot training program. He learned to fly the Convair C-131 Samaritan, a military transport plane, and became a flight instructor. Then he was sent to a university in Madrid to study Spanish, a tour that was now ending, and he and his wife, Rita, who was pregnant with their first child, were preparing to move back to the United States.

But before they left Europe, Robert's father was coming for a visit. John (né Giovanni) Carlone was sixty. He had emigrated from Italy to the United States thirty years before and hadn't been back since. John would join Robert and Rita on a long car trip, driving from Spain's Mediterranean coast, across the French Riviera, then down the Italian peninsula to John's home village, L'Aquila, in central Italy. There they would visit John's brother and sister, Paola and Letizia, whom he hadn't seen since leaving home, and whom Robert had never even met.

The trip went well until they reached Monaco, where John began to feel ill, and it was decided that he should cut the trip short and fly back to New York. On the day of his scheduled departure, he lay down in his room at the hotel to take a short rest before leaving for the airport. About thirty minutes later, Robert went to check on him and found his father dead. It was June 14, 1958, a Saturday.

When Robert notified the local authorities about the situation, he was told that he would have to leave his father in the hotel room (which was not air conditioned) until Monday, because the only licensed mortician in Monaco was away for the weekend. Finding this edict wholly unacceptable, John decided to walk to the American consulate and ask for help. That's when he had another memorable chance encounter. On his way to the consulate, he passed a side-walk cafe where he happened to notice an older couple sitting by themselves at a table. It was his former commander in chief, Harry Truman, enjoying a

sunny afternoon on the Riviera with his wife, Bess, before going to the concert at the opera house in Nice that evening.

"I decided to approach the President, advise him of our predicament and seek his advice," Carlone recalled many years later. Carlone introduced himself as an air force officer and began explaining his dilemma.

Truman motioned for him to sit down. After he heard the details, Truman said, "Son, do you have any paper?" Carlone handed him a small notebook he had in his pocket. Truman opened it and with a blue pen wrote a note for Carlone to give Harold Moseley, the American consul general who had greeted the Trumans and Rosenmans when they arrived at Cannes on the *Independence*.

> Hon. Harold Moseley:—
> This will introduce Captain Robt. A. Carlone.
> His father has just passed away. He needs some doors opened.
> Please help him.
> Harry Truman
> June 14, 1958

Truman handed the notebook back to Carlone. "I hope this does some good for you," he said. "If you ever get to Independence, please do look me up. Good luck to you."

The note that Truman wrote for Robert Carlone.
Harry S. Truman Presidential Library & Museum

Decades later, Carlone marveled at the twist of fate that brought him into Truman's orbit. "The impact of this note from President Truman was incredible," he wrote. "A State Department man was assigned to us, we were moved out of the hotel to another, a mortician made all arrangements from embalming to flying the body back to the states and every other detail was made. If we were not blessed by this chance meeting with President Harry S. Truman, I dread the thought of the probable outcome."

Later that year, Rita Carlone gave birth to a beautiful baby girl. Sadly, she would die before her fourth birthday, a victim of childhood leukemia. In her memory, Robert and Rita established one of Colorado's first chapters of the Leukemia Society (now known as the Leukemia & Lymphoma Society).

Robert Carlone would serve a tour in Vietnam flying C-123s that supplied troops, evacuated the wounded, and sprayed the defoliant Agent Orange. He flew 163 missions. On a mission supporting troops in Khe Sanh in 1968, his plane was hit by more than one hundred rounds of enemy fire, but he managed to land it safely. He was awarded the Silver Star and a Purple Heart. His exposure to Agent Orange also resulted in health problems including type 2 diabetes. He rose to the rank of colonel. He retired from the air force in 1973 and eventually settled in Colorado Springs.

In 1996 he attended a talk given by Robert H. Ferrell, the Truman biographer extraordinaire, at the Air Force Academy in Colorado Springs. Afterward, Carlone told Ferrell the "cherished story" about his encounter with Harry Truman thirty-eight years earlier. Ferrell encouraged him to write the story down and send it to the Truman Library, which he did in a letter dated September 30, 1996. "Please use this, if you see fit, in any way," he wrote. "It was a tremendous honor to have met the President and he certainly had a profound impact on my personal life and as a proud citizen of this country, as he was."

Robert Carlone's daughter Leezá Carlone Steindorf says her father spoke often of his encounter with Harry Truman. "Not only the serendipity of the meeting and the generosity of the president but mostly because his father was a huge figure in his life and his death overseas was a life event for him," she told me. "My father's story is unique in itself, as he was the son of uneducated immigrants and had an extraordinary drive and created a highly successful life and legacy."

The Trumans and Rosenmans spent three weeks at Château Saint-Martin. *Radar*, one of France's glossy celebrity magazines, described a typical day for Truman:

> Mr. Truman has drawn up a precise program of "relaxation": in the morning, he will hike the Alpes-Maritimes. . . . At noon, Harry Truman will feast on the excellent Provençal cuisine, of which he is a connoisseur. In the afternoon, he will read, play the piano and lie down for a few hours in the shade of the pines, all with a smile, like someone who has long been estranged from these simple pleasures.

The morning hikes were part of Harry's health regimen. In the summer of '58, he was still remarkably fit, especially for someone born at a time when penicillin was undiscovered, vaccines were scarcely available, life expectancy at birth was just forty-two years (now it's seventy-nine), and 157 of every 1,000 children born in the United States died before their first birthday (today the rate is 7 in 1,000). Harry himself had an older brother who died shortly after birth. He knew he had survived long odds just to make it to seventy-four, but he still expected to live much longer. After all, his mother, Martha Truman, had made it to ninety-four. Harry attributed his continuing good health to his habit of taking long, brisk morning walks, a habit he had no intention of abandoning on vacation. In Independence, a local cop, Mike Westwood, usually accompanied Harry for his morning exercise, the role requiring a conversationalist more than a bodyguard. Harry never liked to walk alone, literally or figuratively, and in Vence he convinced Sam Rosenman to join him on his morning ambulations. Harry still insisted on walking at his old army marching rate of 120 steps per minute, and although age may have diminished his speed somewhat, he still set a formidable pace—especially for Sam, who rarely exercised.

Harry and Sam would get a ride up the winding road that leads from Château Saint-Martin to a plateau, where they would tread well-worn trails. Interestingly, this area is famous for its paranormal activity. UFOs have been sighted there frequently, and strange lights are reported at night. Harry and Sam reported nothing unusual on their walks (at least that I could find). I didn't see anything weird either, though it was quite foggy when I visited—not ideal UFO spotting conditions.

"My children will never believe this," Sam told Harry one morning. "I want you to write out something and tell them about the early morning walks so they will believe this." So Harry got up early one morning and in his idiosyncratic slashing script wrote out an "affidavit" for Sam to show his children:

Sam (left) and Harry on one of their morning walks.
Harry S. Truman Presidential Library & Museum

Now comes Harry S. Truman, who being duly sworn, doth depose and state as follows, to wit:

That on certain days between the 7th day of June 1958 and the 30th day of June 1958, twelve days in all, Samuel I. Rosenman, a person well known and highly regarded as to truth and veracity by said Harry S. Truman, did arise at an early hour on each of said days and walk over certain parts of the Alpes Maritimes in the southern part of France from eight o'clock until ten o'clock for a distance each day of 2.7 kilometers or nearly two miles at a hundred and twenty steps per minute, duly timed and counted, without stopping until the whole distance was covered; that said Samuel I. Rosenman did this of his own free will and accord without coertion [*sic*]; and further deponent saith not.

Signed Harry S. Truman

Occasionally the Trumans and Rosenmans would take day trips to nearby towns: Nice, Èze, and Cannes in France, Sanremo and Ventimiglia in Italy. The chateau supplied the couples with a Cadillac (a 1955 Fleetwood Sixty Special four-door sedan, for all you car buffs) and a chauffeur, who acted as an ad hoc tour guide. Everywhere he went, Harry remembered, "They yelled at me . . . in a most happy and friendly manner." Restaurants routinely refused to take his money, he explained in a letter to a friend, "because of the Marshall Plan, Point 4 and Korea! Beat that if you can." (The Point Four Program, so named because it was the fourth point in Truman's 1949 inaugural address, provided technical and financial assistance "for the improvement and growth of underdeveloped areas.") Wherever he went, as Truman wrote his friend Tom Evans from France, he always "[had] to behave." He explained, "When I stop to look in a store window or to buy a little H2O flavored with bourbon I am an animal escaped from the circus known as the 'Striped-Assed Donkey from Missouri.'"

Truman was spotted in Sanremo on the Italian Riviera on June 25. "While the ladies visited some clothing and antiques shops," *La Stampa* reported, "Truman and his companion took their places on the terrace of a café almost in front of the Casino and stayed there for over half an hour. Only after a while was the former U.S. president recognized by passers-by, who nevertheless limited themselves to greeting him cordially without disturbing the tranquility of his holidays, requesting autographs or other such intrusions."

It wasn't only the ladies who shopped on this vacation. Harry, the erstwhile haberdasher, made several purchases himself. At Barclay, a swanky *tailleur* in Nice, he bought a dozen silk neckties for eighty-five dollars.

When they were leaving Sanremo, the Cadillac stalled on a narrow street. The car would have to be pushed to pop the clutch and restart it. "Some young men approached to help those they considered ordinary tourists," *La Stampa* said.

> Their surprise was therefore very remarkable when suddenly, opening a door, they saw Harry Truman get out of the car, smiling and lending a hand to push and overcome the obstacle. This stop lasted for a few minutes; while the car was moving off, those present applauded the former U.S. president who, before returning to France, also visited Bordighera and Ventimiglia.

I was unable to find any photographs of this episode, which surprised me, because a pack of photographers seemed to follow the former president everywhere he went on his Mediterranean vacation. These photographers would soon be known as paparazzi. An incident that occurred later in 1958, shortly after Harry went home, popularized the term. It all started with an Italian photographer named Tazio Secchiaroli, who eked out a living as a teenager after the war working as a *scattini*, a photographer taking pictures of tourists in Rome. Of course, many tourists never bothered to meet up with Secchiaroli after he'd developed their pictures in that predigital age. And once cheap consumer cameras became widely available, the *scattini* were rendered obsolete. So Secchiaroli adapted by shooting pictures of celebrities sipping coffee along Via Veneto and selling them to the glossies. These candid, unposed shots proved wildly popular with readers long accustomed to the boring staged publicity photos provided by movie studios.

On August 14, 1958, Secchiaroli snapped a picture of the deposed Egyptian king Farouk in a cafe with two women, neither of whom was his wife. Enraged, the king lunged at Secchiaroli, an incident captured by another photographer on the scene. This brought Secchiaroli to the attention of the Italian director Frederico Fellini, who based a character in his classic 1960 film, *La Dolce Vita*, on the pesky newspaper photographer. Fellini named the character Paparazzo. He chose that name, Fellini later explained, because it suggested to him "a buzzing insect, hovering, darting, stinging."

Unlike many of their targets, Harry Truman really didn't mind the protopaparazzi too much. He'd always had a good relationship with photographers, who, when he was president, were always asking him for "just one more." Truman always obliged, reasoning that "photographers have to make a living, too." After the restrictions placed on them by the preceding administration—FDR, of course, could never be photographed in a way that would make his disability obvious—the grateful photographers formed the One More Club, naming Truman its president. In 1947 the club presented Truman with two cameras: a Graflex Crown Graphic still camera and a Magazine Cine-Kodak 16mm movie camera. Truman took the movie camera on his European vacation in 1958, and in 2022, archivists at the Truman Library and the Harry S Truman National Historic Site discovered eighty-eight seconds of film shot on the trip. It's mostly footage taken on Harry and Sam's morning walks, along with a few shots outside Château

Saint-Martin. Much of it is pretty shaky; Harry Truman, it seems, was a poor cinematographer.

Harry took the photographers who hounded him in stride; it was something that he was well accustomed to. His traveling companions, however, found it tiresome and annoying. "Occasionally we spied someone up a tree with a mini-camera," Dorothy Rosenman remembered. When the two couples visited Èze, a lovely seaside village, they were besieged by a horde of pushy photographers. Dorothy and Bess began to complain loudly, only to be chastised by Harry. "As we went through the old gate, the President drew us to the parapet and gave us a thorough tongue-lashing," Dorothy later wrote. "The tenor of it was: 'After all the efforts I have made to make friends of these nations, you can destroy it by your actions. I want you to stop.' We did."

To the freelance shooters who stalked celebrities across Europe for glossy magazines like *Paris Match* and *Radar*, Harry Truman was an irresistible target. Not because he was glamorous like a movie star but because he was so unusually ordinary. Here was the man who authorized the use of atomic weapons and sat across the table from Stalin strolling down the alleys of Vence, hat in hand, lounging in the hotel pool, or dining with his wife at an outdoor café, just another aging American tourist. Truman would feign surprise at the photographers' interest in him, protesting that he was just a "simple farmer on vacation." *Paris Match* referred to him as *le fermier*—the farmer—when it published a large photo of him and Dorothy Rosenman lounging side by side in a hotel pool. "In typically French fashion," Dorothy recalled, "*Paris Match* carried a picture of the President and me in the pool with a caption which gave the impression that we were vacationing together—no mention of our spouses."

The two couples also ventured farther west in Provence, visiting sites in and around the city of Arles. On this excursion their guide was Margaret Privat, who was married to the mayor of Arles, Charles Privat. Mme Privat spoke perfect English, but with a hint of a Mid-Atlantic accent—because she was from York, Pennsylvania. Just two years earlier, she had been Margaret Boltz, an unmarried, thirty-four-year-old elementary school teacher in York. But in the summer of 1958, she was the first lady of an ancient French city, escorting the former president of the United States on a sightseeing tour.

Born in Lebanon, Pennsylvania, in November 1921 to a steelworker father and a homemaker mother, Margaret volunteered for the Women's Army Corps in the summer of 1942 and was trained in cryptography. After the war she went

to college and earned a teaching certificate. Then she moved to Paris, where she studied "high fashion and millinery" while also working as a secretary for an American intelligence officer. After three and a half years in Paris, she was fluent in French, and she moved back to her home state and began teaching the language to elementary school students in York. After the excitement of the war years and Paris, settling in York must have been a bit of a letdown (not that there's anything wrong with York—it's given the world peppermint patties and barbells, after all—but it's not Paris).

York's elementary school French-language program was most unusual. Then, as now, American public schools rarely offered foreign language instruction in elementary school. But the York city school district's director of elementary education, Victoria Lyles, believed language barriers needed to be broken to improve human relations, and in 1951 she convinced York's board of education to adopt the elementary French curriculum. The program came to the attention of Monde Bilingue, an organization that promoted French language instruction abroad, whose general secretary, Jean-Marie Bressand, lived in Arles. Bressand wrote Lyles, proposing their cities "twin" by exchanging official delegations and cultural programs. Lyles founded the York Twinning Association in 1954. Two years later, the two cities initiated a teacher exchange program: a French teacher from York would go to Arles to teach English for a semester, while an English teacher from Arles would come to York to teach French. Margaret Boltz was chosen as York's first teacher for the program. She left York for Arles in December 1956. She would never return to the city permanently.

In Arles, Margaret began socializing with Mayor Privat, whom she'd met on a trip to the city arranged by the Twinning Association the previous summer. The mayor was a widower in his early forties, a hero of the resistance during the Second World War who was awarded the Legion of Honor. A member of *le Parti socialiste* (the Socialist Party), Privat had been elected mayor of Arles in 1947 and was acclaimed for his efforts to rebuild the city's economy and infrastructure after the war. The American exchange teacher and the socialist mayor fell in love, and Peggy from York and Charles from Arles were married on Christmas Eve 1957 in a church in the French city. This was big news back in York, of course. "The twinning ties between York and Arles, France, were solidified Christmas eve when exchange teacher Margaret V. Boltz became the bride of the mayor of Arles, Charles Privat," the *York Daily Record* reported.

"Mme. Privat wore for the wedding a white wool dress studded with rhine-stones and fashioned along empire lines." The couple honeymooned in the French Alps and then returned to Arles in time to hold a New Year's party.

Margaret Privat never abandoned her American roots. Her cooking, she said, was "a wedding of Pennsylvania Dutch and southern French cuisines." She helped organize a youth baseball team in Arles. The Trojans, as they were named, played their home games inside the city's ancient Roman coliseum, and Margaret helped raise money to buy their uniforms and equipment.

Margaret continued to teach, though her role as the mayor's wife also took much of her time. The steelworker's daughter from central Pennsylvania was now managing a full schedule of social events on the French Riviera. So it wasn't a complete surprise when she and her husband were invited to meet Harry and Bess Truman when they came to Arles with the Rosenmans in June 1958. But she didn't expect to be their tour guide.

"I didn't realize we were going to spend time with them like that," Margaret explained in a letter to her parents in Harrisburg. "I thought it would be an introduction and a few polite words and goodbye."

> We took the Trumans to the antique theater, the arena, the cloister of St. Trephine, the two museums containing Roman sarcophagi and the mosaics and the Venus d'Arles and the Christian museum of sarcophagi and the subterranean grain storage place and the Les Aly-scamps and from there they left us and it was then just a bit past 12:30 so you can see how fast we did it. But it was because they were that much in a hurry and wanted to make another trip in the afternoon.
>
> Mrs. Truman sat in the car while we did the second museum and the cryptoportiques and also didn't get out at Les Alyscamps. She is just like she always seemed in the movies and pictures and he true also to the pictures, very smiling and looking terrific for 74 years old, really amazing. He is somewhat bigger than I imagined him, unless it is from looking at smaller men here. I talked a lot with both of them. He said that the mayor of Pittsburgh probably will be the next governor of Pennsylvania. [Truman was correct: Pittsburgh mayor David L. Lawrence, a Democrat, was elected governor that fall.] I remarked that he still very closely follows

the political scene and he said that he feels he owes the party so much that he wants to help them all he can.

I forget exactly how he put it but I remember I replied that the only thing I do understand about the actions of men in political positions is that one never knows whether what they do is really for the good until very much later. When I told Charles this he got a big kick out of my having touched on the subject of politics with the president. Last thing Truman said when leaving was that I should send him one of the pictures we took for our [the Trumans'] personal use.

Shortly after the Trumans' visit, Charles Privat was elected to the French National Assembly, the equivalent (roughly) of the US House of Representatives, though he continued to serve as mayor of Arles as well. He retired as mayor in 1971 and from the assembly two years later. He died in August 1990 at the age of seventy-six. Mme Privat died in 2011 at age eighty-nine. She was buried next to her husband in a cemetery at Saint-Maurice-de-Cazevieille, a village in the French countryside about forty miles northwest of Arles and four thousand miles east of York.

In 1973 budget cuts killed York's ambitious elementary school French program and, along with it, the teacher exchange program. But the York Twinning Association is still going strong. Although exchange programs with Arles and another sister city, Leinfelden-Echterdingen, Germany, were suspended for the COVID-19 pandemic, they were scheduled to resume in 2023.

As was his custom, during his vacation Harry Truman occasionally jotted down his thoughts on whatever paper was at hand. Seeing the ancient and medieval sites in southern France put him in a contemplative mood, and one day at Château Saint-Martin, he pulled out a piece of hotel stationery and mused on the past and future:

In this South of France there are many places worth seeing for their historical background. There are also some beautiful views if you can get yourself to forget the vandalism of the ignorant Christian Middle Age before the Renisance [sic]. Some of the most beautiful monuments of antiquity were used as quarries and some were wilfully destroyed for propaganda purposes.

Athens, Rome, Alexandria, the great cities of the Nile and the near east along with the historical cities of this southern France are only a few examples. My interest has been to see what a great civilization of the past could do and had done. It makes me wonder what may happen to our so called modern set up. Some three or four thousand years hence there will be wonder as to what we were trying to do. Maybe we'll end up as a lost Atlantis, a destroyed Knossos, a burned Rome and a maliciously destroyed Athens, Alexandria or the ruins in Vietnam and at B[u]khara and Samarkand—who knows.

We may be able with the great scientific discoveries to make Gobi, Sahara, and all of the great American deserts bloom and support in luxury the billions yet unborn or we may use those same scientific discoveries to turn our planet into a fire ball again and fulfill the prophecy of Noah's time about a world destruction by fire instead of the purported destruction of that day. Who knows?

One of the sites close to Château Saint-Martin that the couples visited was the Matisse Chapel, just a short drive down the hill near the center of Vence. Designed by Henri Matisse in the last years of his life, the chapel—formally known as Chapelle du Rosaire (Chapel of the Rosary)—is so beautiful that some visitors are moved to tears. Blue and yellow stained-glass windows fill the room with an ethereal glow that changes according to the whims of the natural light outside. The chapel is Matisse's last, and by many accounts his greatest, masterpiece. It was completed in 1951, just three years before the artist died at the age of eighty-four. On the walls are stark images, murals drawn on white ceramic tiles with simple thick black lines, depicting the Virgin Mary, Saint Dominic, and the Stations of the Cross. Unable to stand, Matisse painted these seated in a wheelchair, with a brush attached to a long pole. That Matisse, an indifferent Catholic and in his life's end stage, came to create one of the most magnificent chapels in Christendom is itself a minor miracle.

Born on the last day of 1869, Matisse seemed destined to be a lawyer like his father, until he suffered a bout of appendicitis at nineteen. To help him pass the time as he recovered, his mother bought him a set of paints, a gift that would change the course of his life and the history of art. Unconstrained by formal training, Matisse, like his friend and rival Picasso, ignored the rigid rules of proportion, perspective, and color that had governed Western art for

centuries. Sometimes he didn't even use a brush: he applied paint to the canvas directly from the tube. *Femme au chapeau* (*Woman with a Hat*), a portrait of his wife, Amélie, looks half-done, the face shaded green.

It was another illness that brought Matisse to Vence and led to the creation of the Chapelle du Rosaire. In 1941, when he was seventy-one, Matisse underwent an operation for intestinal cancer. His recovery was slow and painful. One of the nurses hired to care for him was a young woman named Monique Bourgeois. Although more than fifty years separated them, the artist and the nurse became close friends. The relationship was flirtatious but platonic, their rapport genuine. "M. Matisse was sometimes very cheerful, teasing and mocking me," Bourgeois remembered, "but my playful nature easily adapted to this; we were soon friends."

The friendship continued even after Bourgeois left Matisse's employ to join a convent and become Sister Jacques-Marie. The two kept in close contact. "Although she is a Dominican nun, she is still a marvelous person," Matisse wrote in a letter to a friend in April 1947.

> We talk about this and that in a particular tone of voice, with a lot of gentle teasing. When she had gone, Mme Lydia [Delectorskaya, one of Matisse's models and his longtime companion] expressed her surprise at our way of conversing. I know what struck her: a certain tenderness can be detected, although none is intended. I expressed what was going through Lydia's mind by telling her it was a kind of flirtation. I should like to write "*fleur*tation," because it's rather as if we were throwing flowers at each other's faces, rose petals. And why not! This affection which needs no words yet which brims with meaning is not forbidden.

When Sister Jacques-Marie's order decided to erect a new chapel in Vence, she enlisted Matisse to design it. The artist plunged into the project with his usual obsessiveness. He not only designed the stained-glass windows and painted the tiled walls but also designed the vestments to be worn by the officiants. The project consumed four years, and Matisse considered it the crowning achievement of his career. "This chapel is for me the culmination of a lifetime of work," he wrote, "and the fruit of immense effort, heartfelt but difficult."

With its shimmering colors and striking murals, the magnificence of the chapel is undeniable, indeed, overwhelming, even to visitors exhausted by extended sightseeing. It is a special place.

In the summer of 1958, Harry Truman visited the Matisse Chapel with Bess and the Rosenmans. The chapel had opened just seven years earlier and was not yet considered the landmark it is today: in the 1958 *Michelin Guide*, it merited just one star (out of three) as an "interesting" attraction (two stars was "worth a detour," three stars "worth a special journey"). Truman thought even that single star was one too many. Less than a year later, at the March 28, 1959, meeting of the board of directors of the Truman Library, Truman gave his unvarnished opinion of the Matisse Chapel. Attending the meeting was the historian Arthur Schlesinger Jr., a member of the board and, fortunately for history, an inveterate notetaker.

> HST, as usual, talked a good deal of American history, overflowing with facts and opinions, a good many of them wrong, yet conveying a sense that he regarded all past figures more or less as contemporaries. He thinks every great President has been followed by a mediocre President and claims to include Adams, Madison, Van Buren and himself in the list of mediocrities; makes an exception for Andrew Johnson.
>
> On Modern Art, he was, as usual, at his worst. He told how one evening at Mary Lasker's he looked hard and attentively at a Picasso on her wall until she came up and asked him what he thought about it. HST then said, "Mary, there is just one thing wrong with it; you've hung it upside down."
>
> "I can't understand these modern fellows. I went to a chapel in Southern France decorated by—what's the fellow's name?— Matisse. I've never seen such a thing on my life. There was the Virgin with a couple of big tits spilling out over her dress. I walked through it and never said a thing."

16 | WHEN HARRY MET PABLO

PABLO PICASSO MET JACQUELINE Roque in 1952. She was working at Madoura, the pottery in Vallauris where Picasso made his ceramics. She was twenty-five, divorced with a young daughter. He was seventy and living with another woman, Françoise Gilot, with whom he had two children. He was also still legally married to his first wife, the Russian ballerina Olga Khokhlova, whom he'd wed in 1918. Khokhlova had long sought a divorce from her dissipated husband, but Picasso would not consent to one because, under French law, Khokhlova would be entitled to half his estate. So, even as Picasso moved through a series of long-term relationships—Marie-Thérèse Walter, Dora Maar, Françoise Gilot, and, finally, Jacqueline Roque—and fathered four children with three women, he was still technically a married man. (Khokhlova died of cancer in February 1955 at the age of sixty-three.)

Understandably, Roque was reluctant to become involved with this painter who was a conspicuously notorious womanizer. But Picasso was a dogged suitor. He delivered a single rose to her every day for six months until she agreed to a date; being fabulously rich and famous also probably didn't hurt his cause. In 1953 Françoise Gilot left Picasso, taking their two children with her. Picasso was furious. "Even if you think people like you," he told her, "it will only be a kind of curiosity they will have about a person whose life has touched mine so intimately." Picasso was even more incensed when in 1964 Gilot published a bestselling memoir about their time together, and he ultimately disowned their two children. Gilot, an artist herself, later married Jonas Salk, the developer of one of the first successful polio vaccines. In 2021, one

of her paintings sold for more than a million dollars. She died in June 2023 at the age of 101.

In 1954 Roque moved into Picasso's home in Vallauris. A year later, they moved to Villa La Californie, an imposing mansion high up in the hills above Cannes. As Marie-Thérèse Walter, one of Picasso's previous paramours, once observed, when the artist changed the woman in his life, he also changed everything else, including his home.

Villa La Californie was built by a French general in the early 1920s. The boxy three-story residence, noted for the green ceramic tiles that covered its roof, was already a local landmark when Picasso and Roque moved in.

It was quite unusual for Picasso to welcome strangers into his home. Roque was his gatekeeper, and she usually kept the gate shut tight. Her job, as she saw it, was to keep Picasso from being distracted. As a result, Picasso's last two decades—his two decades with Roque—were the most productive years of his life. But by acting as Picasso's gatekeeper, Roque also alienated herself from the artist's family and friends, opening wounds that would never heal.

"She felt the most important thing for him, for his benefit, was to make his work," Arne Glimcher, founder of Pace Gallery in New York, told the *New York Times* in 2014. "I've seen that with many older artists. What they want most in the world is to get out the work while they have a limited amount of time." Trying to meet with Picasso was like trying to meet the pope: only the most well connected and important were granted an audience. It helped to be worshipful too.

When it came to modern art, Harry Truman was anything but worshipful, but he was certainly well connected and important, and the letter of introduction from Alfred Barr was enough to gain admission to Picasso's inner sanctum. Whose idea was it for the two men to come together? While Truman insisted Picasso requested the meeting, why would he? How would Picasso have even known Truman would be in the area? For that matter, why would Truman request a meeting with Picasso, whom he regarded, if not with disdain, at least with incuriosity?

In my opinion, neither man requested a meeting with the other. Rather, the encounter was orchestrated by Barr, with encouragement from Sam Rosenman, since he and Dorothy had become quite the connoisseurs of modern art. Barr set two people up on a blind date without telling either that it was a date. It

was kind of brilliant actually, arranging this meeting between two of the most famous people in the world and making each believe the other requested it.

"So one morning we were sitting out on the terrace having breakfast," Dorothy Rosenman recalled,

> and I said, "If we're going to see Picasso we'd better call and make an appointment." And at that (the president had gone inside for a moment) Bess said, "I don't think we ought to go to see Picasso." I said, "Why not?" Bess said, "You know what Harry thinks about modern paintings." We [Dorothy and Sam] both said, "You've got something there." When he came back, I said, "Bess raises a point," and I repeated it. He said, "Of course I want to go. He's the foremost painter of the time; of course I won't say anything to hurt his feelings." So we made an appointment and we went.

Around noon on Wednesday, June 11, 1958, Harry and Bess and Sam and Dorothy climbed into the big black Cadillac provided by Château Saint-Martin and made their way from the hills above Vence to the Picasso residence. Just getting to Villa La Californie was difficult. The mansion was at the top of a narrow switchback road that was difficult for big cars to navigate. Maybe that was one of the reasons Picasso liked it. Even today, in a small rental car, some of the turns are so tight they require two-point turns. I'd hoped to visit La Californie myself, but I lacked Truman's connections. The mansion is now occupied by Marina Picasso, Pablo's granddaughter, who inherited one-fifth of his estate, including thousands of works of art—and Villa La Californie, which she calls Pavillon de Flore. Marina is the son of Paulo Picasso, who was Pablo and Olga Khokhlova's only child.

It comes as no surprise that the Picassos were an aggressively dysfunctional family. Pablo often ignored his children, denying them affection and financial support. Same with his grandchildren. In a 2015 interview, Marina told the *Guardian* that Pablo was "non-existent" as a grandfather.

> It was complicated by his last wife Jacqueline, who, to protect him, excluded others, including my father. When my father wanted to see him at the villa, he would have to wait four, five, six hours outside in the street before being received. To a child of four or five

that left a strong impression. I still have a trauma with notions of time, if I have an appointment and the other person is not quite on time, I really suffer. I've worked on it, but before it was very bad.

I sent several letters to Marina at La Californie explaining my project and asking if, notwithstanding her ambivalence toward her grandfather, she would be kind enough to allow me access to the premises, even for just a few minutes. She never replied. In June 2021 I drove up to the mansion just to have a look, accompanied by my interpreter, Eleonora. The villa is on a dead-end street, behind a high stone wall that makes it impossible to see anything on the property. We felt somewhat conspicuous sitting there in the car just staring at the wall like we were casing the joint. After a minute or two, a groundskeeper suddenly appeared and eyed us with suspicion, so we turned around (three-point turn) and skedaddled.

In 1957, the year before the Truman party visited, the writer Carlton Lake went to Villa La Californie to interview Picasso for the *Atlantic*, and he described the scene he encountered upon approaching the imposing residence in the hills:

> Finally, with a certain amount of backtracking, I found Picasso's street. I followed it slowly uphill and after climbing a couple of hundred meters came, on the right, to a villa half hidden by a high black iron fence with a wide, even higher black iron gate. Both the fence and the gate were reinforced with black metal sheeting that closed off the view. Between the wide double gate and a smaller, similarly barred doorway was a marble plaque with the single word *Californie* incised in it. This, I knew, was my destination. . . . The villa, as nearly as I could tell from outside the iron curtain, was a large, bulky, squarish place with a comfortable 1900 look about it. It was three stories high. The windows on the two upper stories—the only ones I could see—had wrought-iron balconies and were crowned by some rather intricately carved scrollwork.

Picasso's home was as chaotic as his personal life. He'd converted La Californie into a sprawling atelier, filling the cavernous rooms with paintings, drawings, ceramics, and sculptures, all in various stages of progress. Picasso

was a hoarder, much to the benefit of art historians—and his heirs, who would donate much of the contents of his homes to the French government in lieu of estate taxes. "He seldom threw anything away, even old envelopes," his biographer John Richardson wrote, "so his hoard was constantly growing and threatening to engulf room after room."

> Everything had its allotted place. I remember an unopened bottle of Guerlain cologne inscribed *"Bonne Année, 1937"*; a framed letter from Victor Hugo to a mistress; masks of all kinds, from eighteenth-century Venetian ones to modern monstrosities in rubber; a Daumier bronze; a model of Barcelona's Christopher Columbus monument in marzipan; a set of Hepplewhite chairs bought by Picasso's father from an English wine merchant in Mál- aga; an ancient panettone that had been nibbled away by mice and resembled a model of the Colosseum; a pile of good, bad, and indifferent tribal sculpture; a distorting mirror from a fairground; photographs (some of the best by Jacqueline) of bullfights and friends; hats by the hundreds; and piles of letters, many of them marked with a cabalistic sign—the word ojo (Spanish for "eye") drawn like two eyes and a nose, meaning "Attention." Nesting in the clutter would be a number of Picassos: among them the bronze cat he used as a stool, precarious stacks of ceramics, lithographs and linocuts pinned to boards, paintings and drawings of all peri- ods, framed and unframed, in all states of completion.

Picasso saved everything—even his nail clippings, which he believed could be dangerous if they fell into the wrong hands. "My father gave me his nail clippings because he was very frightened that people would use them against him," recalled Maya Ruiz-Picasso, his daughter with Marie-Thérèse Walter, in an interview shortly before her death in 2022 at eighty-seven. "He was afraid that someone, anyone, would take them and cast some kind of spell. He gave them to my mother or to me, because he knew that we loved him and we weren't going to cast a spell on him."

And then there were the animals. Picasso loved animals—more than humans, some thought—and his menagerie at La Californie included two dogs (a Dalmatian named Perro and a dachshund named Lump), a parrot, multiple

songbirds, and Picasso's pride and joy, a goat named Esmeralda, who was given free rein of the premises, outside and in. In fact, Picasso went through a long goat phase, during which he portrayed the animal in drawings, paintings, ceramics, and sculptures. In the garden at La Californie there was a bronze sculpture of Esmeralda that the real Esmeralda liked to lick.

So that was the scene that greeted the Trumans and Rosenmans when they arrived at La Californie on that warm June day in 1958 and were ushered into the mansion. It was wild, man.

After a short interval—Picasso always kept people waiting; it was one of his many unattractive peculiarities—the artist and his companion appeared and introductions were made, with Roque and the Rosenmans collectively interpreting for the Trumans and Picasso.* The two American couples had dressed up for the occasion. Harry and Sam both wore dark suits and ties. Harry's suit was double breasted, Sam's single breasted. A triangle of handkerchief poked perfectly out of each man's left breast pocket. Bess and Dorothy wore simple summer dresses in light pastels. Bess also wore white gloves. Roque wore a light blue knee-length skirt with a matching jacket.

Pablo, on the other hand, was casually attired in a vibrant, blue long-sleeved button-up shirt, open at the collar and untucked, with black slacks and white canvas espadrilles. Truman, the former haberdasher who always dressed impeccably, must have given Picasso the side-eye. (I am reminded of his criticism of MacArthur's rumpled appearance in his memoirs.) But Picasso, like Truman, actually chose his attire with great care, ever mindful of the impression he would make or wished to make. His clothier was an Italian tailor, Michel Sapone, whom Picasso gave but one directive: he wanted clothes that would make people say, "Wow, where did you get that?" Sapone made clothes for many famous artists in southern France, including Alberto Giacometti, Hans Hartung, and Joan Miró. He was discreet, and he was happy to accept payment in paintings in lieu of cash. The walls of his humble shop in Nice were covered with works by the century's greatest artists, and when he died, his heirs inherited art worth millions today. Sapone and Picasso became quite close, and the tailor would often visit La Californie with his family, bringing a big dish of pasta for lunch.

* Although he did not share a common language with the Trumans, "Picasso had the gift to get along with people of whose language he knew little or nothing."

Everything Picasso did was calculated. "Tyrannical, entitled and possessed of a massive ego, he used an almost cynical playfulness to project another face to the world," fashion writer Dylan Jones wrote in a 2020 article for *British GQ*. "One of the ways he did this was through what he wore." Picasso always wanted to stand out—insisted on standing out—and demanded to be the center of attention. And so it was when the Trumans and Rosenmans visited. His outfit certainly contrasted with those of the two other men in their conservative suits. By Picasso's standards, however, his attire that day was relatively sedate. He eschewed, for example, the eccentric pants with horizontal stripes and his trademark striped Breton shirt.

The three couples had lunch at the villa. The meal was prepared by Picasso's cook, a maid named Garance (Picasso employed a small army of domestics). The menu is lost to history, though according to John Richardson, who dined with Picasso at La Californie many times, the food served at the villa was usually "simple, basic fare."

After lunch—or perhaps before, the timeline is unclear—Picasso gave his guests a tour of Villa La Californie. From this tour came Harry's one vivid memory of the day. He told the story at the same Truman Library board of directors meeting at which he memorably described the Virgin Mary at the Matisse Chapel. "He had a picture of a goat, and there was the real goat wandering around the yard," Truman said (according to Arthur Schlesinger Jr.). "I said to him, 'Do you mean to say that you took this beautiful goat and turned it into this monstrosity and can say to me that they look alike?' He turned on his heel and walked away. The Boss [Bess] was never so mad at me in her life."

Surely Truman exaggerated. Rather than walking away from criticism, Picasso was much more likely to challenge it. Perhaps he responded by telling Truman one of his favorite stories, about an American GI who came to visit his studio in Paris:

> Right after the Liberation, lots of GIs came to my studio in Paris. I would show them my work, and some of them understood and admired more than others. Almost all of them, though, before they left, would show me pictures of their wives or girl friends. One day one of them who had made some kind of remark, as I showed him one of my paintings, about how "It doesn't really look like that, though," got to talking about *his* wife and he pulled out a tiny pass-

port-size picture of her to show me. I said to him, "But she's so tiny, your wife. I didn't realize from what you said that she was so small." He looked at me very seriously. "Oh, she's not really so small," he said. "It's just that this is a very small photograph." [Picasso laughs.] . . . It sounds silly, I know, but it's true. . . . *Eh bien*, it's the same story here—[he points to a canvas]—it's a question of *optique*.

In the garden Picasso showed his guests one of his sculptures, *L'homme au mouton* (*Man with a Lamb*), a nearly seven-foot-tall bronze of a man holding a lamb. The man's legs are unnaturally elongated, and the lamb seems to be emerging from his belly. The surface of the statue is rough, seemingly unfinished. Picasso created this piece in Paris during the war. Three copies were cast. One Picasso donated to the town of Vallauris, where it stands in a park. Another was sold to a Philadelphian, R. Sturgis Ingersoll, who donated it to the city's art museum. The third was in his backyard, standing in a large patch of tall grass. (Today it's at the Musée Picasso in Paris.) In a photograph, Dorothy Rosenman is seen gently touching the sculpture with her right hand. Picasso stands on her right, seemingly explaining the piece. Dorothy, who wore heels that day, stands over Picasso, and the statue towers over them both. It would be nice to know what Picasso told her. *Man with a Lamb* is considered one of Picasso's most enigmatic pieces, and its meaning is much debated. Does it represent the Lamb of God? Peace? Or is it a memorial to the victims of war? Picasso always insisted it symbolized nothing, but that was his stock answer to the eternal question: *What does it mean?*

When the painter and writer Dorothy Koppelman saw one of the casts of *Man with a Lamb* in 1945 in New York, she wept.

> I was so struck by the impact of this man, roughly hewn, heavy, mute, coming towards us over many centuries—this tall, massive figure gripping the legs of and simultaneously cradling the young lamb with his thin, yearning, outstretched neck—I simply dissolved in tears. The artist has given us *man*, at the beginning both raw and noble, a brute with immense kindness—at once solidly on the earth and rising proudly in space.

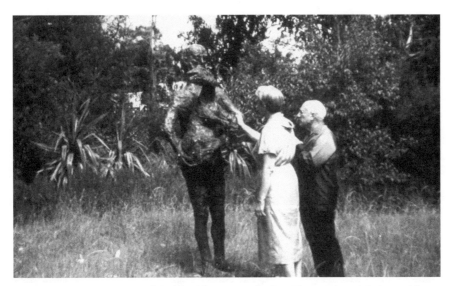

Dorothy Rosenman and Pablo Picasso admire Picasso's sculpture *Man with a Lamb*. Robert Rowen

Of Harry S. Truman's reaction to this masterpiece of twentieth-century art, Dorothy Rosenman simply noted, "HST is confounded."

As Dorothy and Picasso walked away from the statue, Picasso bent down, picked a single flower, a bird of paradise, and presented it to Dorothy.

After he finished showing them around Villa La Californie, Picasso asked the couples if they had visited Madoura, the pottery in Vallauris where he made his ceramics (and, of course, where he met Roque). "We said, 'No, but we're going,'" Dorothy remembered. "He hopped in the car and rode along with us." The couples had only expected to have lunch with Picasso, but now he would give them a guided tour of his haunts on the Riviera.

When Picasso first visited Vallauris in 1946, Madoura's owners, Suzanne and Georges Ramié, invited him to use the pottery. He did, and he enjoyed working in this new medium so much that he moved to the town in 1948, taking up residence in an old perfumery. Picasso would make hundreds of pieces at Madoura—plates, vases, jugs, statues—which he decorated with his favorite motifs: owls, doves, Minotaurs, fish, and, of course, goats. Some he allowed to be reproduced in limited editions ranging from twenty-five to five hundred because, he said, "he wanted everyone who came to the pottery to be able to pick up a Picasso with the change in their pocket."

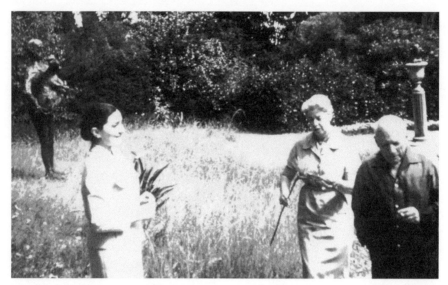

Jacqueline Roque, Dorothy Rosenman, and Pablo Picasso in the garden at La Californie. Dorothy is holding a flower that Picasso picked for her. *Robert Rowen*

Picasso was greeted warmly when he moved to Vallauris but largely left alone, which is why he donated one of the casts of *Man with a Lamb* to the town—it was a thank-you gift. Vallauris had been a center of pottery for centuries, but the proliferation of aluminum, tin, and plastic goods in the first half of the twentieth century decimated the industry. Single-handedly, Picasso revived it. Once he moved in, dozens of new potteries opened, and by 1965 more than three hundred potters were employed in Vallauris.

Vallauris was also where Picasso executed one of his most ambitious works, the giant diptych mural *War and Peace*, which he painted on flexible panels that were attached to the walls inside a deconsecrated medieval chapel in the center of the town. It was, in a way, his response to Matisse's chapel in Vence, though Picasso's chapel is small and dark, almost cave-like. It was also a kind of sequel to *Guernica*, but like most sequels, it's not quite as good as the original. *War and Peace* is conspicuously partisan: the war panel depicts a communist hero defending mankind from a monster riding a carriage filled with corpses (that would be capitalism)—not exactly subtle. The Chapelle de la Guerre et la Paix (Chapel of War and Peace) was scheduled to open to the public officially on June 28, 1958, seventeen days after the Trumans and Rosenmans visited Picasso. The artist must have had much to do to prepare for the opening,

which makes his day spent sightseeing with them all the more noteworthy. (The formal opening would end up being canceled by the de Gaulle government for unspecified "safety reasons.")

According to Dorothy Rosenman, Truman and Picasso "compared notes" when they met. Despite their vastly different political and artistic leanings, the two men had a few things in common. Both were left handed, both were very conscious of their appearance, and both thought de Gaulle was a jackass. Their paths had even crossed before, in a way: Truman once refused Picasso a visa to visit the United States. It was in 1950, and Picasso was leading a "peace delegation" of twelve European intellectuals and politicians who wanted to deliver a petition to Congress calling for "immediate reduction of war budgets and military forces, and prohibition of atomic weapons." The group represented the World Peace Council (also known as the World Congress of Partisans for Peace), an organization founded in 1949 by the Soviet Union's international propaganda arm, Cominform. Picasso drew the WPC's symbol, a white dove, which soon became a symbol for the peace movement worldwide.

The Picasso group's visa request put the United States in a bind, as Walworth "Wally" Barbour, the State Department's consular officer in Moscow, explained in a cable to Secretary of State Dean Acheson on February 21, 1950:

> If visas refused, Soviet press will presumably present decision as another example aggressive reactionary policy US Government, fearful of democratic peace forces, while if granted, statements made in US by Picasso, Aubel and other foreign delegates will be similarly used by Soviet press to emphasize same points. [Eugène Aubel was a French biochemist and outspoken communist.]

Truman's ambassador to France, David K. E. Bruce, urged the State Department to issue the visas, explaining in a cable that "on balance the disadvantages of refusing visas Picasso and Aubel would outweigh advantage in so far as France concerned":

> In view his world-wide reputation, refusal of visa to Picasso would certainly cause unfavorable comment here, particularly in intellectual and "liberal" circles. It would also tend to suggest that we have something to fear from Communist "peace" propaganda.

Ultimately the State Department rejected the group's visa request. In a statement, the department called the World Peace Council the "leading over-all Communist-front organization in the world" and a "major Soviet instrumentality for propaganda and political pressure." The department also said the twelve applicants were all "either known communists or fellow travelers and therefore subject to exclusion from the United States under the immigration laws." The FBI and State Department had been keeping tabs on Picasso since at least October 1944, when the artist released a statement explaining why he had decided to join the French Communist Party:

> I have become a Communist because our party strives more than any other to know and to build a better world, to make men clearer thinkers, more free and more happy. I have become a Communist because the Communists are the bravest in France, in the Soviet Union, as they are in my country, Spain. I have never felt more free, more complete since I joined.

According to a heavily redacted version of the FBI's dossier on Picasso (file no. 100-337396), which was released in 1990, the agency classified Picasso as a "Security Matter—C" (for communist) and a possible "Subversive." The American and French governments expended considerable resources keeping tabs on the short bald man who drew funny pictures. It's possible he was under surveillance on the day he went sightseeing with Harry Truman.

Picasso gave the Americans a tour of Madoura, showing them the long wooden tables where the clay was worked into shape and the kilns where flames transformed it into pottery. At Madoura, Pablo invited Dorothy and Bess to each select a ceramic plate to take home. Dorothy chose a rather conventional plate. Bess, however, picked one that depicted a very Picassoesque faun, the half-man, half-goat creature of mythology, a favorite theme of the artist at the time.

"Why did you select that?" Dorothy asked Bess. "You know you don't like that type."

"If I'm going to have a Picasso," Bess answered, "I'm going to have a Picasso."

The plates are still in the families. They're now worth somewhere in the neighborhood of $10,000 each.

After the tour, everybody posed for pictures outside in front of the door-way. They all took turns standing with Picasso, like guests posing for pictures with the bride at a wedding: the three women with Picasso, the Rosenmans with Picasso, the three couples posing together, and, of course, that memorable picture of Picasso and Truman shaking hands. (Here I am reminded of the Alice Roosevelt Longworth quote about Teddy Roosevelt: "My father always wanted to be the corpse at every funeral, the bride at every wedding, and the baby at every christening." Picasso was that way too.)

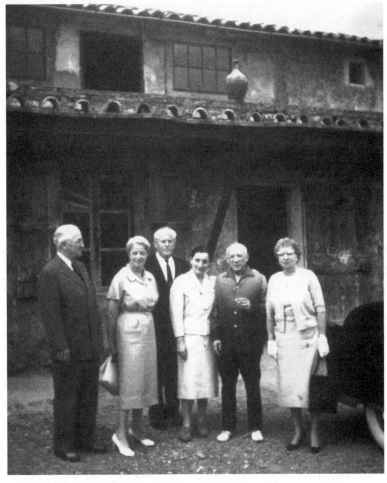

Group photo! The three couples pose in front of the Madoura pottery in Vallauris. From left to right: Harry Truman, Dorothy Rosenman, Sam Rosenman, Jacqueline Roque, Pablo Picasso, and Bess Truman. *Robert Rowen*

When I went to Vallauris with my interpreter, Eleonora, in the summer of 2021, I was disappointed to find the Madoura pottery closed, surrounded by a chain-link fence with a sign warning against unauthorized entry. A few blocks away, we visited the Musée Magnelli, a pottery museum where many of Picasso's ceramics are displayed. The museum director, Céline Graziani, explained to me that the Madoura pottery had been vacant for years, and the complex was falling into disrepair. Local officials had raised €3 million to restore it and turn it into another Picasso tourist attraction. But bureaucratic delays and the coronavirus pandemic had put those plans behind schedule. The pottery is now scheduled to reopen by 2025. Meanwhile, the market for the pieces that Picasso made here continues to boom. A 2012 Christie's auction of 543 Picasso ceramics grossed a staggering $12.5 million.

From Vallauris, the three couples made their way five miles east to the seaside town of Antibes. Picasso began vacationing in Antibes in 1920 with his first wife, Olga Khokhlova, who enjoyed socializing with the wealthy Russians who wintered on the Riviera. Picasso enjoyed the spectacular scenery and abundant sunlight. Picasso, with his then-companion Françoise Gilot, resumed vacationing in Antibes. In 1946 he was introduced to the curator of the town's museum, the tall and dapper Romuald Dor de la Souchère.

The museum in Antibes occupied Château Grimaldi, a medieval fortress that dates to the fourteenth century, probably built on the ruins of a Roman fortress that had stood on the site centuries earlier. When the big square building was up for sale in 1925, Dor de la Souchère, who taught Greek and Latin at the local secondary school and dabbled in archeology, raised enough money to buy it and turn it into a museum, "in which all curiosities, *objets d'art* and, in general, all documents of interest to the natural sciences, history, art and archeology of the district of Antibes will be assembled." It was, for a time, a sleepy local museum, but Dor de la Souchère had grand ambitions for it, and when Picasso mentioned that he "needed space," the curator offered him a room in the museum to use as an atelier. Implicit in the offer was the understanding that Picasso would, in return, donate a painting or two to the museum.

To Dor de la Souchère's surprise and delight, Picasso said yes. "I set him up in the large room on the second floor," Dor de la Souchère later explained.

> I have arranged for all he could need: easels, tables, mattresses for resting, colors and brushes. I have told Sima [the Polish art-

ist Michel Sima, born Michał Smajewski, who was Dor de la Souchère's assistant] to look after him, to serve him and supply him with all he might need for his work. I have given Picasso the key to the room and he has tied it to his belt. . . . He came just about every day early in the afternoon and painted, often until very late in the evening, by the light of two enormous projectors. With the most heterogeneous objects found in the museum stock, he assembled a great number of objects in a disorder which pleased and often inspired him. . . . He arrived at the museum on the 17 September. He left on the 10 November to return to Paris, before the arrival of the cold weather and perhaps because his adventure had simply ended.

Picasso left behind twenty-three paintings, which are still in the museum's collection today. He enjoyed the arrangement so much that he moved from Paris to Antibes in 1948 and continued to work at the museum until he moved to La Californie in Cannes in 1955. Picasso donated so many pieces to the museum that there was barely room for anything else. In 1966 the museum would be named in his honor, becoming the first Picasso museum in the world and the first museum ever dedicated to a living artist. Today the museum's collection includes 245 works by Picasso, and before the pandemic it welcomed more than 125,000 visitors a year.

The curator of the Musée Picasso today is Jean-Louis Andral, who works out of a small office on the museum's second floor, just a few steps away from where Picasso worked. The room's one, small window looks out onto the impossibly blue Mediterranean. When I met with him in June 2021, the museum was still getting on its feet after a series of COVID-19 lockdowns in France. Jean-Louis has written a history of the museum and a book about Picasso's time in Antibes, but before I contacted him, he didn't know that Picasso had given Harry Truman a tour sixty-three years earlier, and he was intensely interested in the story. I asked him to imagine what it must have been like, the former US president and Picasso exploring the collection.

"It probably wasn't a very big deal," he tells me in English, which, fortunately for me, he speaks perfectly. "The staff was accustomed to famous visitors. He [Picasso] knew the staff of the museum, which was not big at that

time, maybe one or two people inside the museum, you know, so he was a permanent guest. So he could come anytime, of course."

After we chatted in his office, Jean-Louis gave me a tour of the museum, stopping to pause at some of his favorite paintings: *Fillette au panier de fleurs* (*Young Girl with a Flower Basket*), *Le peintre et son modèle* (*The Painter and His Model*), *Femme couchée à la mèche blonde* (*Woman Lying with Blond Hair*). Then we stepped out onto the terrace, which affords sweeping views of the coastline.

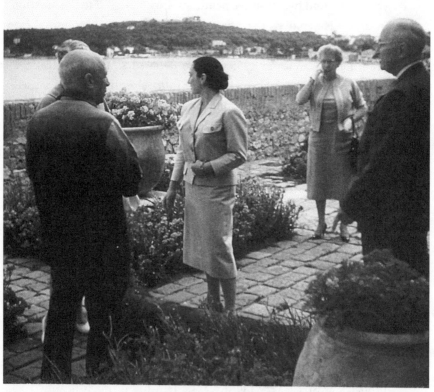

Pablo and Harry in conversation on the terrace at Château Grimaldi. Jacqueline stands in the middle, Bess in the back. *Harry S. Truman Presidential Library & Museum*

Sam Rosenman took two pictures of Picasso and his "tour group" on the terrace. In one, Picasso and Harry seem to be engaged in conversation. In the other Harry is walking away from Picasso, toward the camera, his hands thrust in his jacket pockets. Behind him, Picasso and Dorothy Rosenman are looking down at some planted flowers, chatting. The look on Truman's face is inscrutable. He could be thinking to himself, *Well, that was the damnedest conversation I ever had!* Or maybe he just needed to go back to the car to fetch something.

The terrace has changed little since Truman was here, apart from the addition of several sculptures by the French artist Germaine Richier, who died just a year after the Truman visit at the age of fifty-six. Jean-Louis pointed out several landmarks, including the La Garoupe lighthouse, which was visible on the peninsula in the distance. Then I took his picture, trying to replicate Sam's terrace photos, positioning Jean-Louis roughly where Picasso had stood.

Harry walks away, while Dorothy and Pablo look over the flowers. Bess is standing at the left. *Robert Rowen*

Jean-Louis Andral, chief curator of the Musée Picasso in Antibes, on the museum's terrace, June 2021. *Photo by author*

Although he does not appear in either of Sam Rosenman's photos taken on the terrace, I am fairly certain the museum's founding curator, Romuald Dor de la Souchère, was in attendance that day. At seventy, he was still hale and hearty, and it seems unlikely he would miss this important visit. He must have marveled at what he had wrought, transforming this museum from an obscure provincial repository of curiosities and documents to an internationally renowned museum of modern art. "Antibes was the first Greek colony towards the sunrise in the western Mediterranean," Dor de la Souchère once wrote.

> It is on the orbit of a sea route that in the 16th century was called the "island route" with the final destination being Málaga, the last Greek colony towards the sunset. Picasso was born at Málaga: in his Château at Antibes, we can see the first museum that any artist lived to see dedicated to his glory. Picasso, who felt at home everywhere, was foremost an inhabitant of Antibes, since visitors come from all over the world to see the "Picasso of Antibes," now one of the magnetic poles of modern painting.

That was the end of the tour. The couples said their goodbyes and au revoirs. Roque and Picasso were returned to La Californie, and the Trumans and the Rosenmans went back to Château Saint-Martin.

In the car on the way back to the chateau, Bess mentioned that she'd noticed Jacqueline make the sign of the cross when the group passed through a disused chapel at Château Grimaldi. "It won't help her," Bess said; "it won't help her a bit."

The next day, Sam Rosenman wrote Alfred Barr a letter thanking him for arranging the visit:

> Dear Mr. Barr
> Many thanks for your kind help in opening the door to the "Private World of Pablo Picasso."
>
> We all had a most interesting and enjoyable day. After showing us his studio and garden, he took us over to Vallauris to his ceramics studio, and then to the museum at Antibes, which is presently exhibiting many of his pictures. He is a most vibrant personality with great enthusiasms and vivacity—and we were very happy to have had the opportunity to meet him. Mme. Roque also was very charming. They both send you their most cordial greetings.
>
> I am grateful to you for your courtesy.
> Very sincerely yours,
> Samuel I. Rosenman

Apparently sent in the same envelope was a note that Harry wrote to Barr—a little terser and giving no indication that Picasso had converted him to the modern viewpoint in art:

> Dear Mr. Barr:—
> I'm in agreement with Judge Rosenman. All of us had a most pleasant and instructive visit with Mr. Picasso.
>
> His museum in the old Roman Fort was intriguing, especially with regard to the Roman artifacts. Picasso's pictures and ceramics were also very interesting.
>
> Thanks very much for your interest in arranging the visit.
> Sincerely,
> Harry Truman

Barr later wrote Picasso: "Judge Rosenman and Mr. Truman wrote me after their visit telling me how much they had enjoyed meeting you and how

generous you had been in receiving them." That was laying it on a little thick, but despite their innumerable differences, Truman and Picasso really did hit it off. "I went to lunch with Picasso," Truman later said of that day. "A short, jolly man, bald, I liked him a lot."

Remarkably, no paparazzi captured the spectacle of Truman and Picasso touring the South of France. No doubt the two principals were grateful for that, though the photographers must have kicked themselves when they learned the two famous men had spent the day together: pictures of the former US president and the communist artist cavorting would have been worth a fortune.

Shortly after Harry met Pablo, a letter from Dale Pontius, the Roosevelt University professor who had wanted Truman to ask Picasso about painting a mural at the school, finally reached the former president in Vence. Pontius had erroneously addressed it to Nîmes. "We think it would be a great event for the Middle West to get his consent to paint one of his challenging murals on the walls of our university," Pontius wrote. "We would greatly appreciate any good words you might be able to offer to gain his acceptance."

Truman sent Pontius a handwritten reply:

> June 15, 1958
> Professor Dale Pontius
> Roosevelt University
> Chicago, Ill.
> Dear Professor Pontius:
> Your letter of June 4th arrived after our call on Picasso—at his request.
> Anyway it seems to me that a university named Roosevelt would try to obtain one of our able American painters for your purpose rather than a French Communist caricaturist.
> Sincerely,
> Harry Truman

On July 1, the Trumans and Rosenmans boarded the *Constitution* for the trip home. The vacation had been, Harry later wrote, "a joyously good time from start to finish." Before the ship departed, Harry held one last press conference in the ship's salon, commenting for the first time on domestic politics in the United States, since, he reasoned, being on an American ship sailing for New York was akin to being on American soil. Mostly he wanted

to talk about the "failures and bunglings" of the Eisenhower administration. "The people of the United States of America understand the facts now," he said. "They undoubtedly will express their views about what has been going on in the White House next November and in November 1960. They will not be misled and fooled as they once were by Mr. Nixon, his little dog, and a Madison Avenue script with Hollywood overtones."

Harry also mentioned to reporters that he'd met with Pablo Picasso while he was on the Riviera. He said he'd had an "interesting 2-hour talk" with the artist. When a reporter asked him if he'd invited Picasso to visit him in the United States, Truman answered, "We do not invite Communists to visit the United States."

EPILOGUE

THE ASSOCIATED PRESS'S BRIEF account of Truman's visit with Picasso appeared in many American newspapers on July 2, but the report was overshadowed by world events, namely the ongoing crisis in Algeria and the Cuban revolution. Coincidentally, the biggest story on the front page of the *New York Times* that day was the demolition of a dam on the New York–Ontario border that created a massive new lake (and forced the relocation of ten communities on the Canadian side), an important step in the completion of George Dondero's pet project, the St. Lawrence Seaway.

Truman's meeting with Picasso was still important symbolically. In a world growing more divided by the minute—ideologically, socially, and culturally—the news that these two figures representing wildly divergent worldviews could spend a pleasant day sightseeing together was a welcomed respite from the strife that seemed to cover every inch of the front pages.

But it didn't exactly rock the world.

That's because the world was changing, and rapidly. As the *Constitution* carried the Trumans and Rosenmans back to the United States in July 1958, Althea Gibson, a Black American, won her second consecutive women's singles title at Wimbledon, and President Eisenhower signed the Alaska Statehood Act (it would officially become the forty-ninth state the following January). Later that month, a skiffle band from Liverpool, the Quarrymen, made their first record, a cover of Buddy Holly's "That'll Be the Day" and an original composition called "In Spite of All the Danger." Two years later, they changed their name to the Beatles.

We don't know what George Dondero made of the Truman-Picasso summit. His reaction was likely similar to that of a local French prefect who, according to Dorothy Rosenman, gave Truman "a good scolding" because "he felt that he shouldn't have gone to see Picasso, that it only encouraged Picasso because Picasso was a communist."

The fact that the Truman-Picasso summit made such small waves proved, in a way, that Alfred Barr had achieved his ultimate goal for modern art: widespread public acceptance. What was once avant-garde was moving into the mainstream. Cubism, now fifty years old, seemed almost quaint compared to newer movements like abstract impressionism. In January 1961, John F. Kennedy, the first president born in the twentieth century, took office. The Kennedy administration pointedly supported modern art and the people who made it. Alfred and Margaret Scolari Barr were invited to attend the inauguration, as were two artists whose work was included in the ill-fated Advancing American Art exhibition fourteen years earlier: Stuart Davis and Max Weber. In November 1962 Jacqueline Kennedy attended an art exhibition in Washington, DC, sponsored by the Organization of American States, admiring abstract and postimpressionist works by artists from Argentina, Brazil, Chile, and Uruguay. On October 26, 1963, less than four weeks before he was murdered, John F. Kennedy delivered the most forceful defense of art and artists by a US president to that date. "If art is to nourish the roots of our culture," Kennedy said in a eulogy for the poet Robert Frost at Amherst College, "society must set the artist free to follow his vision wherever it takes him."

> We must never forget that art is not a form of propaganda; it is a form of truth. . . . In free society art is not a weapon and it does not belong to the spheres of polemic and ideology. Artists are not engineers of the soul. It may be different elsewhere. But democratic society—in it, the highest duty of the writer, the composer, the artist is to remain true to himself and to let the chips fall where they may. In serving his vision of the truth, the artist best serves his nation. And the nation which disdains the mission of art invites the fate of Robert Frost's hired man, the fate of having "nothing to look backward to with pride, and nothing to look forward to with hope."

I'm writing this paragraph on my laptop while waiting for my car to be serviced at the dealer. Decorating the drab gray walls of the waiting room are two generic abstract paintings, black-and-gray squiggles on white canvas, no doubt purchased from a wholesaler who specializes in furnishings for such

public spaces. Modern art is mundane now. Some would argue it's not even modern anymore.

As the *Constitution* neared New York, Harry Truman sat down and carefully wrote out a list of the items he and Bess had accumulated overseas and would be importing into the United States, noting their value: those silk neckties ($85.00), handkerchiefs ($32.26), five bottles of perfume ($25.00), and so on. Included on the list was "Picasso 1 plate," which Truman valued at $50.00. Harry calculated the total value of his and Bess's imports at $510.65 (though on his customs declaration he rounded the amount down to $510.00—scandalous indeed). At the time, tourists returning to the United States could import goods worth up to $500.00 duty-free, so the Trumans were required to pay only a small import tax. (Today the limit is $800.00.)

When it came to converting Harry Truman to the modern viewpoint in art, Alfred Barr had, alas, failed again. Just like when Barr sent him that book on modern art back in 1947, Harry still thought it was all ham and eggs. Bess remained unconverted as well. Back home in Independence, a local newspaper reporter asked her what she thought of Picasso. "I'm not an art critic," she said, "but I think any 11-year-old could do what he is doing."

In 1959 Sam and Dorothy Rosenman went to Japan. They invited the Trumans to join them. Harry declined. "I would love to," he said, "but I don't dare." Only fourteen years had passed since he'd authorized the use of atomic weapons against Japan. Understandably, he felt he would not be welcomed with open arms. But in Japan, Dorothy found the former president would have been received warmly. "They respected him so much because of the way he controlled the military," she said. "In other words the MacArthur incident," referring to Truman's firing of General Douglas MacArthur for insubordination in 1951.

Harry Truman, Sam Rosenman, and Pablo Picasso all died within six months of each other, between December 1972 and June 1973. Bess Truman died in 1982, Jacqueline Roque in 1986, and Dorothy Rosenman in 1991.

ACKNOWLEDGMENTS

MANY PEOPLE HELPED MAKE this book possible. The art historian Jessica Skwire Routhier read the manuscript and her suggestions improved it significantly. My interpreters Alessandra Blondet in Italy and Eleonora Larina-Kaabi in France were indispensable (and excellent travel companions). Cammie Williams translated the Italian newspaper articles into English for me.

For sharing their insights, I am indebted to Jean-Louis Andral, chief curator and director of the Musée Picasso in Antibes, France; Danielle Mohr Funderburk, collections manager, and Aaron Levi Garvey, director of curatorial affairs, at the Jule Collins Smith Museum of Fine Art at Auburn University in Auburn, Alabama; Céline Graziani, director of the Musée Magnelli in Vallauris, France; and Julián Zugazagoitia, director of the Nelson-Atkins Museum of Art in Kansas City, Missouri.

As usual, the staff at the Harry S. Truman Presidential Library & Museum was supremely helpful. I am especially grateful for the assistance of Jim Armistead, archives specialist, Laurie Austin, audiovisual archivist, and Randy Sowell, archivist.

Thanks also to Valerie Muller, head of communications at the Château Saint-Martin & Spa in Vence, France, and Carla Reczek, librarian at the Detroit Public Library in Detroit, Michigan.

Clifton Truman Daniel, Eve Kahn, Rebecca Keim, Anne Stewart O'Donnell, John Petersen, and Lucy Roche assisted with research.

I am grateful to Lynn Garland, Andrew Rowen, and Robert Rowen, grandchildren of Samuel and Dorothy Rosenman, for their support.

Numerous archives and libraries were consulted, and each was invaluable: Museu Picasso de Barcelona; Musée national Picasso-Paris; Library of Congress Main Reading Room, Manuscript Reading Room, and Newspapers and Periodicals Reading Room, Washington, DC; the Museum of Modern Art Archives,

New York City; National Archives at College Park, Maryland; National Gallery of Art Library, Washington, DC; Office of the Historian, Foreign Service Institute, US Department of State, Washington, DC; and Smithsonian Institution Archives of American Art, Washington, DC.

I am especially thankful to those who shared their memories and family stories of meeting Harry Truman on this trip: Melanie Carlone, Mark Flaherty, Robert Hofmekler, Frank J. Hoose Jr., Tom Hoose, Eliot Pontius, Julie Simpson, and Leezá Carlone Steindorf.

I am deeply grateful to Jerry Pohlen, my editor at Chicago Review Press, for his encouragement and advice throughout this project, as well as all the others we have worked on together over the past fifteen years. Thanks also to the superb production team at CRP, including Frances Giguette, Jonathan Hahn, and Benjamin Krapohl.

To Jane Dystel, my literary agent, your guidance and support have been, as always, inestimable. Finally, to my wife, Allyson, and our daughter, Zaya, thank you for your love and support, and for putting up with my stories about Picasso and Truman.

NOTES

Introduction

"termites": 81 Cong. Rec. H11584–11585 (daily ed. August 16, 1949).

"ham and eggs art": Drew Pearson, Washington Merry-Go-Round, *Winona (MN) Republican-Herald*, February 18, 1947.

"half-baked": Drew Pearson, Washington Merry-Go-Round, *Indianapolis Star*, June 3, 1947.

"I am going to tell you": Harry S. Truman, "Address at a Dinner of the Federal Bar Association," April 24, 1950, Harry S. Truman Presidential Library & Museum, https://www.trumanlibrary.gov/library/public-papers/94/address-dinner-federal -bar-association.

1. The Nelson Gallery

"My choice early in life": Hamby, *Man of the People*, 15.

"veritable quagmires": "The City Election and Public Improvements," *Kansas City Star*, March 15, 1881.

"Kansas City needs good streets": "City Election," *Kansas City Star*.

"a Reynolds, a Corot": Members of the Staff of the Kansas City Star, *William Rockhill Nelson*, 177. Sir Joshua Reynolds and Thomas Gainsborough were English portraitists known for developing the grand manner style; Jean-Baptiste-Camille Corot and Constant Troyon were early associates of the Barbizon group of French landscape painters; French impressionist Claude Monet and English landscapist John Constable were increasingly popular among American collectors; and Jusepe de Ribera was an important seventeenth-century painter from Spain.

"Then his thought turned": Staff of the Kansas City Star, 177.

"don't square at all": Kevin Hardy, "Kansas City Star Removes Name, Image of William Rockhill Nelson," *Kansas City Star*, January 10, 2021.

"I have had in mind": "Art Treasures Presented," *Kansas City Times*, November 12, 1896.

"shrine of painting and sculpture": "The City's Start in Art," *Kansas City Star*, February 24, 1897.

"In the main art gallery": "A Crowded Public Library," *Kansas City Star*, February 24, 1905.

"Kansas City is young": "Acts for Higher Culture," *Kansas City Times*, November 5, 1904.

"A $10,000 Oil Painting": "A $10,000 Oil Painting," *Kansas City Times*, October 5, 1905.

"fine Indian Paintings" and *"We do this because"*: "A New Art Gallery," *Kansas City Star*, March 14, 1907.

"Been reading an article": Ferrell, *Off the Record*, 299.

"execrable": Richardson, *A Life of Picasso I*, 21.

"drew like Raphael": Miller, *Einstein, Picasso*, 9.

"no more or less mature": Richardson, *A Life of Picasso I*, 29.

"These early experiences": Richardson, 68.

"[The teachers here]": Richardson, 90.

"geometrical schemas, to cubes": Miller, *Einstein, Picasso*, 295.

"When we invented cubism": Richardson, *A Life of Picasso II*, 105.

"Traditional perspective gave me": Richardson, 105.

"How it happened, I myself": Hitler, *Mein Kampf*, 9.

"We always owed the bank": Harry S. Truman, "Longhand Note," n.d., Harry S. Truman Papers, President's Secretary's Files, Harry S. Truman Presidential Library & Museum, https://www.trumanlibrary.gov/library/truman-papers/longhand-notes-undated-file/undated-4-31.

"plowed, sowed, reaped": McDonald, "Farming Skills."

"It was on the farm": McDonald, "Farming Skills."

"I always give my occupation": Kirkendall, "Harry S Truman," 482.

"I'm going to be happy": Harry S. Truman to Mary Ethel Noland, January 20, 1919, Harry Truman's World War I, Correspondence File, Harry S. Truman Presidential Library & Museum, Independence, MO.

2. Insults to Classical Ideals

"old and decrepit": Zayas, *How, When, and Why*, 2.

"obsessed": Rose, *Alfred Stieglitz*, 20.

"I am robbing you": Rose, 62.

"the greatest photographer": Brandow and Ewing, *Edward Steichen*, 15.

"a medium of individual": Alfred Stieglitz, "An Apology," *Camera Work*, 1 (January 1903): 15.

"there wasn't enough": Perlman, "Edward Steichen and '291.'"

"If artists won't admit": Perlman, "Edward Steichen and '291.'"

"Our Little Gallery": Perlman, "Edward Steichen and '291.'"

"anti-photographic art": Greenough, *Alfred Stieglitz: The Key Set.*

"the artistic soul": Gelett Burgess, "Is it Possible Life Is Like This?" *Chicago Examiner*, November 26, 1911.

"Works were expected": Roe, *Private Lives*, 9.

"There are hardly fifteen": Delacour and Leca, "Decline and Fall," 447.

"That fatal rejection has": Delacour and Leca, 446.

"The galleries were full": Marius de Zayas, "The New Art in Paris," *Camera Work*, 34–35 (April–July 1911): 30.

"deadly movement": Zayas, *How, When, and Why*, x.

"I could not understand": Zayas, "New Art," 29.

"There is one picture": Zayas, *How, When, and Why*, 157.

"In 1910 we thought that": Zayas, 21.

"reinterprets the female nude": Metropolitan Museum of Art, "Standing Female Nude," accessed April 27, 2023, https://www.metmuseum.org/art/collection/search/488477.

"It has been called": "Art Photographs and Cubist Painting," *New York Sun*, March 3, 1913.

"I want to tell at present": Marius de Zayas, "Pablo Picasso," *Camera Work*, 34–35 (April–July 1911): 66.

"The display is the most extraordinary": Quoted in "Picasso Exhibition," *Camera Work*, 36 (October 1911): 49.

"It's anarchic, certainly": Quoted in "Picasso Exhibition," 53–54.

"a genuine stimulus": "Art Photographs and Cubist Painting," *New York Sun*.

"Such mad pictures": Eakin, *Picasso's War*, 19.

"I certainly did enjoy": Ferrell, *Dear Bess*, 23.

a *"good fellow"* he'd heard of: Ferrell, 21.

"sowing oats all week": Ferrell, 26.

"play cards and dance": Ferrell, 23.

"I only grabbed his tail": Ferrell, 32.

"Dear Bessie": Ferrell, 39.

3. A Beautiful Circle

"Originality is the bane": Lunday, *Modern Art Invasion*, 5.

"a mental jolt to stir": Brown, *Armory Show*, 26.

"by holding exhibitions": "Artists in Revolt, Form New Society," *New York Times*, January 3, 1912.

"The difference": "Artists in Revolt," *New York Times*.

"a lot of rich old ladies": "Artists in Revolt," *New York Times*.

"be[spoke] the popularity": "Record Automobile Display," *New York Tribune*, January 14, 1906.

"The members of this association": Lunday, *Modern Art Invasion*, 59.

"some of the most stupidly": Royal Cortissoz, "The 'Ism' Exhibition," *New York Tribune*, February 17, 1913.

"entirely ready to confess": Art Notes, *New York Times*, February 17, 1913.

"Be it said to the credit": Cortissoz, "The 'Ism' Exhibition."

"small minority of artists": Cox, *Artist and Public*, 147.

"All art is symbolic": Cox, 33–35.

"despite the extraordinary pace": Eakin, *Picasso's War*, 20.

"outcube the Cubists": "Will Out-Cube the Cubists," *New York Times*, March 17, 1913.

"burlesques on several": "Will Out-Cube the Cubists," *New York Times*.

"ridiculing the modernists": "Cubists Burlesqued in Real Art Spasms," *New York Sun*, March 23, 1913.

"that children can": "Cubists Burlesqued," *New York Sun*.

"Nude Descending a Staircase (No. 2)": Philadelphia Museum of Art, "Nude Descending a Staircase (No. 2)," accessed April 27, 2023 https://philamuseum.org/collection/object/51449.

"retinal": Tomkins, *Duchamp*, 11.

"The whole idea of movement": Kern, *Culture of Time and Space*, 117.

"prize puzzle": "New York's Amazing Exhibition," *Hartford Courant*, March 8, 1913.

"The painting by Duchamp": The Week in Art Circles, *Cincinnati Enquirer*, June 29, 1913.

"My aim was a static representation": Tomkins, *Duchamp*, 79.

"typographical error on the part": "Hughes and the Cubist," *Knoxville Sentinel*, June 10, 1913.

"On an old symbolic staircase": "Poets Rise in Revolt at Impressionist Art," *Indianapolis News*, September 6, 1913.

"an explosion in a shingle mill": "Innocence as an Art Critic," *New York Times*, March 1, 1913.

"If I caught my boy": Lunday, *Modern Art Invasion*, x.

"find the lady" through "You've tried": "The Armory Puzzle," *American Art News*, March 8, 1913. Duchamp always insisted the painting depicted a woman, not a man.

"I laughed out loud": Lunday, *Modern Art Invasion*, 71.

"an hour or two among": "Roosevelt as an Art Critic," *Brooklyn (NY) Daily Times*, March 5, 1913.

"seemed to take the greatest" and "the only things": "The Colonel, Too, on Page 1," *New York Times*, March 5, 1913.

"It is true" and "Take the picture": Roosevelt, "Layman's Views," 718–719.

"Mrs. David Beach": "Jerome G. Beatty Walks in," *Kansas City Star*, May 31, 1912.

"You've heard of the Cubists?": Jerome G. Beatty, "The New Delirium," *Kansas City Star*, February 23, 1913.

4. MoMA

"challenge the conservative": "The Museum of Modern Art History," MoMA, About Us page, accessed April 27, 2023, https://www.moma.org/about/who-we-are/moma -history.

"extremely conservative": Kantor, *Alfred H. Barr, Jr.*, 27.

"ts legacy is" through *"to admit the things"*: Kantor, 31.

"an artist of extraordinary skill": Burroughs, *Loan Exhibition*, xiv.

"violently" protested the exhibition: "Modernistic Art in Metropolitan Held Degenerate," *New York Herald*, September 6, 1921.

"a deterioration of": "Modernistic Art," *New York Herald*.

"a great increase": "Vilified Art Lures Throng to Museum," *New York Herald*, September 7, 1921.

"My mother had become": Margaret Scolari Barr, oral history interview with Paul Cummings, February 22–May 13, 1974, Archives of American Art, Smithsonian Institution, https://www.aaa.si.edu/collections/interviews/oral-history-interview -margaret-scolari-barr-relating-to-alfred-h-barr-13250.

"there were no pictures": Scolari Barr, oral history.

"And this had an extraordinary": Scolari Barr, oral history.

"was his ability to popularise": Van Hensbergen, *Guernica*, 118.

"I know of no pair": Kantor, *Alfred H. Barr, Jr.*, 16.

"We lived in this very cheap": Scolari Barr, oral history.

Kunstbolschewismus: Eakin, *Picasso's War*, 265–266.

"When he came back to this country": Scolari Barr, oral history.

"It is not the mission": Farago, "Degenerate Art."

"'Works of art' that are": Barron and Guenther, *"Degenerate Art,"* 376.

"This section can only be entitled": Barron and Guenther, 380.

"The harlot as a moral ideal!": Barron and Guenther, 375.

"Painted sabotage of national defense": Barron and Guenther, 373.

"reveal the philosophical": Barron and Guenther, 360. The exhibition guide is reproduced and translated in its entirety in Barron and Guenther, *"Degenerate Art."*

"approximately 800 paintings": "Provenance Research Project," MoMA, accessed April 27, 2023, https://www.moma.org/collection/provenance/.

"We must intensify": Golomstock, *Totalitarian Art*, 107.

"The highest praise": Golomstock, 179.

"clowns who wallow": Golomstock, 108.

"In this way": Golomstock, 108.

"In Spain they're killing": Eakin, *Picasso's War*, 308.

"party of one": Danchev, "Picasso's Politics."

"For three hours": Van Hensbergen, *Guernica*, 36–37.

"Something about this particular tragedy": Eakin, *Picasso's War*, 316.

"incomprehensible": Van Hensbergen, *Guernica*, 107.

"the dream of a madman": Eakin, *Picasso's War*, 319.

"The arts cannot thrive": "Roosevelt Calls Art and Culture Keys to Peace," *Philadelphia Inquirer*, May 11, 1939.

5. Advancing American Art

"advanced creative work": Davidson, "Advancing American Art," 7.

"well-known Boston import merchant": "Edward A. Davidson, Boston Merchant, Dead," *Boston Globe*, February 15, 1941.

"broadest segment of the": Ausfeld and Mecklenburg, *Advancing American Art*, 13.

"creative and experimental work": Davidson, "Advancing American Art," 8.

"the United States is a country": Davidson, 37.

"reports from the field": Davidson, 8.

"One of the main problems": Davidson, 7.

"Some excellent but conservative painters": Davidson, 9.

"The range of styles": Davidson, 10.

"weighted on the side of": Georgia Museum of Art, *Art Interrupted*, 30.

"the most significant": Sivard, "Advancing American Art," 93.

"the best group show": Ausfeld and Mecklenburg, *Advancing American Art*, 15.

"The pictures make a beautiful": Genauer, "Art for All," 103.

"GIVING US THE BIRD": "Debunking State Department's Art," *San Francisco Examiner*, November 26, 1946.

"strongly marked with": Sivard, "Advancing American Art," 93–94.

published a two-page spread: "Your Money Bought These Paintings," *Look*, February 18, 1947, 80–81.

"portrays a beefy female": "Rips State Dept. for Art Exhibit Costing $49,000," *Chicago Tribune*, February 14, 1947.

"something between Primo Carnera": Wang, *Becoming American?*, 128.

"While going to art school": Kuniyoshi, *Yasuo Kuniyoshi*, 6.

"Being a stranger in": Yasuo Kuniyoshi Papers, 1906–2016, bulk 1920–1990, box 2, folder 41, Archives of American Art, Smithsonian Institution, Washington, DC.

"one of the very best artists": Kuniyoshi Papers, box 1, folder 18

"no members of the nations": Kuniyoshi Papers, box 1, folder 20.

"technical and specialized skills": Kuniyoshi Papers, box 1, folder 48.

"My life and my interest": Kuniyoshi Papers, box 1, folder 48.

"It's the idea of a woman": Kuniyoshi Papers, box 2, folder 39.

"the most fascinating business": Walt Kuhn, "Sketches in Sawdust," *Collier's*, April 10, 1948.

"No wonder foreigners think": "Rips State Dept. for Art Exhibit Costing $49,000," *Chicago Tribune*, February 14, 1947.

"a Chicago Bears tackle": "Rips State Dept.," *Chicago Tribune*.

"objected . . . to any inference": "Americans Object to U.S. Paintings," *Marshfield (WI) News-Herald*, February 13, 1947.

"closely scrutinized": "Rips State Dept." *Chicago Tribune*.

"The paintings are a travesty": John Taber to George C. Marshall, February 4, 1947, Advancing American Art: Exhibition Records, 1946–1977, Archives of American Art, Smithsonian Institution, Washington, DC.

"While in his office, newsmen": Drew Pearson, Washington Merry-Go-Round, *Shreveport (LA) Journal*, February 18, 1947.

"Truman's way of belittling": Wang, *Becoming American?*, 129.

"aerialists, riders and showgirls" and *"I am delighted"*: "Truman Is Gratified by Girls' Praise as Art Critic," *Tampa (FL) Tribune*, March 2, 1947.

"could not be spoken of": "Questions Concerning the Department's Art Program . . . ," Department of State, Division of Libraries and Institutes, July 1947, Advancing American Art: Exhibition Records, 1946–1977, Archives of American Art, Smithsonian Institution, Washington, DC.

"the public streamed to see it": Drew Pearson, Washington Merry-Go-Round, *Lancaster (PA) Intelligencer Journal*, May 20, 1947.

"is able to contribute to": "Questions Concerning," State Department.

"I don't pretend to be an artist": Drew Pearson, Washington Merry-Go-Round, *Indianapolis Star*, June 3, 1947.

"The paintings would not appear": "Art Museum Head Defends U.S. Exhibit, Denies It's Ugly," *St. Louis Star-Times*, March 31, 1947.

"I know nothing about art": "Marshall Puts Ban on 'Circus Ladies,'" *Springfield (MO) News-Leader and Press*, May 6, 1947.

"Freedom of expression for artists": Quoted in Alvin H. Goldstein, "Authorities on Art at Convention Condemn Political Meddling and Cancellation of U.S. Exhibit Abroad," *St. Louis Post-Dispatch*, May 29, 1947.

"It is strange that a nation": Daniel Defenbacher to George Marshall, April 9, 1947, in Vuchetich and Caniglia, "Walker Curator."

"In all the sarcastic cross-examination": Pearson, Washington Merry-Go-Round, May 20, 1947.

"I appreciated very much": Harry Truman to Alfred Barr, May 7, 1947, Alfred H. Barr Jr. Papers, I.A.605, Museum of Modern Art Archives, New York, NY.

"The withdrawal of these paintings": "Artists Hit US Humiliation," *Daily Worker*, June 15, 1948, Advancing American Art: Exhibition Records, 1946-1977, Archives of American Art, Smithsonian Institution, Washington, DC.

"Stateless, formerly Japanese": Kuniyoshi Papers, box 1, folder 6.

"the single worst mistake": Sivard, "Advancing American Art," 95.

"This particular exhibit is": Sivard, 94.

"The Central Intelligence Agency used": Saunders, "Modern Art."

6. Stalwart Republican

grades of 99 or 100: George Dondero's eleventh-grade report card, George Dondero Papers, Burton Historical Collection, Detroit Public Library.

"stalwart Republican": "From: History of Oakland County," George Dondero Papers, Burton Historical Collection, Detroit Public Library.

"Mayor Dondero is a deep student": "Royal Oak," *Detroit Free Press*, March 18, 1923.

"As to Bob": Hazel Beckwith to George Dondero, January 7, 1963 [erroneously dated 1962], George Dondero Papers, Burton Historical Collection, Detroit Public Library.

"Your letter saddened me": George Dondero to Hazel Beckwith, January 15, 1963, George Dondero Papers, Burton Historical Collection, Detroit Public Library.

"a recognized authority on": "From: History of Oakland County," George Dondero Papers.

"The New Deal is Christ's Deal": Athans, "New Perspective," 228.

"liar" and *"betrayer"*: Athans, 228.

"Nazism was conceived as": "Coughlin Traces Nazi Persecution to Reich's Fear of Jewish Reds," *New York Daily News*, November 21, 1938.

"Jewish International Bankers": "Raising of False Issue Assailed by Fr. Coughlin," *Brooklyn (NY) Tablet*, December 10, 1938.

"for presenting controversial issues": "Giving Coughlin the Air," *Capital Times* (Madison, WI), August 10, 1940.

"attacks upon another's race": "Giving Coughlin the Air," *Capital Times*.

"unprincipled, self-seeking demagog": Clifford A. Prevost, "Coughlin Is Assailed in Congress by Two of Its Catholic Members; All but Three in House Applaud," *Detroit Free Press*, February 19, 1936.

"Emily Post of the House": James L. Wright, "A Mister Emily Post," *Buffalo News*, June 19, 1941.

"they are both lonely": Esther Van Wagoner Tufty, Michigan in Washington, *Holland (MI) Evening Sentinel*, February 5, 1968.

"Dondero fathers his constituents": Clifford A. Prevost, "Dondero Is City's Only G.O.P. Congressman," *Detroit Free Press*, July 12, 1942.

"My dear Mr. President": George Dondero to Harry S. Truman, April 16, 1945, Papers of Harry S. Truman, President's Personal File, box 511, Harry S. Truman Presidential Library & Museum, Independence, MO.

"My dear Mr. Dondero": Harry S. Truman to George Dondero, April 25, 1945, Papers of Harry S. Truman, President's Personal File, box 511, Harry S. Truman Presidential Library & Museum, Independence, MO.

"Let us develop the resources": "Dondero Cites Soo Locks in Need for Seaway Project," *Sault Ste. Marie (MI) Evening News*, May 6, 1954.

7. Gallery on Wheels

mounted on "roller galleries": "Gallery-on-Wheels," *Art Digest*, January 15, 1949.

"society gal": "Society Gal's Army Book Gives Rookie Useful Tips," *Boston Globe*, October 23, 1942.

"real estate man": "Her Workshop Is for the Guidance of GI Writers," *Kansas City Star*, July 27, 1947. In her early seventies, Mary Bruce Sharon would begin painting watercolors depicting scenes of her Kentucky childhood. These pictures are now considered superb examples of American primitivism.

"She learned to draw": "Her Workshop Is for the Guidance," *Kansas City Star*.

"You aren't there to plumb": Henrietta Sharon, "Boston Girl Artist Sketches Sailors to Help Recovery," *Boston Globe*, November 28, 1943.

"Most of them were bad sketches": Sharon, "Boston Girl Artist," *Boston Globe*.

"The idea for an exhibition": Aument, "Art Is Swell," 3.

"Seeing paintings, talking with some": Aument, 3.

"one of the most prominent": Aument, 3.

"There was a party atmosphere": "Paintings for Paraplegics," *Look*, 48.

"Pictures, many by well-known": "Painting for Paraplegics," 48.

"We are firmly convinced": Aument, "Art Is Swell," 4.

"The Members of Congress should": 81 Cong. Rec. H2317 (daily ed. March 11, 1949) (statement of Rep. Dondero).

"this 'gallery-on-wheels' exhibit": 81 Cong. Rec. H2317.

"nearly all are individuals": 81 Cong. Rec. H2317.

"I have no facts": 81 Cong. Rec. H2317.

"Our platform called for": Taylor, *Way It Was*, 357.

"I do know that these individuals": 81 Cong. Rec. H2318.

"We operated the show": Aument, "Art Is Swell," 4.

"There was no romance": Henrietta Sharon, "Russia's War With God!," *Junior League Magazine*, May 1930.

"Mr. CANFIELD. Mr. Speaker": 81 Cong. Rec. H2318.

"Certainly the art exhibits": 81 Cong. Rec. A2551 (daily ed. April 29, 1949).

"We can truthfully say": 81 Cong. Rec. A2551.

U.S. SPONSORS LEFTIST: "U.S. Sponsors Leftist Painting Exhibits, Dondero Alleges," *Baltimore Sun*, March 11, 1949.

CHARGES "PINK" PAINTERS: "Charges 'Pink' Painters Smear U.S. in Art Talks," *Chicago Tribune*, March 12, 1949.

LEFT WING ART ON TOUR: "Left Wing Art on Tour Again," *Spokesman-Review* (Spokane, WA), March 12, 1949.

"a spearhead of radical influence": 81 Cong. Rec. H6372 (daily ed. May 17, 1949).

"ACA stands for American Contemporary Art": 81 Cong. Rec. H6372.

"It is an amazing condition": 81 Cong. Rec. H6375.

"It seemed to me that": Genauer, "Still Life," 89.

"It is up to the art critics": Genauer, 90.

"What lies behind the Congressman's attack": Genauer, 91.

"She has distorted": 81 Cong. Rec. A6305 (daily ed. October 13, 1949).

"Modern Art Shackled to Communism": 81 Cong. Rec. H11584–11585 (daily ed. August 16, 1949).

"I call the roll of infamy": 81 Cong. Rec. H11584.

"Cubism aims to destroy": 81 Cong. Rec. H11584.

"My colleague's personal opinion": 81 Cong. Rec. H12099 (daily ed. August 23, 1949).

"These new critics of modernism": Howard Devree, "Modernism Under Fire," *New York Times*, September 11, 1949.

"The year 1949 must be": "Art and Communism," *Des Moines Tribune*, August 29, 1949.

"At a time when our Nation": 82 Cong. Rec. H2423–2427 (daily ed. March 17, 1952).

"obvious that those who equate": Barr, "Is Modern Art," 30.

8. The Patriotic Council

"Communists or members of": "Dallas Group Contends Museum Red Art Planted," *Fort Worth Star-Telegram*, February 23, 1956.

"among the most distinguished": "Art or Propaganda?," *Washington Post*, June 3, 1956.

"In fact, of course": Saarinen, "Art Storm." Saarinen's husband was the renowned architect and industrial designer Eero Saarinen.

"brainwash and create public attitudes": Alvin M. Owsley, quoted in 84 Cong. Rec. H10423 (daily ed. June 14, 1956) (statement of Rep. Dondero).

"a rambling, disjointed book": William Henry Chamberlin, "Foreign Policy Subjected to Lurid Attack," *Chicago Tribune*, May 4, 1952.

"an 'intellectual' peddler of bigotry": Robert H. Collins, "Freedom Forum Teacher Selling Book Viewed as Attack on Jews," *St. Louis Post-Dispatch*, June 14, 1964.

"The Reds are moving in": Carraro, *Jerry Bywaters*, 188–189.

"Your tax money": Carraro, 189. Punctuation as in original.

"cleared the four accused": "Controversial 'Sport in Art' Exhibit Slated," *Odessa (TX) American*, February 7, 1956.

"The fundamental issue at stake": Jerome K. Crossman, Gerald C. Mann, and Waldo Stewart, "Dallas Trustees Take a Stand" (letter to the art editor), *New York Times*, February 19, 1956.

"The courageous stand of the": Saarinen, "Art Storm."

"budgetary considerations" and *"No comment"*: Anthony Lewis, "U.S. Cancels Tour by Art; Irked Texans," *Des Moines Register*, May 26, 1956.

"The patriots saved our allies": "Attacks on Our Art Frequently Overlooked," *Akron Beacon Journal*, July 22, 1956.

"It may not be unpatriotic": "Art in the Heart of Texas," *New York Times*, May 27, 1956.

"alert" and *"well-informed citizens"*: 84 Cong. Rec. H10421–10423, 10425.

"too modern": "Art: Dean of Sculptors," *Time*, June 11, 1956, https://content.time.com /time/subscriber/article/0,33009,862182,00.html. Zorach later sold one of the panels, *Epic of America*, weighing nearly a ton and measuring thirty feet by thirty-two feet, to Fairleigh Dickinson University in Teaneck, New Jersey, for the cost of casting (about $20,000). The piece now hangs on the face of the school's Giovatto Library.

"We just took the Picasso rug": "Picasso's Art Shoved Out of Dallas Library," *Fort Worth (TX) Star-Telegram*, November 21, 1956.

"The practice of sending abroad": George Dondero, address given at banquet of American Artists Professional League, March 30, 1957, George Dondero Papers, Archives of American Art, Smithsonian Institution, Washington, DC.

"If you let your whiskers grow": 73 Cong. Rec. H2431 (daily rec. February 12, 1934).

"for posterity": Witsil, "Lincoln Lore."

"From the hand of": 73 Cong. Rec. H2431.

"Dondero bowed unctuously": Duane Billings, in discussion with the author, July 29, 2022, Salina, KS.

"cried for days": Billings, discussion.

"He was a crook": Billings, discussion.

"The Library does not have any comment": Carla Reczek, e-mail message to author, December 2, 2022.

9. Sam and Dorothy

"It's not 'Mr. President' anymore": "Harry Has a Grand Time Riding Home to Missouri," *New York Daily News*, January 22, 1953.

"to get from under": Harry S. Truman to Vic Householder, November 29, 1953, Vic H. Householder Papers, box 1 (Correspondence between Harry S. Truman and Vic Householder, 1953–59), Harry S. Truman Presidential Library & Museum, Independence, MO. For a comprehensive account of the Trumans' 1953 road trip, the author humbly refers the reader to his book *Harry Truman's Excellent Adventure: The True Story of a Great American Road Trip* (Chicago: Chicago Review Press, 2009).

"Roosevelt, recognizing that he was not": Rosenman, *Working with Roosevelt*, 13.

"a New Deal for": Franklin D. Roosevelt, Address Accepting the Presidential Nomination at the Democratic National Convention in Chicago, July 2, 1932, https://www.presidency.ucsb.edu/documents/address-accepting-the-presidential-nomination-the-democratic-national-convention-chicago-1.

"I have often tried to find": Rosenman, *Working with Roosevelt*, 72.

"My husband said to me": Dorothy Rosenman, interview by Walter James Miller, *The Reader's Almanac*, WNYC-FM (New York), June 7, 1976, https://www.wnyc.org/story/dorothy-rosenman/.

"With Roosevelt, you could": Samuel Rosenman, interview by James Perlstein, 1959, Columbia University Libraries, https://dlc.library.columbia.edu/catalog/cul:f1vhhmgspc.

"After V-J Day, I knew": Ross, "Return," 23.

"I do not see the significance": Samuel Rosenman, "Suggestions by Samuel I. Rosenman Re 'Uncorrected Draft Subject to Revision by the President' of the 'Memoirs' by Harry S. Truman," Harry S. Truman Papers, Post-Presidential Papers, box 36, Harry S. Truman Presidential Library & Museum, Independence, MO (hereafter Harry S. Truman Papers, Post-Presidential Papers will be referred to as HST PPP).

"His shirt was unbuttoned": Truman, *Years of Trial*, 364.

"As I have told you": Samuel I. Rosenman to Harry S. Truman, December 10, 1956, HST PPP, box 36.

"knowledgeable about art": Ralph F. Colin, oral history interview, August 15, 1969, Archives of American Art, Smithsonian Institution, https://www.aaa.si.edu/collections/interviews/oral-history-interview-ralph-f-colin-12526.

"Those two people": Harry S. Truman to Samuel I. Rosenman, February 13, 1959, HST PPP, box 36.

"representative in Grasse": Pierre Wertheimer to Samuel I. Rosenman, April 2, 1958, HST PPP, box 36.

"It is rather like a private": Wertheimer to Rosenman.

"The strictest incognito": Wertheimer to Rosenman.

"The owner M. Geneve": Wertheimer to Rosenman.

"We would like very much": Samuel I. Rosenman to M. Geneve, April 8, 1958, HST PPP, box 36.

"regarding the matter of": W. H. McConnell to Harry S. Truman, April 15, 1958, HST PPP, box 755.

"sink into the languorous life": Devine, "Wealthy Widow."

"I am firmly convinced": Devine, "Wealthy Widow."

"Mrs. Truman and I": Harry S. Truman to Mrs. Charles Ulrick Bay, April 30, 1958, HST PPP, box 755.

10. "Come On Up"

"soft on communisum": "Truth Hurts Truman," El Paso (TX) Herald-Post, October 20, 1952.

"almost completely morally degenerate": "McCarthy Calls Truman Puppet," Marshfield (WI) News-Herald, February 13, 1952.

"five star front man": "President Asserts Republicans Would Ruin Labor Unions," Fresno (CA) Bee, October 23, 1952.

"Dear President Truman": Dwight D. Eisenhower to Harry S. Truman, May 20, 1958, HST PPP, box 755.

"YOUR LETTER AND INVITATION": Harry S. Truman to Dwight D. Eisenhower (Western Union telegram), May 23, 1958, HST PPP, box 755.

"If I didn't agree": Jones, "Even at 100."

"any man or woman who": Howard Vincent O'Brien, "Roosevelt College in Chicago," Decatur (IL) Herald, October 27, 1945.

"There were Chinese, Japanese": O'Brien, "Roosevelt College in Chicago."

"They weren't hidden!": Joe Hatcher, "GOP Chieftains Still Shun Responsibility of McCarthy," Elizabethton (TN) Star, October 31, 1952.

"Because we believe in": "Gets Continuance," Chicago Tribune, October 29, 1952.

"I happen to be a political": "Reactions, Heckler and TV Trouble," Wisconsin Rapids Daily Tribune, October 28, 1952.

"Colonization of two kinds exist": Theodore Shabad, "U.S. Professor Assails Soviet Before 2,000 at Kremlin Rally," New York Times, July 10, 1962.

"It was one of the few times": Shabad, "U.S. Professor Assails Soviet."

"Mr. Truman told me": Dale Pontius to Director, Truman Archives, October 12, 1978, Personal Papers and Organizational Records, Harry S. Truman Collection, box 12, Harry S. Truman Presidential Library & Museum, Independence, MO.

"He promised that he": Pontius to Director.

11. Distracting Visitors

"[Barr] has remarked that": Macdonald, "West Fifty-Third Street–II," 60.

"squirm out the window": Peter Kihss, "Fire in Modern Museum; Most Art Safe," *New York Times*, April 16, 1958.

"Dear M. Picasso: I enclose": Alfred Barr to Pablo Picasso, May 26, 1958, Alfred H. Barr Jr. Papers, XI.C.17, Museum of Modern Art Archives, New York, NY.

"Dear M. Picasso, Very rarely": Barr to Picasso.

"May I suggest that": Alfred Barr to Ralph Colin, May 26, 1958, Alfred H. Barr Jr. Papers, XI.C.17, Museum of Modern Art Archives, New York, NY.

12. At Sea

"from which a passenger": "The 'Independence,'" *Life*, February 19, 1951, 53.

"several swank 5th Ave. shops": "City Acclaims New Ocean Queen," *Brooklyn (NY) Daily Eagle*, January 22, 1951.

"curtains, lamp shades": "City Acclaims New Ocean Queen," *Brooklyn Daily Eagle*.

"a really royal welcome": "New Queen of Seas Gets Royal Welcome," *Wilmington (DE) Morning News*, January 23, 1951.

"Every Voyage a Gay Cruise": "Modern American Living at Sea" (American Export Lines promotional brochure, ca. 1958), HST PPP, box 756.

"Our crossing was a most": Harry S. Truman, "To France" (note handwritten on Château Saint-Martin stationery), May 26, 1958, HST PPP, box 755.

"We even wore hats": Julie Obarski Simpson, in telephone discussion with author, August 8, 2022.

"Mom said that she liked": Tom Hoose, e-mail message to author, October 12, 2022.

"He looked down at me": Robert Hofmekler, in telephone discussion with author, August 18, 2022.

"If I should be led": Howard Handleman, "De Gaulle 'Ready' to Accept Power Under New Rules," *San Francisco Examiner*, May 20, 1958.

"France has found the man": "De Gaulle Welcomed by Friends," *Spokesman-Review* (Spokane, WA), June 2, 1958.

"son of a bitch": Offner, *Another Such Victory*, 51.

"some sign of lasting": May and Oursler, *Prudential*, 119.

"The campaign which introduced": May and Oursler, 121.

"Arrived at the port": Truman, "To France."

13. Naples

"I hope that the French": "Truman Reaches Italy," *New York Times*, June 4, 1958.

"I'd just like to say": "Breve sosta a Napoli dell'ex Presidente Truman," *Il Mattino* (Naples, Italy), June 4, 1958.

"The only reason for my trip": "Breve sosta a Napoli," *Il Mattino*.

"a private citizen from Missouri": "Breve sosta a Napoli," *Il Mattino*.

"The bill would continue": Harry S. Truman, Veto of Bill to Revise the Laws Relating to Immigration, Naturalization, and Nationality, June 25, 1952, Harry S. Truman Presidential Library & Museum, https://www.trumanlibrary.gov/library/public -papers/182/veto-bill-revise-laws-relating-immigration-naturalization-and-nationality.

"Today, we have entered": Truman, Veto of Bill.

"with all my heart": "Truman evita ogni commento su De Gaulle e la crisi francese," *La Stampa* (Turin, Italy), June 4, 1958.

"Italian GDP per capita": Bianchi and Giorcelli, "Reconstruction Aid," 5.

"Coming from America where": Joyce Ronald, "Joyce, Friends Find Themselves in Midst of Celebration for Pope," *Mitchell (SD) Daily Republic*, March 15, 1958.

"All Italian men LOVE": Ronald, "Joyce, Friends Find Themselves."

"No one who has been": "Romance for Export," *Baltimore Sun*, May 26, 1959.

"Firing the pistol": "Roman Romeos Are Routed," *Richmond (VA) News Leader*, July 1, 1958.

"a bevy of buxom blondes": "Roman Romeos Are Routed," *Richmond New Leader*.

"Lu was browsing through": Joyce Ronald, "Joyce and Lu Crash Naples Gates for Glimpse of Bess and Harry," *Mitchell (SD) Daily Republic*, June 11, 1958.

"We drove right through": Ronald, "Joyce and Lu Crash Naples Gates."

"a regiment of Bersaglieri": "Greetings to Grant," *Inter Ocean* (Chicago, IL), December 27, 1877.

"accorded a welcome": "10,000 Cheer Roosevelt When He Lands at Naples," *Brooklyn (NY) Daily Times*, April 4, 1909.

"a catastrophe for the environment": Friends of the Earth, "Cruise Ships' Environmental Impact," Friends of the Earth, March 14, 2022, https://foe.org/blog/cruise-ships -environmental-impact/.

14. Genoa

"Harry Truman has the virtue": "Truman di passaggio a Genova sorridente e affabile con tutti," *La Stampa* (Turin, Italy), June 6, 1958.

"Our last sight was the cemetery": Twain, *Innocents Abroad*, 108.

"unforgettable uncle" and *"backbone of our family"*: Obituary for Paolo Picasso, *Il Secolo XIX*, March 5, 2021, https://necrologie.ilsecoloxix.it/necrologi/2021/866115 -picasso-paolo.

"When Truman entered": "Truman a Genova si invita a un rinfresco matrimoniale," *Il Tirreno* (Livorno, Italy), June 6, 1958, HST PPP, box 755.

15. Le Fermier

"Cabinet of national unity": "De Gaulle in Power," *New York Times*, June 2, 1958.

"The first night we were": Dorothy Rosenman, interview by Monte Poen, New York, NY, December 15, 1980, Harry S. Truman Presidential Library & Museum, https:// www.trumanlibrary.gov/soundrecording-records/sr2013-56.

"swinging night": "Princess Grace Throws Giant Monaco Shindig," *Fort Lauderdale (FL) Sunday News*, June 15, 1958.

"I decided to approach": Robert Carlone to Elizabeth Safly, September 30, 1996, Personal Papers and Organizational Records, Harry S. Truman Collection, box 3, Harry S. Truman Presidential Library & Museum, Independence, MO.

"Son, do you have": Carlone to Safly.

"Hon. Harold Moseley": Carlone to Safly.

"I hope this does some": Carlone to Safly.

"The impact of this note": Carlone to Safly.

"cherished story": Carlone to Safly.

"Please use this": Carlone to Safly.

"Not only the serendipity": Leezá Carlone Steindorf, e-mail message to author, September 18, 2022.

"Mr. Truman has drawn up": "Repos, sourires et bonnes tables pour Truman en vacances," *Radar* (France), June 15, 1958.

"My children will never believe this": Rosenman, interview by Poen.

"Now comes Harry S. Truman": Harry Truman, undated handwritten "affidavit," HST PPP, box 755. Truman even drew an official "seal" on the document.

"They yelled at me": Harry Truman to John Snyder, June 27, 1958, Christie's, https:// www.christies.com/lot/truman-harry-s-two-autograph-letters-signed-5217052/.

"because of the Marshall Plan": Truman to Snyder.

"for the improvement and growth": Harry Truman, Inaugural Address (Washington, January 20, 1949), Harry S. Truman Presidential Library & Museum https:// www.trumanlibrary.gov/library/public-papers/19/inaugural-address.

"[had] to behave": Rowen, *Six Weeks with Truman*, 40.

"While the ladies visited": "Truman a Sanremo spinge l'auto bloccatasi in una viuzza," *La Stampa* (Turin, Italy), June 26, 1958.

"*Some young men approached*": "Truman a Sanremo spinge l'auto," *La Stampa*.

"*a buzzing insect, hovering*": "The Press: Paparazzi on the Prowl," *Time*, April 14, 1961.

"*just one more*": Austin, "One More Club."

"*photographers have to make*": Austin, "One More Club."

"*Occasionally we spied someone*": Rosenman and Rosenman, *Presidential Style*, 506.

"*As we went through*": Rosenman and Rosenman, 506.

"*simple farmer on vacation*": "Incognito aux Baux le fermier Harry Truman," *Paris Match*, June 28, 1958, HST PPP, box 755.

"*le fermier*": "Incognito aux Baux le fermier Harry Truman," *Paris Match*, HST PPP.

"*In typically French fashion*": Rosenman and Rosenman, *Presidential Style*, 507.

"*high fashion and millinery*": "York Exchange Teacher Caps Twinning Project with Marriage to Arles Mayor," *York (PA) Gazette and Daily*, December 31, 1957.

"*The twinning ties between York*": "York Exchange Teacher," *York Gazette and Daily*.

"*a wedding of Pennsylvania Dutch*": By the Way, *York (PA) Dispatch*, November 2, 1960.

"*I didn't realize we were*": "York-Arles Couple Guide Trumans in France," *York (PA) Gazette and Daily*, July 3, 1958.

"*In this South of France*": Harry S. Truman, "To France" (note handwritten on Chateau Saint-Martin stationery), May 26, 1958, HST PPP, box 755.

"*M. Matisse was sometimes*": Pulvenis de Séligny, *Matisse*, 19.

"*Although she is a Dominican nun*": Pulvenis de Séligny, 20. The French word for flower is *fleur*; Matisse is making a pun by combining *fleur* and *flirtation*: *fleurtation*.

"*This chapel is for me*": Pulvenis de Séligny, 7.

"*interesting*" through "*worth a special journey*": *1958 Michelin France* (Paris: Pneu Michelin), 20.

"*HST, as usual, talked*": Schlesinger, *Journals*, 56.

16. When Harry Met Pablo

"*Even if you think people*": Schwartz, "Picasso's Muse."

"*She felt the most important*": Hilarie M. Sheets, "Picasso and His Last Muse," *New York Times*, October 23, 2014, https://www.nytimes.com/2014/10/26/arts/artsspecial/picasso-jacqueline-at-pace-gallery-in-new-york.html.

"*So one morning*": Rosenman, interview by Poen.

"*non-existent*" as a grandfather: Chrisafis and Brown, "Marina Picasso."

"*Finally, with a certain amount*": Lake, "Picasso Speaking."

"*He seldom threw anything away*": Richardson, *Sorcerer's Apprentice*, 235–236.

"*My father gave me his nail clippings*": Ruiz-Picasso and Widmaier-Picasso, "Maya Ruiz-Picasso."

"*Wow, where did you*": Christie's, "The Man Who Dressed Picasso."

"Picasso had the gift": Miller, *Einstein, Picasso*, 33.

"Tyrannical, entitled and possessed": Jones, "Pablo Picasso Used Clothes."

"simple, basic fare": Richardson, *Sorcerer's*, 237.

"He had a picture": Schlesinger, *Journals*, 56.

"Right after the Liberation": Lake, "Picasso Speaking."

"I was so struck by": Koppelman, "Picasso's *Man*."

"HST is confounded": Written by Dorothy Rosenman on the stereoscopic slide depicting her and Picasso admiring *Man with a Lamb*, photo courtesy of Robert Rowen.

"We said, 'No, but": Rosenman, interview by Poen.

"he wanted everyone who came": Christie's, "Madoura Collection."

"safety reasons": "Left-Right French Clash Has Picasso in Middle," *Baltimore Sun*, June 28, 1958.

"compared notes": Rosenman, interview by Poen.

"immediate reduction of war budgets": "U.S. Bars Picasso and Peace Group," *Philadelphia Inquirer*, March 4, 1950.

"If visas refused": State Department cable from Moscow to Secretary of State, February 21, 1950, Picasso FBI file no. 100-337396, Museo Nacional Centro de Arte Reina Sofía, https://guernica.museoreinasofia.es/en/document/fbi-file-pablo-picasso.

"on balance the disadvantages": State Department cable from Paris to Secretary of State, February 23, 1950, Picasso FBI file no. 100-337396, Museo Nacional Centro de Arte Reina Sofía, https://guernica.museoreinasofia.es/en/document/fbi-file-pablo -picasso.

"leading over-all Communist-front": Foreign Relations of the United States, 1950, vol. 4, *Central and Eastern Europe; the Soviet Union* (Washington, DC: US Government Printing Office, 1980), 273, US Department of State, Office of the Historian, https:// history.state.gov/historicaldocuments/frus1950v04/pg_273.

"I have become a Communist": FBI cable from John Edgar Hoover to Special Agent [name redacted] in Paris, January 16, 1945, Picasso FBI file no. 100-337396, Museo Nacional Centro de Arte Reina Sofía, https://guernica.museoreinasofia.es /en/document/fbi-file-pablo-picasso.

"Security Matter—C": Mitgang, "When Picasso Spooked."

"Why did you select that?": Rosenman, interview by Poen.

"My father always wanted": Walsh, *Celebrity in Chief*, 25.

"in which all curiosities": Andral, *Musée Picasso*, 8.

"needed space": Andral, 10.

"I set him up in": Andral, 10.

"It probably wasn't a": Author interview with Jean-Louis Andral, June 30, 2021.

"Antibes was the first Greek colony": Andral, 16.

"It won't help her": Rosenman, interview by Poen.

"Dear Mr. Barr Many thanks": Samuel Rosenman to Alfred Barr, June 15, 1958, Alfred H. Barr Jr. Papers, XI.C.17, Museum of Modern Art Archives, New York, NY.

"Dear Mr. Barr:—I'm in": Harry S. Truman to Alfred Barr, June 15, 1958, Alfred H. Barr Jr. Papers, XI.C.17, Museum of Modern Art Archives, New York, NY.

"Judge Rosenman and": Alfred Barr to Pablo Picasso, undated (probably March 1961), Alfred H. Barr Jr. Papers, I.A.366, Museum of Modern Art Archives, New York, NY.

"I went to lunch with Picasso": Schlesinger, *Journals*, 56.

"We think it would be": Dale Pontius to Harry S. Truman, June 4, 1958, HST PPP, box 755.

"June 15, 1958": Harry Truman to Dale Pontius, June 15, 1958, Personal Papers and Organizational Records, Harry S. Truman Collection, box 12, Harry S. Truman Presidential Library & Museum, Independence, MO.

"a joyously good time": Harry S. Truman, inscription on souvenir booklet, Samuel I. Rosenman Papers, box 13, Harry S. Truman Presidential Library & Museum, Independence, MO.

"failures and bunglings" and *"The people of the United States"*: Harry S. Truman, Statement by Harry S. Truman, aboard the U.S.S. [*sic*] Constitution, July 1, 1958, Cannes, France, HST PPP, box 756.

"interesting 2-hour talk": "Truman Sees Picasso," *Kansas City Times*, July 2, 1958.

"We do not invite Communists": "Truman Sees Picasso," *Kansas City Times*.

Epilogue

"a good scolding": Rosenman, interview by Poen.

"If art is to nourish": John F. Kennedy, remarks at Amherst College, Amherst, MA, October 26, 1963, John F. Kennedy Presidential Library and Museum, https://www.jfklibrary.org/archives/other-resources/john-f-kennedy-speeches/amherst-college-19631026.

"Picasso 1 plate": Harry S. Truman, undated handwritten note on stationery headed "From the Desk of Harry S. Truman," [presumably July 1958], HST PPP, box 755.

"I'm not an art critic": "'Adams–Goldfine Up to Ike'—Truman," *Kansas City Times*, July 14, 1958.

"I would love to" and *"They respected him"*: Rosenman, interview by Poen.

BIBLIOGRAPHY

Adamic, Louis. "Aliens and Alien-Baiters." *Harper's Magazine*, November 1936.

Alexander, John W. "Is Our Art Distinctively American?" *Century Magazine*, April 1914.

Andral, Jean-Louis. *Musée Picasso Antibes: A Guide to the Collections*. English ed. Paris: Hazan, 2008.

Athans, Mary Christine. "A New Perspective on Father Charles E. Coughlin." *Church History* 56, no. 2 (1987): 224–235. https://doi.org/10.2307/3165504.

Aument, Henrietta Sharon. "Art Is Swell." *Junior League Magazine*, April 1949.

Ausfeld, Margaret Lynn, and Virginia M. Mecklenburg. *Advancing American Art: Politics and Aesthetics in the State Department Exhibition, 1946–1948*. Montgomery, AL: Montgomery Museum of Fine Arts, 1984.

Austin, Laurie. "Harry S. Truman and the 'One More Club': The President Makes a Movie." *The Unwritten Record* (blog). National Archives, October 13, 2020. https://unwritten-record.blogs.archives.gov/2020/10/13/harry-s-truman-and-the-one-more-club-the-president-makes-a-movie/.

Barr, Alfred H., Jr. "Is Modern Art Communistic?" *New York Times Magazine*, December 14, 1952.

———. *Picasso: Fifty Years of His Art*. New York: Museum of Modern Art, 1946.

———. *What Is Modern Painting?* 6th ed. New York: Museum of Modern Art, 1956.

Barron, Stephanie, and Peter Guenther, eds. *"Degenerate Art": The Fate of the Avant-Garde in Nazi Germany*. Los Angeles: Los Angeles County Museum of Art, 1991.

Bianchi, Nicola, and Michela Giorcelli. "Reconstruction Aid, Public Infrastructure, and Economic Development: The Case of the Marshall Plan in Italy." SSRN, November 26, 2021. https://doi.org/10.2139/ssrn.3153139.

Brandow, Todd, and William A. Ewing. *Edward Steichen: Lives in Photography*. New York: W. W. Norton, 2008.

Brassaï. *Conversations with Picasso*. Translated by Jane Marie Todd. Chicago: University of Chicago Press, 2002.

Brown, Milton W. *The Story of the Armory Show*. New York: Abbeville, 1988.

Burns, Lucy. "Degenerate Art: Why Hitler Hated Modernism." BBC News, November 6, 2013. https://www.bbc.com/news/magazine-24819441.

Burroughs, Bryson. *Loan Exhibition of Impressionist and Post-Impressionist Paintings.* New York: Metropolitan Museum of Art, 1921.

Carelli, Francesco. "'Painting with Scissors': Matisse and Creativity in Illness." *London Journal of Primary Care* 6, no. 4 (January 2014): 93. https://doi.org/10.1080/17571 472.2014.11493424.

Carraro, Francine. *Jerry Bywaters: A Life in Art.* Austin, TX: University of Texas Press, 2010.

Chrisafis, Angelique, and Mark Brown. "Marina Picasso: Selling My Grandfather's Art Is a Way of Helping Me Heal." *Guardian* (US ed.), May 24, 2015. https://www .theguardian.com/artanddesign/2015/may/24/marina-picasso-selling-pablo -picasso-art-help-heal-miserable-childhood.

Christie's. "The Madoura Collection of Picasso Ceramics," May 30, 2012. Video, 5:07. https://www.youtube.com/watch?v=KPbJjM9laxE.

———. "The Man Who Dressed Picasso." June 1, 2020. https://www.christies.com /features/Michel-Sapone-The-man-who-dressed-Picasso-8065-1.aspx.

Clark, T. J. *Picasso and Truth: From Cubism to Guernica.* Princeton, NJ: Princeton University Press, 2013.

Cowdrick, Charles. "The First Nelson Gallery." *Pitch Weekly* (Kansas City, MO), January 23, 1997.

Cox, Kenyon. *Artist and Public: And Other Essays on Art Subjects.* New York: C. Scribner's Sons, 1914.

Cox, Neil. *An Interview with Pablo Picasso.* New York: Cavendish Square Publishing, 2014.

Craven, Thomas. *Modern Art: The Men, the Movements, the Meaning.* New York: Simon and Schuster, 1940.

Danchev, Alex. "Picasso's Politics." *Guardian* (US ed.), May 8, 2010. https://www.the guardian.com/artanddesign/2010/may/08/pablo-picasso-politics-exhibition-tate.

Davidson, J. LeRoy. "Advancing American Art." *American Foreign Service Journal* 23, no. 12 (December 1946): 7–10, 37.

De Hart Mathews, Jane. "Art and Politics in Cold War America." *American Historical Review* 81, no. 4 (1976): 762–787. https://www.jstor.org/stable/1864779.

Delacour, Hélène, and Bernard Leca. "The Decline and Fall of the Paris Salon: A Study of the Deinstitutionalization Process of a Field Configuring Event in the Cultural Activities." *M@n@gement* 14, no. 1 (2011): 436–466. https://www.cairn.info/revue -management-2011-1-page-436.htm.

Devine, Frank. "This Wealthy Widow Went to Wall Street." *New York Daily News,*

December 9, 1956.

Dodd, Monroe. *The Star and the City: For 125 Years, Kansas City's Chronicler and Crusader.* Kansas City, MO: Kansas City Star Books, 2006.

Dor de la Souchère, Romuald. *Picasso in Antibes.* London: Lund, Humphries, 1960.

Dossin, Catherine. *The Rise and Fall of American Art, 1940s–1980s: A Geopolitics of Western Art Worlds.* Milton Park, UK: Routledge, 2016.

Duncan, David Douglas. *The Private World of Pablo Picasso: The Intimate Photographic Profile of the World's Greatest Artist.* New York: Harper, 1958.

Eakin, Hugh. *Picasso's War: How Modern Art Came to America.* New York: Crown, 2022.

English, Charlie. *The Gallery of Miracles and Madness: Insanity, Modernism, and Hitler's War on Art.* New York: Random House, 2021.

Erickson, Christine K. "'I Have Not Had One Fact Disproven': Elizabeth Dilling's Crusade Against Communism in the 1930s." *Journal of American Studies* 36, no. 3 (2002): 473–489.

Farago, Jason. "Degenerate Art: The Attack on Modern Art in Nazi Germany, 1937 Review—What Hitler Dismissed as 'Filth.'" *Guardian* (US ed.), March 13, 2014. https://www.theguardian.com/artanddesign/2014/mar/13/degenerate-art -attack-modern-art-nazi-germany-review-neue-galerie.

Ferrell, Robert H., ed. *Dear Bess: The Letters from Harry to Bess Truman, 1910–1959.* Reprint ed. Columbia, MO: University of Missouri Press, 1998.

———. *Harry S. Truman: A Life.* Columbia, MO: University of Missouri Press, 1996.

———, ed. *Off the Record: The Private Papers of Harry S. Truman.* Columbia, MO: University of Missouri Press, 1997.

Finamore, Daniel, and Ghislaine Wood, eds. *Ocean Liners: Speed and Style.* Salem, MA: Peabody Essex Museum, 2018.

Franc, Helen M. "Alfred Barr at the Modern." *Art Journal* 49, no. 3 (Autumn 1990): 325–329. https://doi.org/10.2307/777128.

Furlough, Ellen. "Making Mass Vacations: Tourism and Consumer Culture in France, 1930s to 1970s." *Comparative Studies in Society and History* 40, no. 2 (April 1998): 247–286.

Genauer, Emily. "Art for All to See." *Ladies' Home Journal,* November 1946.

———. "Still Life with Red Herring." *Harper's Magazine,* September 1949.

Georgia Museum of Art, ed. *Art Interrupted: Advancing American Art and the Politics of Cultural Diplomacy.* Athens, GA: Georgia Museum of Art, 2012.

Gilot, Françoise, and Carlton Lake. *Life with Picasso.* Reprint ed. New York: NYRB Classics, 2019.

Gladwell, Malcolm. *David and Goliath: Underdogs, Misfits, and the Art of Battling Giants.* Boston: Little, Brown, 2013.

Goethe, Johann Wolfgang von. *Italian Journey: 1786–1788*. New York: Penguin, 1992.

Golomstock, Igor. *Totalitarian Art in the Soviet Union, the Third Reich, Fascist Italy, and the People's Republic of China*. 2nd ed. Translated by Robert Chandler. New York: Overlook Duckworth, 2011.

Greenberg, David. *Presidential Doodles: Two Centuries of Scribbles, Scratches, Squiggles, and Scrawls from the Oval Office*. New York: Basic Books, 2006.

Greenfeld, Howard. *Ben Shahn: An Artist's Life*. New York: Random House, 1998.

Greenough, Sarah. *Alfred Stieglitz: The Key Set; The Alfred Stieglitz Collection of Photographs*. Washington, DC: National Gallery of Art, 2002.

———, ed. *Modern Art and America: Alfred Stieglitz and His New York Galleries*. Washington, DC: National Gallery of Art, 2000.

Hamby, Alonzo L. *Man of the People: A Life of Harry S. Truman*. New York: Oxford University Press, 1995.

Hauptman, William. "The Suppression of Art in the McCarthy Decade." *Artforum*, October 1973.

Hazel, Michael V. *The Dallas Public Library: Celebrating a Century of Service, 1901–2001*. Denton, TX: University of North Texas Press, 2001.

Hitler, Adolf. *Mein Kampf*. Translated by Ralph Manheim. New York: Mariner Books, 1999. http://archive.org/details/mein-kampf-by-adolf-hitler-ralph-manheim-translation.

Hofstadter, Richard. *Anti-Intellectualism in American Life*. New York: Vintage Books, 1963.

Hyman, Sidney. *The Lives of William Benton*. Chicago: University of Chicago Press, 1969.

Jacques-Marie, Soeur. *Henri Matisse: The Vence Chapel*. Paris: Bernard Chauveau Édition, 2014.

Jacques-Marie, Soeur, Henri Matisse, and Arthur Goldhammer. "Henri Matisse." *Grand Street*, Autumn 1994, 78–89. https://doi.org/10.2307/25007785.

Jones, Dylan. "Pablo Picasso Used Clothes in the Same Way He Used His Art." *British GQ*, April 8, 2020. https://www.gq-magazine.co.uk/culture/article/pablo-picasso-art-style.

Jones, Patrice M. "Even at 100, Dale Pontius Is Outspoken." *Chicago Tribune*, July 31, 2006.

Kantor, Sybil Gordon. *Alfred H. Barr, Jr., and the Intellectual Origins of the Museum of Modern Art*. Cambridge, MA: MIT Press, 2002.

Keen, Kirsten Hoving. "Picasso's Communist Interlude: The Murals of 'War' and 'Peace.'" *Burlington Magazine* 122, no. 928 (July 1980): 464–470.

Kern, Stephen. *The Culture of Time and Space, 1880–1918*. Cambridge, MA: Harvard University Press, 2003.

Kirkendall, Richard S. "Harry S Truman: A Missouri Farmer in the Golden Age." *Agricultural History* 48, no. 4 (October 1974): 467–483.

Kluger, Richard, and Phyllis Kluger. *The Paper: The Life and Death of the New York Herald Tribune.* New York: Knopf, 1986.

Kohn, Tara. "Elevated: Along the Fringes of 291 Fifth Avenue." *Panorama: Journal of the Association of Historians of American Art* 4, no. 2 (Fall 2018). https://journalpanorama.org/article/elevated/.

Koppelman, Dorothy. "Picasso's *Man with a Lamb*: Opposites as One." Terrain Gallery, accessed April 27, 2023. https://terraingallery.org/aesthetic-realism/art-criticism/picassos-man-with-a-lamb-opposites-as-one/.

Krenn, Michael L. *Fall-Out Shelters for the Human Spirit: American Art and the Cold War.* Chapel Hill, NC: University of North Carolina Press, 2005.

Kuniyoshi, Yasuo. *Yasuo Kuniyoshi.* American Artists Group, monograph no. 11. New York: American Artists Group, 1945.

Lake, Carlton. "Picasso Speaking." *Atlantic*, July 1, 1957. https://www.theatlantic.com/magazine/archive/1957/07/picasso-speaking/305714/.

Larson, Gary O. *The Reluctant Patron: The United States Government and the Arts, 1943–1965.* Philadelphia: University of Pennsylvania Press, 2016.

Lindey, Christine. *Art in the Cold War: From Vladivostok to Kalamazoo, 1945–1962.* New York: New Amsterdam Books, 1990.

Littleton, Taylor D., and Maltby Sykes, eds. *Advancing American Art: Painting, Politics, and Cultural Confrontation at Mid-Century.* 2nd ed. Tuscaloosa: Fire Ant Books, 2005.

Look. "Paintings for Paraplegics." April 12, 1949.

Lunday, Elizabeth. *The Modern Art Invasion: Picasso, Duchamp, and the 1913 Armory Show That Scandalized America.* Guilford, CT: Lyon Press, 2015.

Macdonald, Dwight. "Action on West Fifty-Third Street–I." Profiles. *New Yorker*, December 12, 1953.

———. "Action on West Fifty-Third Street–II." Profiles. *New Yorker*, December 19, 1953.

Marquis, Alice Goldfarb. *Alfred H. Barr, Jr.: Missionary for the Modern.* Chicago: Contemporary Books, 1989.

Masheck, Joseph. "Teddy's Taste." *Artforum*, November 1970.

Mather, Frank Jewett, Jr. *Modern Painting.* Garden City, NY: Garden City Publishing, 1927.

May, Earl Chapin, and Will Oursler. *The Prudential: A Story of Human Security.* New York: Doubleday, 1950.

McCullough, David. *Truman.* New York: Simon & Schuster, 1992.

McDonald, John W. "Farming Skills Helped Mold a President." Harry S. Truman
 Presidential Library & Museum, accessed April 27, 2023. https://www
 .trumanlibrary.gov/education/student-resources/farming-years/farming-skills
 -helped-mold-a-president.
Mclanathan, Richard B. K. "Art in the Soviet Union." *Atlantic*, June 1, 1960. https://
 www.theatlantic.com/magazine/archive/1960/06/art-in-the-soviet-union/659108/.
Members of the Staff of the Kansas City Star. *William Rockhill Nelson: The Story of
 a Man, a Newspaper and a City*. Cambridge, MA: Riverside Press, 1915. http://
 archive.org/details/williamrockhilln00camb.
Menand, Louis. "Unpopular Front." *New Yorker*, October 9, 2005. https://www
 .newyorker.com/magazine/2005/10/17/unpopular-front.
Miller, Arthur I. *Einstein, Picasso: Space, Time, and the Beauty That Causes Havoc*. New
 York: Basic Books, 2002.
Miller, Merle. *Plain Speaking: An Oral Biography of Harry S. Truman*. New York:
 Berkley, 1974.
Mitgang, Herbert. "When Picasso Spooked the F.B.I." *New York Times*, November 11,
 1990. https://www.nytimes.com/1990/11/11/arts/art-when-picasso-spooked-the
 -fbi.html.
Morris, Lynda, and Christoph Grunenberg, eds. *Picasso: Peace and Freedom*. London:
 Tate Publishing, 2010.
Offner, Arnold A. *Another Such Victory: President Truman and the Cold War, 1945–1953*.
 Stanford, CA: Stanford University Press, 2002.
Penrose, Roland. *Portrait of Picasso*. New York: Museum of Modern Art, 1957.
Perlman, Bennard B. "Edward Steichen and '291.'" *Baltimore Sun*. March 28, 1973.
Peters, Olaf, ed. *Degenerate Art: The Attack on Modern Art in Nazi Germany 1937*.
 Munich: Prestel, 2014.
Petropoulos, Jonathan. *Goering's Man in Paris: The Story of a Nazi Art Plunderer and
 His World*. New Haven, CT: Yale University Press, 2021.
Picasso, Marina. *Picasso: My Grandfather*. New York: Riverhead Books, 2001.
Pulvenis de Séligny, Marie-Thérèse. *Matisse: The Chapel at Vence*. English ed.
 Translated by Caroline Beamish. London: Royal Academy Publications, 2013.
Richardson, John. *A Life of Picasso I: The Prodigy, 1881–1906*. New York: Alfred A.
 Knopf, 2007.
———. *A Life of Picasso II: The Cubist Rebel, 1907–1916*. New York: Alfred A. Knopf, 2007.
———. *A Life of Picasso III: The Triumphant Years, 1917–1932*. New York: Alfred A.
 Knopf, 2007.
———. "At the Court of Picasso." *Vanity Fair*, November 1, 1999. https://www
 .vanityfair.com/news/1999/11/picasso-199911.

———. *The Sorcerer's Apprentice: Picasso, Provence, and Douglas Cooper*. Chicago: University of Chicago Press, 2001.

Robertson, Craig. *The Passport in America: The History of a Document*. New York: Oxford University Press, 2010.

Roe, Sue. *The Private Lives of the Impressionists*. New York: HarperCollins, 2006.

Roosevelt, Theodore. "A Layman's Views of an Art Exhibition." *Outlook*, March 29, 1913.

Rose, Phyllis. *Alfred Stieglitz: Taking Pictures, Making Painters*. New Haven, CT: Yale University Press, 2019.

Rosenman, Dorothy Reuben. *A Million Homes a Year*. New York: Harcourt, Brace, 1945.

Rosenman, Samuel I. *Working with Roosevelt: Franklin D. Roosevelt and the Era of the New Deal*. New York: Da Capo Press, 1972.

Rosenman, Samuel Irving, and Dorothy Reuben Rosenman. *Presidential Style: Some Giants and a Pygmy in the White House*. New York: Harper & Row, 1976.

Ross, Lauren. "When Art Fought the Cold War: A Touring Exhibition Recreates the CIA's 1946 Secret Weapon That Scandalised Conservatives." *Art Newspaper*, April 30, 2013. https://www.theartnewspaper.com/2013/05/01/when-art-fought-the -cold-war-a-touring-exhibition-recreates-the-cias-1946-secret-weapon-that -scandalised-conservatives.

Ross, Lillian. "Return," *New Yorker*, March 23, 1946.

Rowen, Robert M. *Six Weeks with Truman*. Self-published, 2012.

Ruiz-Picasso, Maya, and Diana Widmaier-Picasso. "Maya Ruiz-Picasso on Growing Up with Her Famous Father's Homemade Toys, His Superstitious Collection of Nail Clippings, and 'Uncle' Braque." *Artnet News*, September 9, 2022. https://news .artnet.com/art-world/maya-picasso-interview-excerpt-2172387.

Saarinen, Aline B. "Art Storm Breaks on Dallas." *New York Times*, February 12, 1956.

Sandberg, W. J. H. B. "Picasso's 'Guernica.'" *Daedalus*, Winter 1960. https://www .amacad.org/publication/picassos-guernica.

Saunders, Frances Stonor. *The Cultural Cold War: The CIA and the World of Arts and Letters*. New York: New Press, 2013.

———. "Modern Art Was CIA 'Weapon.'" *Independent*, October 21, 1995. https://www .independent.co.uk/news/world/modern-art-was-cia-weapon-1578808.html.

———. *Who Paid the Piper? The CIA and the Cultural Cold War*. London: Granta Books, 1999.

Schlesinger, Arthur M., Jr. *Journals, 1952–2000*. New York: Penguin, 2007.

Schwartz, Alexandra. "How Picasso's Muse Became a Master." *New Yorker*, July 15, 2019. https://www.newyorker.com/magazine/2019/07/22/how-picassos-muse -became-a-master.

Sharon, Henrietta Bruce. *It's Good to Be Alive*. New York: Dodd, Mead, 1945.

Sheets, Hilarie M. "Picasso and His Last Muse." *New York Times*, October 23, 2014. https://www.nytimes.com/2014/10/26/arts/artsspecial/picasso-jacqueline-at-pace -gallery-in-new-york.html.

Sivard, Susan. "The State Department 'Advancing American Art' Exhibition of 1946 and the Advance of American Art." *Arts Magazine*, April 1984, 92–98.

Taylor, Glen Hearst. *The Way It Was with Me*. Secaucus, NJ: L. Stuart, 1979.

Tomkins, Calvin. *Duchamp: A Biography*. New York: H. Holt, 1998.

Truman, Harry S. *Mr. Citizen*. Independence, MO: Independence Press, 1972.

———. *Years of Trial and Hope*. New York: Doubleday, 1956.

Twain, Mark. *The Innocents Abroad*. Knoxville, TN: Wordsworth Editions, 2010; orig. publ. by American Publishing, 1869.

Van Hensbergen, Gijs. *Guernica: The Biography of a Twentieth-Century Icon*. New York: Bloomsbury, 2004.

Van Wagner, Judy K. Collischan. *Women Shaping Art: Profiles of Power*. New York: Praeger, 1984.

Vuchetich, Jill, and Julie Caniglia. "The Walker Curator Who Sparked a Red-Baiting Scandal." Walker Art Center, October 10, 2012. https://walkerart.org/magazine /from-the-archives-the-walker-curator-who-sparked-a-red-baiting-scandal.

Walsh, Kenneth T. *Celebrity in Chief: A History of the Presidents and the Culture of Stardom*. New York: Taylor & Francis, 2016.

Wang, ShiPu. *Becoming American? The Art and Identity Crisis of Yasuo Kuniyoshi*. Honolulu, HI: University of Hawai'i Press, 2011.

Witsil, Frank. "Lincoln Lore: Michigan Home to Many Artifacts of President." *Detroit Free Press*, February 12, 2007.

Wolf, Tom M. *The Artistic Journey of Yasuo Kuniyoshi*. Washington, DC: Smithsonian American Art Museum, 2015.

Wolferman, Kristie C. *The Nelson-Atkins Museum of Art: A History*. Columbia. MO: University of Missouri Press, 2020.

Zayas, Marius de. *How, When, and Why Modern Art Came to New York*. Cambridge, MA: MIT Press, 1996.

INDEX

Page numbers in *italics* refer to images; page numbers followed by *n* refer to notes.